大江東去浪淘盡

千古風流人物故壘

邊人道是三國周郎

赤壁亂石崩雲，驚濤裂岸，捲起千堆雪。江山如畫，一時多少豪傑。

CONTEMPORARY TAIWANESE LITERATURE AND ART SERIES *II*
ART

當代台灣文學藝術系列 2

美術卷

TAIPEI CHINESE CENTER,
PEN INTERNATIONAL
中華民國筆會

Contents

Preface 8

Wang Pan-Youn 王攀元 10

Wang Pan-Youn: Where Bitterness Is Beauty, and Loneliness Is Art
苦澀是美感，孤獨是藝術
Joseph WANG 王哲雄
Translated by Yauling HSIEH 謝瑤玲 and Joel J. JANICKI 葉卓爾

Li Chi-Mao 李奇茂 26

Nativist Themes vs. Lofty Sentiments: on Li Chi-Mao's Paintings
鄉野豪情：李奇茂的傳奇與成就
HSIAO Chong-ray 蕭瓊瑞
Translated by David VAN DER PEET 范德培

Yuyu Yang 楊英風 42

My Life as an Artist
楊英風藝術生命的自述
Yuyu YANG 楊英風
Translated by Michelle Min-chia WU 吳敏嘉

Sun Chao 孫超 58

Sun Chao's Road to Ceramics
我的陶瓷之路
SUN Chao 孫超
Translated by SUN Yilin 孫逸齡

Liu Kuo-Sung 劉國松 76

Liu Kuo-Sung: Master of Modern Chinese Ink and Wash
劉國松：中國水墨一代宗師
 LEE Chun-yi 李君毅
 Translated by David VAN DER PEET 范德培

Cheng Shan-Hsi 鄭善禧 94

No Art Without Color: *Joie de Vivre* in the Works of Cheng Shan-Hsi
丹青妙手鄭善禧
 LIU Jung Chun 劉榕峻
 Translated by David VAN DER PEET 范德培

Ju Ming 朱銘 110

Thus Speaks Ju Ming
朱銘曰
 PAN Hsuan 潘煊
 Translated by Carlos G. TEE 鄭永康 , Yauling HSIEH 謝瑤玲 and Joel J. JANICKI 葉卓爾

Lin Hsin-Yueh 林惺嶽 126

Lin Hsin-Yueh's Focus on the Motherland
林惺嶽畫作的母土凝望
 Chao-yi TSAI 蔡昭儀
 Translated by Sterling SWALLOW 師德霖

Lee Yih-Hong 李義弘 144

Lee Yih-Hong: Pioneer Ink Wash Painter in Postwar Taiwan
臺灣戰後水墨的拓荒者李義弘
 WU Chitao 吳繼濤
 Translated by David VAN DER PEET 范德培

Ho Huaishuo 何懷碩 160

Ho Huaishuo and the Artist's Affair with the Moon
流逝的月光──永恆的美感
YEN Chuan-ying 顏娟英

Lee Ku-Mo 李轂摩 176

Infinity in a Scroll: Lee Ku-Mo's Painting and Calligraphy
李轂摩的書畫世界
Shih-Ping TSAI 蔡詩萍
Translated by Linda WONG 黃瑩達

Tong Yang-Tze 董陽孜 192

The Calligraphy of Tong Yang-Tze
董陽孜的書法
Compiled by Michelle Min-chia WU 吳敏嘉

Tong Yang-Tze: Choosing a Different Path
董陽孜總是選擇不一樣的路
Cora WANG 王力行
Translated by David VAN DER PEET 范德培

A-Sun Wu 吳炫三 208

Primitive Charm in the Art of A-Sun Wu
阿三的蠻荒魅惑
Carlos G. TEE 鄭永康

Syue Ping-Nan 薛平南 224

Syue Ping-Nan: Master of Calligraphy and Seal Making
薛平南：書印雙雋
TSAI Ming-tsan 蔡明讚
Translated by David VAN DER PEET 范德培

Shi Song 奚淞 240

Buddhist Artist Shi Song
修行人的藝術實踐——大樹之歌 · 畫說佛傳

YEN Chuan-ying 顏娟英

Translated by Brent HEINRICH 韓伯龍

Yuan Chin-Taa 袁金塔 256

Yuan Chin-Taa's Art of Boundary Crossing
袁金塔的越界飄移與定錨

CHUANG Kun-liang 莊坤良

Translated by Darryl STERK 石岱崙

Meiing Hsu 徐玫瑩 272

Life as a Fugue: The Art of Meiing Hsu
徐玫瑩的賦格人生

CHEN Man-hua 陳曼華

Translated by David VAN DER PEET 范德培

Tu Wei Cheng 涂維政 288

A Poem of Our Time: Tu Wei Cheng's Art
時代之詩：涂維政的藝術創作

SHEN Bo Cheng 沈伯丞

Translated by Linda WONG 黃瑩達

Notes on Authors and Translators 303

Preface

The Taipei Chinese PEN—A Quarterly Journal of Contemporary Chinese Literature from Taiwan, founded in 1972, is primarily a literary magazine. It nevertheless is home to a beautiful tradition: each issue hosts an exhibition of the work of a local artist from Taiwan, so that those who are interested in the literature of Taiwan also have a chance to appreciate its art.

2011 saw the publication of the much acclaimed *Contemporary Taiwanese Literature and Art Series*, which introduced in a single volume the masterpieces of 18 artists featured in the magazine in the 30 years prior to 2011. The volume fills in the gap left by the lack of a publication of a similar nature in English for so many years.

After I assumed the post of the President of Taipei Chinese PEN in 2015, a sequel to the 2011 volume was planned, and another group of 18 artists chosen. They are Wang Pan-Youn, Li Chi-Mao, Yuyu Yang, Sun Chao, Liu Kuo-Sung, Cheng Shan-Hsi, Ju Ming, Lin Hsin-Yueh, Lee Yih-Hong, Ho Huaishuo, Lee Ku-Mo, Tong Yang-Tze, A-Sun Wu, Syue Ping-Nan, Shi Song, Yuan Chin-Taa, Meiing Hsu, and Tu Wei Cheng. They represent among the best in Taiwan in painting, calligraphy, sculpture, ceramic, metal art, installation art, etc. Their creations span a wide spectrum of styles that includes modern and classical, as well as a blending of the local and the foreign.

Some of the artists featured in this volume were born in China and moved to Taiwan with the Nationalist government in 1949. Together with their fellow artists from Taiwan, these 18 highly acclaimed artists showcase the best Taiwan has to offer in art creativity.

The introductory essays for each artist in this volume are mostly edited reprints from *The Taipei Chinese PEN* quarterly. Some were written specifically for an exhibition, others were assessments of the artist based on many years of careful observation. A few of them were written by the artists themselves to recap their

journey through the kingdom of art. We tried not to standardize the format so readers get to know the artists from a variety of angles.

I owe many thanks to the editors of *The Taipei Chinese PEN* quarterly, mostly to Nancy Chang Ing, Chi Pang-yuan, Perng Ching-Hsi, Tien-en Kao, and Yanwing Leung, for their careful selection and presentation of the artists in each volume of the quarterly.

I need also to thank my PEN colleagues for their commitment to the preparation of materials for the present volume. The hard work of Yanwing Leung, Feimei Su, and Sarah Hsiang is especially noted.

This volume is supported by a grant from the Ministry of Culture. PEN member Professor Hsinya Huang has been instrumental in securing a generous donation from entrepreneurs Mr. Hsiung-Ching Lee and Mr. Chin-Nan Hsieh, both avid art lovers. To them I owe special thanks. Finally, I thank our publication partner the prestigious Linking Publishing Company for their professional management from page layout to marketing of the present volume!

Pi-twan Huang
President
Taipei Chinese Center
PEN International

Wang Pan-Youn

Where Bitterness Is Beauty, and Loneliness Is Art

苦澀是美感
孤獨是藝術

Joseph WANG 王哲雄

Turning toward Nowhere 歸向何方 1980 Oil on Canvas 91×91cm

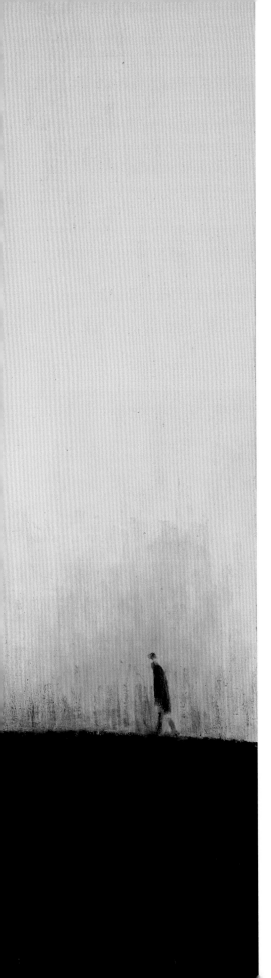

王攀元 (1912-2017)

Wang Pan-Youn (also Wang Pan-Yuan)

Born in Jiangsu, China, Wang Pan-Youn graduated from Shanghai Academy of Fine Arts where he learned from many great masters. The first few years after coming to Taiwan in 1949, he had to struggle to survive due to the hardships of wartime. He settled in Yilan in 1957 and taught middle school there until his retirement. In Yilan, Wang helped the Lan-Yang Painting Society organize activities to promote Yilan's young artists.

An artist with distinctive personal style, Wang is often called a "poet on canvas." The composition of his paintings are simple, but the subject matter is diverse with opulent and beautiful colors, a modern style rich in Oriental literary connotation.

Wang Pan-Youn won the 2001 National Arts Award. He was also laureate of the 2017 Executive Yuan National Cultural Award, the year he passed away in December at the advanced age of 105.

Wang Pan-Youn is a legendary figure in the art circle in Taiwan. His paintings are endowed with a special quality, one that reveals loneliness and sorrow but at the same time contains within a flaming life force.

Wang's art comes from his loneliness that is bitter yet at the same time transcendental. His art not only expresses his feelings, but, in a most praiseworthy fashion, his noble thoughts. I wrote the following poem for him after having once visited his exhibition:

> I have combed the boundless blue sea,
> Teetering alone in the blustery rain.
> Not to surrender to pathos ever,
> But to transform sorrow into pride.

Wang Pan-Youn was born 1912 in Jiangsu in east China. His father, Wang Han-hua, liked music and was adept at playing the pipa (a Chinese plucked string instrument with a fretted fingerboard). His mother was a virtuous and well-mannered lady who liked reading classical Chinese poetry. The Wang family was a typical Chinese clan with representatives of three generations all living under the same roof. Their mansion was a great and beautiful palace-like structure that took up acres of land. However, Wang Pan-Youn did not have the opportunity to enjoy a luxurious life. When his father died in 1913, his uncle took over the immense estate and the financial concerns of the Wang family, and the rich and powerful family began to see its glory fade. His mother, who had always immersed herself in books and poetry, was forced to witness the cruel struggle over the property with her in-laws even before she was able to recover from the loss of her husband. Wang Pan-Youn was only three years old at the time. He might not have understood worldly wisdom, but as he grew up in such a sad and unhealthy atmosphere, he became reticent and taciturn.

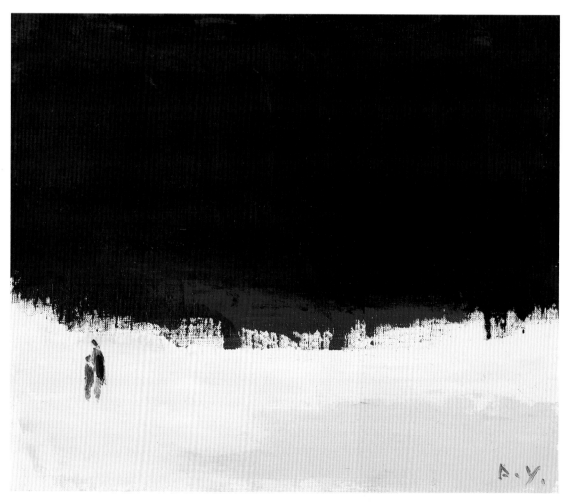

Heavenly Earth 天上人間 1994 Oil on Canvas 45.5×38cm

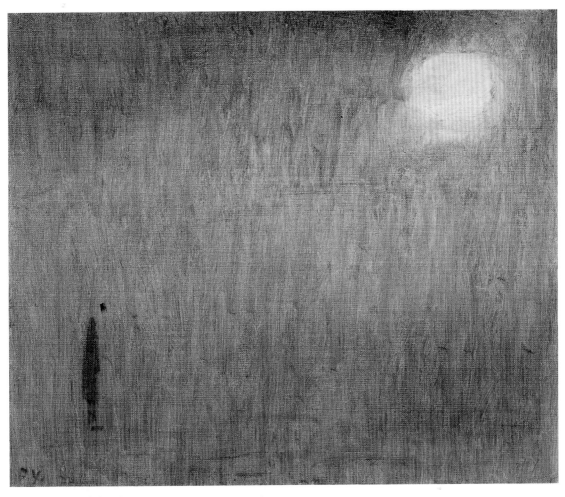

Lamentation 今夕何夕 1994 Oil on Canvas 45.5×38cm

In 1924, his mother died when Wang was thirteen years old. With all his aunts who used to care for him also married away, Wang became a true "orphan," confused and sad. From that time on, he had to cope with all kinds of unpredictable tests in life all by himself.

In 1925, Wang Pan-Youn passed the competitive examination and was accepted into the prestigious Huai An Middle School. After he graduated there, he was allowed to continue study in its Senior High School Division without having to take any examination. This was due to his excellent grades. While he was in senior high school, he met Mr. Wu Fu-zhi, his art teacher, who led him into the artistic world of painting.

Wang Pan-Youn took his study seriously. He put aside his grief and accumulated much knowledge through studying hard. He experienced a great deal of relief on the school campus. During the years that he studied at Huai An, he rarely went home even during summer and winter vacations. He treasured the freedom and the carefree feeling he experienced while living in the school dorm. But he could not mingle with his classmates. Hidden in the reticent appearance of

Wang Pan-Youn was a warm and passionate heart. The only person who tried to understand him was his art teacher, Mr. Wu Fu-zhi. He paid special attention to him and found that Wang Pan-Youn had a talent for art. He encouraged him to develop and cultivate that talent.

Wang Pan-Youn was lucky enough to receive the assistance from Mr. Wu, and meanwhile he found some odd jobs, such as selling evening papers to earn his living. However, his income

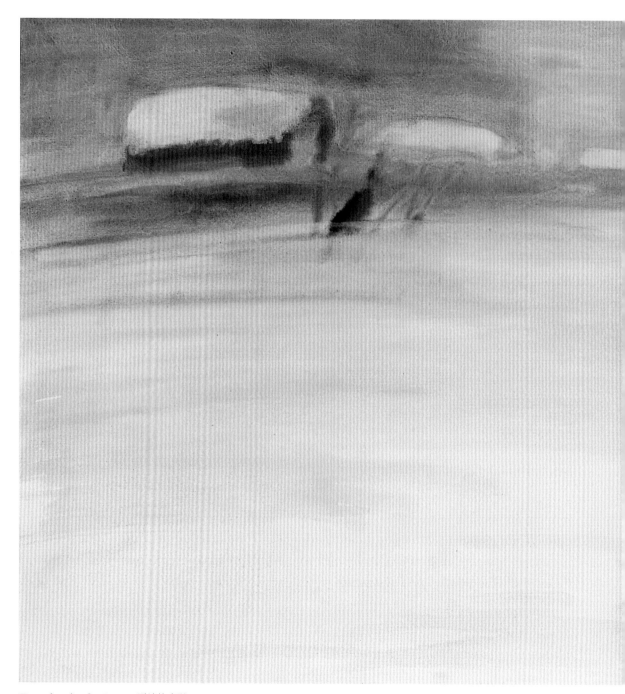

Running in the Snow 雪地的奔馳 1975 Watercolor 79×54cm

was not always sufficient for him to have full meals, so sometimes he was forced to skip meals or ate yams instead of rice when he was hungry. Although he did not have a materially rich life, his spiritual life was full.

Once he transferred to the Shanghai Academy of Art, he chose Western Painting as his major. His instructor at that time was Mr. Zhang Hsien 張弦 , who had studied art in France. Wang Pan-Youn told me: "During the three years at the Academy, he taught me everything about oil painting and sketching. He was a serious teacher and an optimistic person. I miss him a lot. I graduated from the Academy in 1936, and he died of meningitis in the following year." Mr. Zhang Hsien laid a solid foundation for Wang's oil painting and sketch. He always emphasized that an artist had to cultivate his mind and develop a special style, an advice that greatly influenced Wang Pan-Youn in his choice of directions and the quality of his paintings.

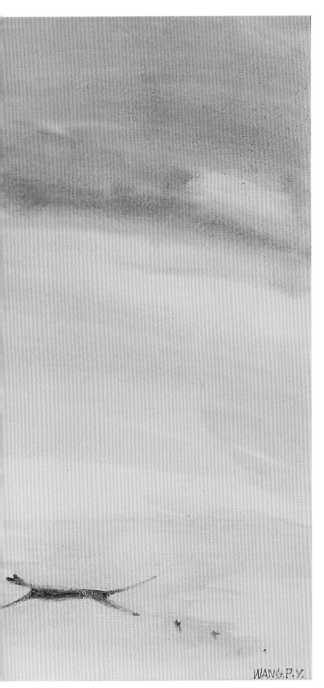

Actually, there were many outstanding teachers at the Shanghai Academy of Art at that time. For example, Tsai Yuan-pei 蔡元培 , one of the Academy's board members, was an educator of art who was knowledgeable and idealistic. Liu Hai-shu 劉海粟 , President of the Academy, was popular among students with his course "Artistic Trends." His point of view was exact and accurate, and he was an advanced thinker who greatly inspired his students. Other teachers such as Chen Ren-hau 陳人浩 , an expert in watercolor painting, Professors Pan Yu-liang 潘玉良 and Wang Ji-yuan 王濟遠 , who taught at the graduate program, and Pan Tien-shou 潘天壽 who taught Chinese painting, were all great artists and scholars. Wang Pan-Youn told me, "During the New Year holidays, I did not want to go home, so I went to sit in on classes at the graduate school. I did not pay for the lectures as the other students did. Professor Pan Yu-liang planned to go back to France. She asked us, 'Who wants to go to France

with me? I can take you along.' We could board at her place in France without having to worry about accommodations. I wanted to go along with Professor Pan and went home to ask for the money for the trip. But my family refused to allow me to go." Wang Pan-Youn tried to persuade his family to pay for his trip from his share of the family property, but all his efforts were in vain.

When he was studying in the Department of Western Art at the Shanghai Academy of Art, he realized that as a Chinese, he should have a good understanding of traditional Chinese ink and wash painting. So he took time to audit the class in Chinese painting offered by Mr. Pan Tien-shou. This helped him develop his own personal painting style, so much so that we can sense the atmosphere of ink and wash painting in his oil paintings and watercolor paintings.

Bitterness is beauty, loneliness is art

The word "bitterness" cannot even describe the hardship of Wang Pan-Youn's life. After he graduated from the Academy, life did not start to take a better turn. National calamity and wars forced Wang to live a destitute and homeless life. At long last, the Second World War came to

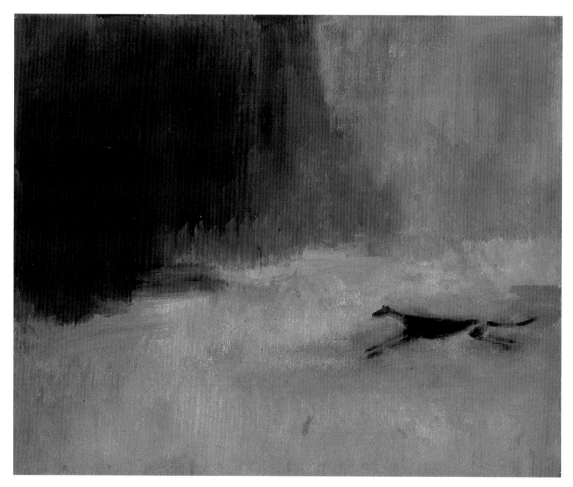

Fleeing 奔 1951 Watercolor 39.5×32.cm

an end. In the spring of 1946, Wang Pan-Youn went back to Shanghai to teach at the Dan Yang Middle School. In June 1949, he came to Taiwan in a roundabout way together with his wife, Ni Yue-ching. They first stayed in Fengshan in southern Taiwan, but could not find work because they were out-of-towners and had no connections there. He was forced to become a longshoreman at the harbor in order to earn his living. In the fall of 1952, he finally found a teaching job as an art teacher at Luodong High School in northeast Taiwan. Although he continued to live in miserable and unhealthy conditions, he had at least a regular income after years of wandering around with no place to call home.

The artistic achievement of Wang Pan-Youn is the result of his long years of suffering and the loneliness in his life. His artistic quality does not cater to any form of sensuous pleasure, nor can his talent be characterized as romantic or sensational. As such, he was dependent on the recommendations of established artists such as Li De 李德 , Max Liu 劉其偉 , and Hu Chie 胡茄 , who appreciated and recognized his talent before his paintings managed to attract any significant attention. In 1966, thanks to the promotion of Li De, the first exhibition of Wang Pan-Youn's paintings at the International Gallery attracted a large number of viewers who were deeply moved

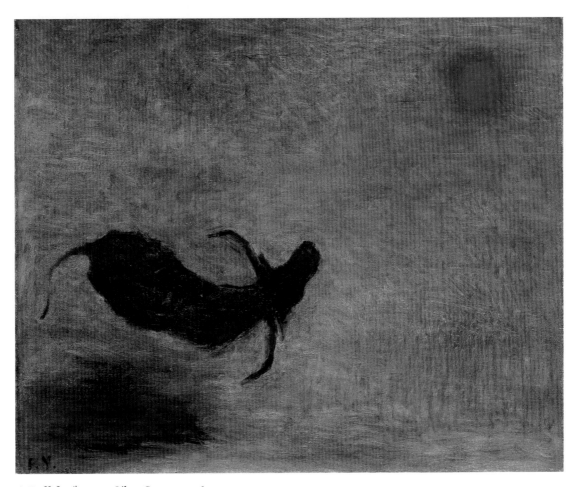

A Buffalo 牛 1970 Oil on Canvas 73×60cm

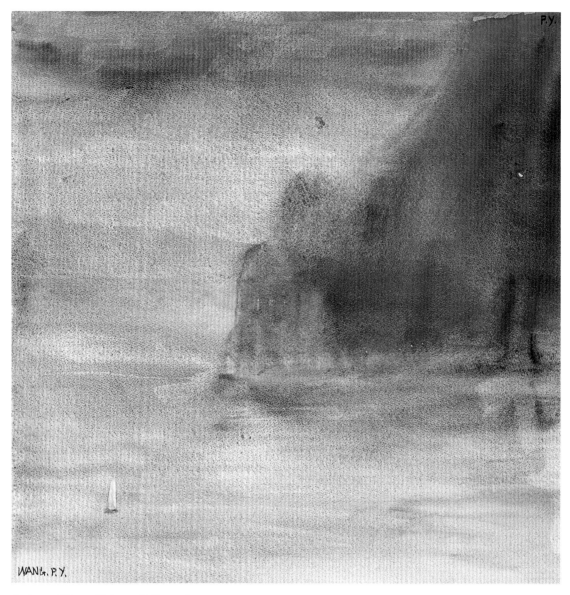

Autumn Water 秋水　1976　Watercolor　50×50cm

by the 32 watercolors in the exhibition. It happened that the film crew of the Hollywood movie, The Gunboat of San Paolo, had been in town to take some shots on location. Members of the crew came to the gallery by chance, and they liked Wang Pan-Youn's paintings so much that they decided to buy all of the paintings on display at the exhibition. Wang Pan-Youn was paid 20,000 NT dollars for the sale of his works, a significant sum of money for the artist at the time. As Wang's children were growing up and the family required more living space, Wang sold his little tiled-roofed house and bought a spacious concrete house with the money he had and a loan from the bank. But he did not pay back the loan for ten years.

In 1973, as his health began to decline, Wang Pan-Youn applied for retirement from the high

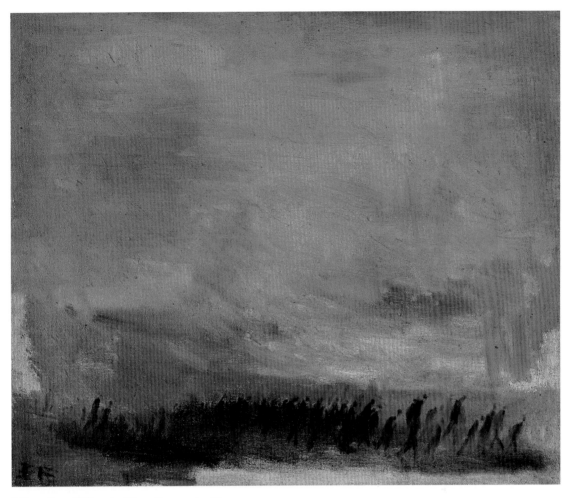

Migration 遷徙 1961 Oil on Canvas 45×38cm

school where he had been teaching. By that time his children had all grown up. So he was able to focus on painting. Often he would not stop painting until the wee hours of the morning. In 1987, Wang Pan-Youn was invited to hold a solo retrospective exhibition in the National Gallery of the National Museum of History. The exhibition included 60 works of his that he had painted over the years. It turned out to be an exhibition that paraded all the stages of his creative process. The icons of his "autobiographical symbolism," such as running dogs, flying geese, suns that lost their shining rays, cold and desolate grasslands, trunks of dead trees, lonesome old men, lone sails in the vast sea, crescent moons, chaotic worlds, and lonely female figures and dancers, served to create the transcendental "bitter beauty" of his art.

He came to enjoy success during the later years of his life. Due to the success of the exhibition at the National Museum of History, Eslite Gallery decided to sponsor an exhibition of his works that included 60 of his watercolors and oil paintings. The style of these paintings was similar to that of the paintings previously exhibited, but this time the colors on display were clearer and brighter. In June of the same year, the Taiwan Museum of Art also invited Wang to hold a one-

Turning to the Floating Clouds 問行雲　1995　Oil on Canvas　23×16cm

man show. Wang's artistic achievement was further confirmed.

The most touching characteristic of Wang's paintings is the "bitter beauty," which was cultivated through his long period of suffering and personal torment. This "bitter beauty" of his has nothing in common with sentimentalism characterized by wailing and plaintiveness. Instead, he tried to look at his own life from an objective third-person point of view and recount his life experiences, his overwhelming homesickness, and his pure love. His point of view adds a delicate and superb quality to the "bitter beauty" of his paintings. For example, in his watercolor *Fleeing*, painted in 1951, a lone black dog appears running recklessly and ever so lightheartedly in a fantasy land of chaos formed of blocks of gray and green suggesting mountains and grasslands. Where is the dog running to and for what? Is it running to the future in the far distance? Is it looking for its master? Or is it just enjoying the exhilarating sense of running free? Is it going to run alone forever? All these questions are related to Wang Pan-Youn's life. He tries to show his life and his thought with the image of the dog running in the wild field. Wang told me, "I have lived a most traumatic and torturous life, but I never blame heaven or others for my misfortune. I do not complain and I do not have a religion. I follow nature's way, which comes in cycles. No one can do anything against nature. One has to follow one's own path. Science may conquer nature, but no human can go against the heavenly principles of nature. I strive for simplicity. I like things that are simple." Thus open-mindedness and simplicity are Wang's principles as well as the sublimation of his feelings of loneliness.

Wang also said, "I like painting animals, especially dogs. First of all, dogs are loyal to their masters. Secondly, when I was in my hometown, I had no playmates. Nobody wanted to play with me and nobody liked me. I was always alone. Even the servants would bully me. We had many dogs in my family then; they included Tibetan mastiffs, German shepherds, and mongrels. We had dogs in the front yard to prevent thieves from breaking into the house. I played with the dogs a lot, so I have a special feeling for dogs." So dogs are a part of his life. Birds, too. Wang remembers that when he was little there were lots of birds in his house. "They are a reflection of my mind," said Wang. However, such reflection takes the form of an autobiographical expression: the solitary birds in his paintings fly blindly as if they were searching for a home and reveal a kind of sad beauty. We can see this in *A Flying Goose* (oil painting, 1965), or in the lonely and depressed *A Tired Bird* (oil painting, 1986) and *A Dying Bird* (oil painting, 1973).

The human figures in Wang's paintings are always alone, too. They symbolize loneliness and alienation. In Wang's paintings the subject matter reveals the wisdom of seeing oneself in others. Male figures are usually reflections of the artist himself or his imagined self. Female figures are the sublimation of a love mixed with tender feelings of gratitude and admiration. Examples of such are *A Girl in Blue Dress* (watercolor, 1950) and *A Dancer* (watercolor, 1984).

The "boat" is also a symbol of the vastness and sad beauty that Wang often conveys in his paintings. Sometimes the image of the boat appears alone without any sail; sometimes passengers

are on boats with no sails, and when there are both passengers and sails on the boats, they are still redolent of loneliness and desolation. Occasionally several boats appear in a single painting, but the whole atmosphere still seems lonely and quiet, such as *None Avails* (watercolor, 1982), *Jialing River* (watercolor 1966), *Eking out an Existence* (watercolor, 1966), *Boats* (oil painting, 1966), and *Brilliance of Sunset* (oil painting, 1980). As a matter of fact, boats also reflect Wang's personal complex. He once said, "The year I graduated from the Shanghai Academy of Art, I went to Hangzhou with my girl friend to go row-boating. The last time I went boating with her, it was drizzling. She came to where I was living in Shanghai to look at the rain, and she wrote, 'Keeping what's left of the disappearing lotus leaves for the sound of the rain.' Now that I think back, I feel so sad. My studio is now called the 'Rain Harmony Lodge.'" Wang is a person who cherishes old memories. He thought of the boats, then the rain, then his girl friend. Therefore, boats are for him

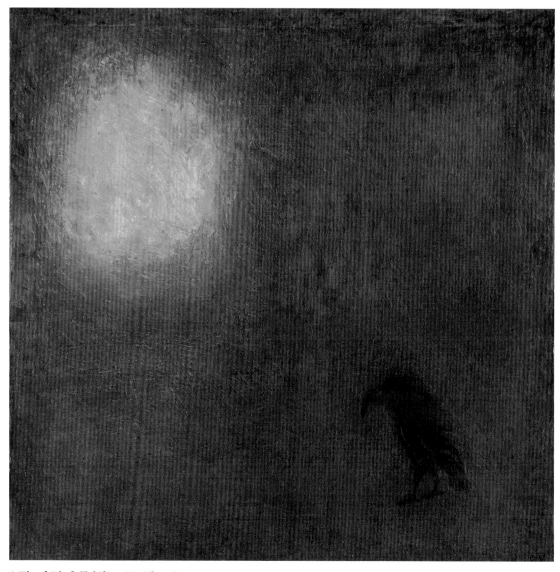

A Tired Bird 易水寒 1986 Oil on Canvas 74×74cm

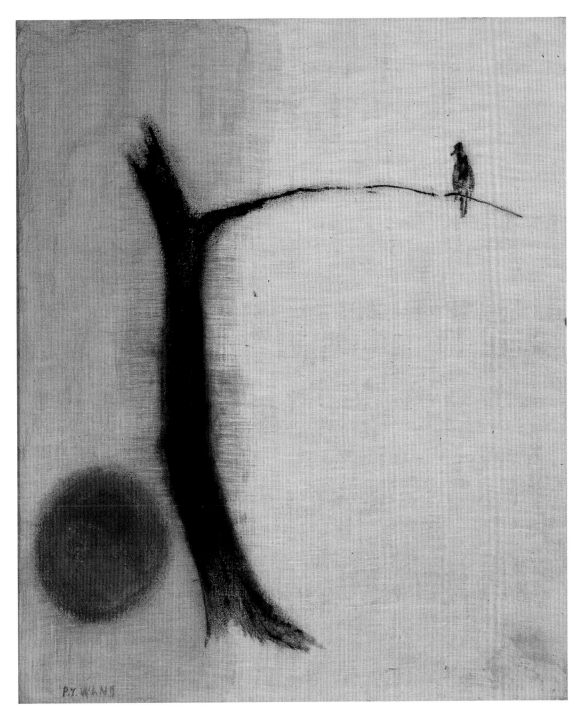

The Setting Sun 落日 1952 Oil on Canvas 45.5×38cm

not merely a means of transport; they symbolize the love between man and woman.

Symbolist painters like to use the sun and the moon as symbols of their feelings. Wang uses a more poetic expression to handle these feelings and overcome his lovesickness. For example, in *Moonlight* (watercolor, 1976), a lone boat under the moon serves as Wang's version of Li Bai's "I

tilt my head up to look at the bright moon, and lower my head down to brood over my hometown." But the vague and intangible reflection on the water brings to the painting a poetic atmosphere and transcendence. As for the sun, Wang always remembers the sun from his childhood memories. However, he insists that the reason why the sun often appears in his paintings is that "the sun represents 'permanence.' It will never change. If it's gone, the whole universe is gone as well. The sun is the soul of the universe; besides, I like the red color of the sun."

As a matter of fact, Wang Pan-Youn's paintings do not always fit neatly under the category of "lyrical aria." The structures of his paintings are at times rather avant-garde. Some of his landscapes feature a single dominant color, such as *A Blue Lake* (watercolor, 1965), *Clouds at Sunset* (watercolor, 1960). *A Painting in Monochrome* (oil painting, 1970), *A Distant Planet* (oil painting, 1975), *A Nursery* (oil painting, 1985), and *A Painting in Monochrome* (oil painting, 1985). Some of his paintings have rather abstract structures in a modernist sense. Such structures are referred to as "new perspectives" by the artist and at first glance they bring to mind the 'Colorfield' school of painting. They can be seen in some of the following paintings: *Brilliance* (watercolor, 1956), *A Rising Sun* (oil painting, 1969), *Missing An Old Friend* (oil painting, 1966), *Guishan Isle* (oil painting, 1962), *Sorrowfulness* (oil painting, 1978), *The Horizon* (oil painting, 1964), *The Choice* (oil painting, 1985), *Sunrise at Mount Taiping* (oil painting, 1988), and *The Iron Anchor* (oil painting, 1995). In all of these paintings abstract and concrete elements harmonize. Bands of colors reflect the rich but introspective feelings of the artist. They are different from the cold reasoning evident in the evenly painted hues of the 'Colorfield' school of painting.

The later and more recent paintings of Wang Pan-Youn continue to evoke a poetic atmosphere, the symbols and the vastness, as well as the lonely wanderer of his earlier works. But it is obvious that the colors of these paintings are purer and clearer, somehow simpler and brighter as well. Moreover, the dimensions of the canvas are much bigger. All these bestow to the paintings of Wang Pan-Youn a greater sense of mystery and space, like a being in the universe. For example, in *A Dog* (oil painting, 1980), the entire painting consists of primarily a single color, pink. At the upper left corner can be seen a highly conceptualized mountain, and in the bottom right corner is a very realistic black dog. The two forms divided by a diagonal line form a sharp contrast, and the loneliness and the sad beauty that are characteristic features of Wang's paintings are situated in a universe that creates a sense of the absolute. *Red Dust* (oil painting, 1980) is similar to the early paintings of Robert Motherwell, a great master of American abstract expressionism. Huge blocks of single colors cover the entire canvas, with only the corners showing the background color. Such a bold and modern composition (all is red but for a black patch in the upper right corner) is actually a continuation of Wang's "new perspective" in which the horizon is elevated. The red color in the painting is also similar to his manner of layering in his watercolor paintings. The painting, rich with meaning, even suggests the concept of Zen. Similarly, *The Mountain Dwelling* (oil painting, 1998) also is Zen-like in its contrast of black and white with cosmic overtones. The composition of the painting is also rich in spiritual content.

Wang's later paintings show that his skills in conveying a symbolically charged poetic atmosphere have approached the level of perfection. *Withered Lotus* (oil painting, 2000), illustrates the moral of "growing out of mud without being polluted." As Wang himself expressed it, "good words should be concise." Wang's paintings are not just about visual beauty. They are expressions of philosophical thought and the concept of Zen. *A Horse* (oil painting, 2000) reveals permanent life force through its sharp diagonal composition: the sun constantly radiates heat and energy; it brings light to the earth and life to all creation.

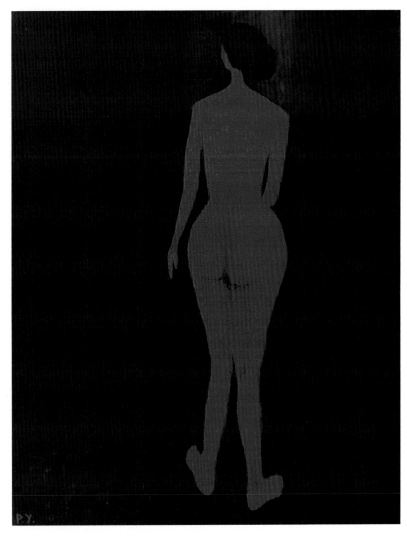

A Red Shadow 紅影 1980 Oil on Canvas 116×90cm

The paintings of Wang Pan-Youn are the reflection of his hard and lonely life. But they do not degenerate into a mere teary protest; rather, they represent a transcending experience. The rich layers of colors in his watercolors, the modernist compositions of his oil paintings, the imagistic expression of his Oriental ink and wash paintings, and the absolute spiritual emptiness of the vast universe in his paintings—all this suggests that Wang's creation is unprecedented. Wang Pan-Youn occupies a very significant position in the art history of Taiwan.

Translated by Yauling HSIEH 謝瑤玲 and Joel J. JANICKI 葉卓爾

* Excerpted from *Panyuan zhui ri—Wang Pan-Youn zixuanji*《攀圓追日 —— 王攀元自選集》(*In Pursuit of Solar Perfection—Paintings of Wang Pan-Youn, a Self-Selection*). Taipei: Metaphysical Art Gallery, 2001. All the pictures and the essay are courtesy of Metaphysical Art Gallery.

Li Chi-Mao

Nativist Themes vs. Lofty Sentiments: On Li Chi-Mao's Paintings

鄉野豪情：
李奇茂的傳奇與成就

HSIAO Chong-ray 蕭瓊瑞

Crows Returning at Evening Bells 晚鐘歸鴨（柏林鐘聲） 1972 Ink on Paper 40×40cm

李奇茂 (1925-)
Li Chi-Mao (also Li Qi-Mao)

Born in Anhui, China, Li Chi-Mao came to Taiwan in 1949. He graduated from Fu Hsing Kang College's Department of Fine Arts. Li is skilled at capturing human and animal figures in motion. He is also adept at depicting the magnificence of Taiwan's rural scenery and its local people. He also portrays local customs and characters with vivid brushstrokes.

Li Chi-Mao has long been committed to art education and has won the National Arts Award and the Ministry of Education's Arts Education Contribution Award. He received a Ph.D. in literature from Korea's Dankook University, and has enthusiastically promoted international exchanges. The city of San Francisco has also designated November 29 as "Li Chi-Mao Day" for his contribution to the cultural exchanges between Taiwan and the United States.

When fleeing from war-ravaged mainland China to Taiwan in 1949, Li Chi-Mao was 25 years old, a young man teeming with youth and ambition. He has the tall and sturdy build of a typical northern Chinese, and it was only a year after his arrival on the island that he held his first solo exhibition in Taipei. Always full of confidence and determination, he quickly made Taiwan his new home, but the rugged landscapes and desert vistas of his homeland forever remained an important source of inspiration, a place where his very soul is still anchored. The 1950 exhibition marked the start of an amazing career, one underpinned by travels around the world and exhibitions in many parts of our planet—all of which further contributed to Li's wide vision and creative panache. Decades have gone by in a flash, and the aspiring youth of yore has become a giant in the world of painting, a legend shaped by the special circumstances of both Taiwan's and his own individual history.

Li's hometown in China was a typical rural area, and memories from his childhood include images of old men smoking pipes, strong young oxen pulling plows in the fields, or trips with his grandfather to faraway Shanxi, way over the plains and mountains, to buy horses. Those journeys, made in the cold of winter and with the bitter north wind blowing in powerful gusts,

meant a long struggle across the loess plateaus, an exhausting slog in which humans and animals had only each other to find warmth and company. Through wide fields under vast skies, they slept on the ground and ate small rations of food. Arduous as they were, these trips reunited man and nature, forming a major foundation of the artist's later predilection for nativist themes and lofty sentiments, and his strong focus on the power of perseverance and the simple things in life.

During his adolescence, Li had received some basic training in traditional Chinese literati painting, giving him the skill and confidence to hold a solo exhibition in his second year in Taiwan, also a clear indication of his extroverted character and a personality that revels in challenges. Even as a private at Taichung's Ching-Chuan Kang Air Base, Li Chi-Mao continued to improve his ink and wash technique. He was particularly taken with the work of Huang Junbi 黃君璧 , then master of the Lingnan 嶺南 School and one of Taiwan's leading painters, and since he didn't get a chance to admire his oeuvre firsthand, Li would cut his paintings out of newspapers and magazines, and copy them again and again and again. His efforts caught the attention of one of his superiors in the political warfare department, and soon his talent attracted wider notice. In 1952, the brothers Liang Youming 梁又銘 and Liang Zhongming 梁中銘 , both renowned artists, encouraged and mentored him, enabling Li to get accepted into the fine arts department of Fu Hsing Kang College (today's Political Warfare Cadres Academy), the very best art school a would-be painter in the

The Calligraphy of Huai Su 懷素習書 2017 Ink Painting on Paperboard 24.2×27.3cm

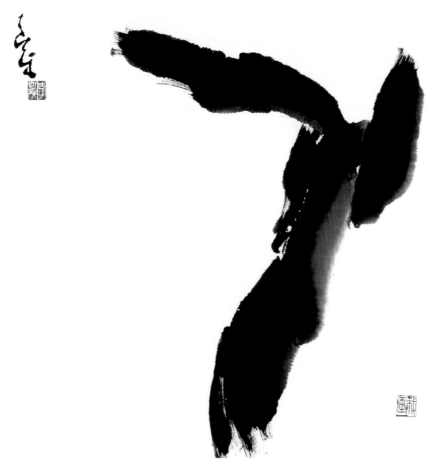

Falcon 鷹 2010 Ink on Paper 70×70cm

armed forces could hope to join. He graduated in 1956.

His training in political warfare forced Li to gradually relinquish his preference for ink and wash landscape painting, and become more involved with portraits, bird and flower paintings, and depictions of other animals. The education he received at that time placed much emphasis on sketching from life, and allowed for little or no development of an individual style. This helped Li to lay some solid groundwork by practicing the basic skills and techniques to perfection. Always striving for excellence and precision, he would go as far as buying a chicken at the local market and take it back home for his sketching assignment. He would pluck out all its feathers, put the "naked" bird on a table, and proceed to keenly observe all its movements, from strutting and fluttering to pouncing and pecking, seeing every muscle move. With quick brushstrokes, Li would capture the chicken in all its different poses and positions, and from any angle one might care to imagine. In a similar painstaking fashion, he practiced his skill in painting horses, goats, sheep, cows, or people.

While learning to draw from life in the most meticulous manner, Li Chi-Mao by no means neglected the artistic side of his creative pursuits. In particular, he began to copy old and modern masters, including members of the Shanghai School, such as Ren Bonian 任伯年 and Wu

Changshuo 吳昌碩 , or the much earlier ink wash painter and calligrapher Bada Shanren 八大山人 and the landscape painter Shitao 石濤 . But few painters had a bigger influence on Li than Qi Baishi 齊白石 with his succinctly vivid style.

By 1959, Li had made a name for himself, and his alma mater offered him a teaching position. Now he could work as a professional creative artist with a stable income, and he soon attained even wider recognition in art circles, a fact reflected in the many awards he was given over his long career. He also became involved in Taiwan's burgeoning Modern Painting Movement. The year 1957 had seen the foundation of the Fifth Moon Group and the Eastern Painting Group, followed in 1958 by the Modern Print Society. A new era was dawning, and one of the proponents of a fresh beginning in the arts was Li Zhongsheng 李仲生 , formerly a teacher at the Fu Hsing Kang College.

When Li Chi-Mao entered the College in 1952, Li Zhongsheng happened to be one of the professors at the school's fine arts department. For Li Chi-Mao, the influence of the Liang brothers (Liang Youming and Liang Zhongming) was crucial in the formation of his own style, especially with regard to composition and layout, but also in other areas, such as the depiction of the human figure, or deft ink and wash representations of animals with a few swift strokes.

The Modern Painting Movement reached its peak in 1968, by which time Li Chi-Mao had already cemented his status as one of Taiwan's main "official" representatives in the field of fine

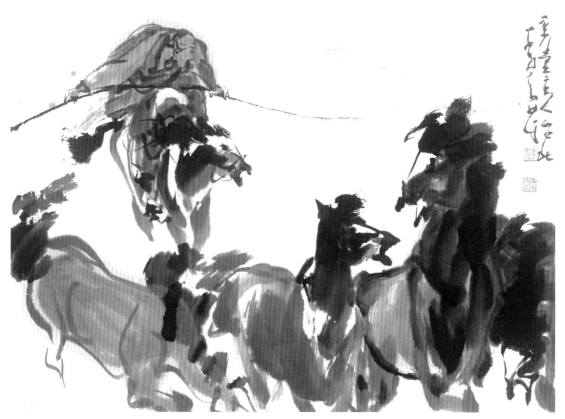

Catching the Horse 套馬圖 　2001　Ink and Colors on Paper　70×100cm

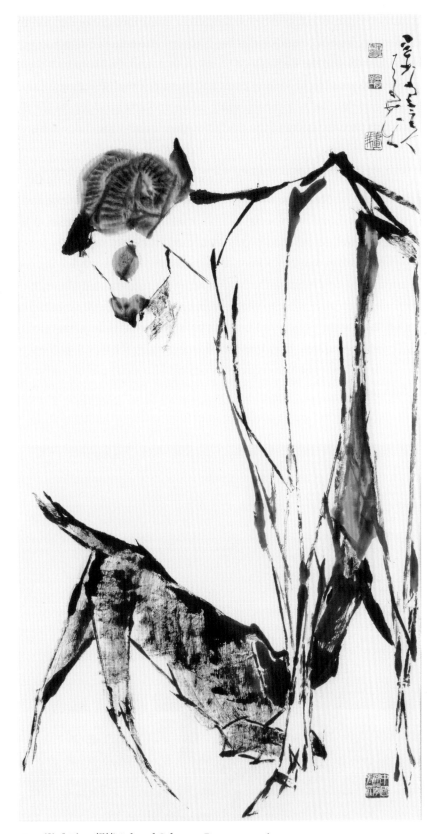

Familial Ties 親情 Ink and Colors on Paper 70×136cm

arts: his work had been shown in traveling exhibitions in many foreign countries. Preparations were already under way for a big exhibition at the National Museum of History to mark the 60th anniversary of the founding of the Republic of China in 1971, and the Museum's then director, Wang Yuqing 王宇清 , asked Li Chi-Mao to paint 100 pictures titled "Paintings of the Father of the Nation" to celebrate Sun Yat-sen, the founding father and first president of the Republic. The pictures mostly depict human figures in the traditional black-and-white ink wash style, sometimes shown in front of buildings or other types of background, also executed in ink. The series of paintings met with great acclaim, and went on many traveling exhibitions abroad.

However, today Li Chi-Mao's fame rests mostly on another series of works, the "Sketches from Europe," which was shown as a special exhibition at the National Museum of History in 1973. Since the 1960s, Li, as a well-known and highly acclaimed artist, had had many opportunities to travel abroad to participate in numerous joint or solo exhibitions. In 1972, having completed the monumental *Paintings of the Father of the Nation* series for the National Museum of History, he took a break from his creative work to visit Europe as a sort of cultural ambassador. His solo exhibition went on show at the Gallery of Fine Arts in West Berlin while he traveled to France, Italy, and Spain, creating countless drawings and sketches along the way. Upon his return to Taiwan in June 1973, the National Museum of History held a special exhibition for him titled *Sketches from Europe*.

Taipei MRT 北淡捷運 2012 Ink on Paper 136×450 cm

This exhibition revealed to the public a different facet of the painter Li Chi-Mao. There were brilliant images of female Spanish flamenco dancers, but also many ink wash sketches showing landscapes in Western Europe, the most stunning of which is probably *Crows Returning at Evening Bells* (also known as *Evening Bells of Berlin*). A square composition, this picture is dominated by hues of gray and black, showing crows flying through a hazy scene at dusk. The erect structure in the center of the painting is a church steeple, blurry and indistinct in the twilight of evening, while the horizontal area left white (*liubai* 留白 , or area of a painting or seal surface intentionally left blank) in the picture's background represents the last glimmer of sunlight before darkness falls, probably reflected from a river. Together, the vertical tower and horizontal gloaming light form the shape of a cross, adding a layer of religious or even mystical significance to the whole scenery. Back then, Taiwanese painters and audiences had only recently been introduced to the wonders of abstract painting, and this piece, hovering between the concrete and the abstract as it does, satisfied a demand for art that was both traditional in its ink and wash approach, but also avant-garde and "Western" in its compositional style. The sublimely simplified shape of the steeple, reduced to pure form, rising into the clouds of the evening sky, combined with the crows returning to their nests at the tolling of the bells, all executed in a highly evocative and poetical style, produce a poignant aesthetic effect. This outstanding painting was also reproduced on the back cover of the then newly established *Lion Art* Magazine 雄獅美術 , further boosting Li Chi-Mao's popularity, already much enhanced by his successful visit to Europe. At this juncture, Li also

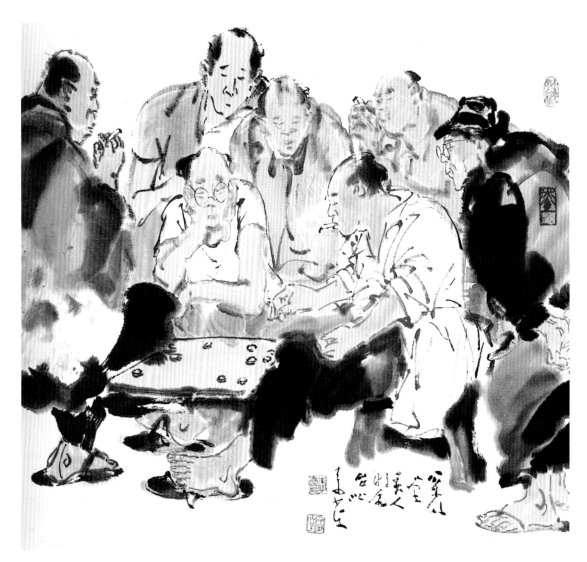

Playing Chess 嬉棋 1980 Ink on Paper 60×60cm

showed himself to be quite the innovator: he didn't refer to himself as a "literati painter" or "Chinese (style) painter," as was the conventional usage at the time, but simply called himself an "ink wash painter."

Li's European sketches showed the artist working in a mode rather distinct from his usual approach, but this "vague" style reminiscent of watercolor was in no way foreshadowing the new period that was about to dawn in the artist's career. The 1970s saw the gradual formation and growth of Taiwan's Nativist Movement, especially in literature and the arts, and it was only natural for Li Chi-Mao to turn from the exotic themes and customs depicted in his travel paintings to creating visual records of his second home's sights and scenes, focusing on Taiwan landscapes and slices of life.

In fact, Li Chi-Mao had begun to make Taiwan landscapes and slices of life an important part

of his output as early as the 1960's, quite in sync with the appearance of nativist works such as renowned director Li Hsing's movie *Beautiful Duckling*. Even before his trip to Europe, Li's Taiwan-centered pieces displayed some of the hallmarks of his later, more mature 1970s style, in particular a penchant for magnificent momentum and aesthetically appealing, catchy images. Frequent themes included herds of cattle and other animals crossing wide, turbulent rivers, often accompanied by people and carts, all of them shown as they are venturing into the shallow parts of the

Maternal Love 母愛 1980 Ink on Paper 60×60cm

rapidly flowing water, and proceeding in a roughly S-shaped formation fading into the painting's background. One can clearly discern the cows' hooves stepping cautiously into the river, some of them with their head raised and looking into the distance, others with head lowered to drink the water. Several dogs are walking next to them, and the whole caravan is seen to be steered in the desired direction by a number of farmers wearing broad-brimmed straw hats. And across the expanse of water, on the opposite bank of the river, we discover yet another convoy slowly moving forward. In some ways, the whole picture is strongly reminiscent of the big Technicolor movie productions of that era.

Some of Li's best nativist works showing rural scenes were painted in the year 1980, including the relatively small *Simpletons in the Tea Room*, *Playing Chess*, and *Matsu on Tour*, as well as a series of oversized pictures titled *Night Market*. All of these remain a staple of exhibitions of the artist's work.

The 1980s were probably Li's most productive period. A good example for his work of this time is a painting of Zhong Kui, a demon catcher in Chinese mythology (and a common motif on household gates). The impressive figure stands with both hands raised high above his head, holding a sword, while his protruding eyes are staring fixedly at a spot at the bottom right of the composition. He is standing on just one of his naked feet, balanced on his toes, with the other foot

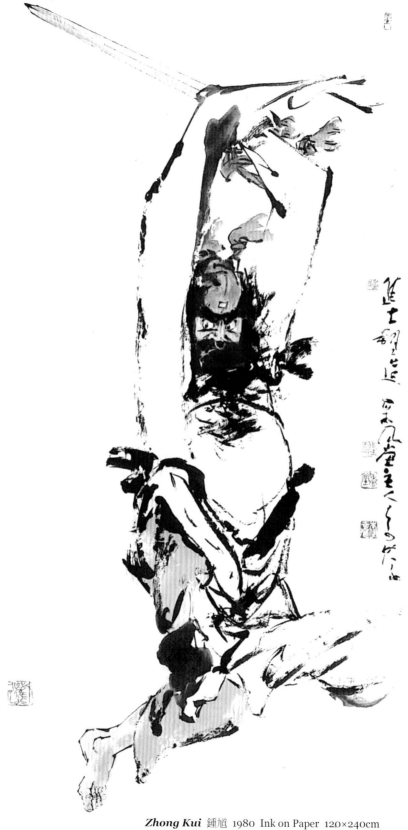

Zhong Kui 鍾馗 1980 Ink on Paper 120×240cm

up in the air: the very image of someone about to strike a deadly blow. The painting is quite large at approximately 4 times 8 feet, and executed in vigorous, expressive brushstrokes that generate a dynamic sense of movement. Animal paintings of that period include *Taiwan Water Buffaloes*, *A Herd of Cattle*, *Cows at Play*, and *Five Monkeys*, all of them highly original compositions by an artist at his inspired best, brimming with lifelikeness and verve.

While Taiwan-themed paintings became a major part of Li Chi-Mao's output during his middle and later years, he always continued to also produce works reminiscing about his homeland in the north of mainland China, the deserts and mountains of his childhood. As early as the 1960s, Li had painted a whole series of works showing scenes and scenery from Anhui Province and the surrounding areas, but today some of his paintings from the year 1980 are often considered to be

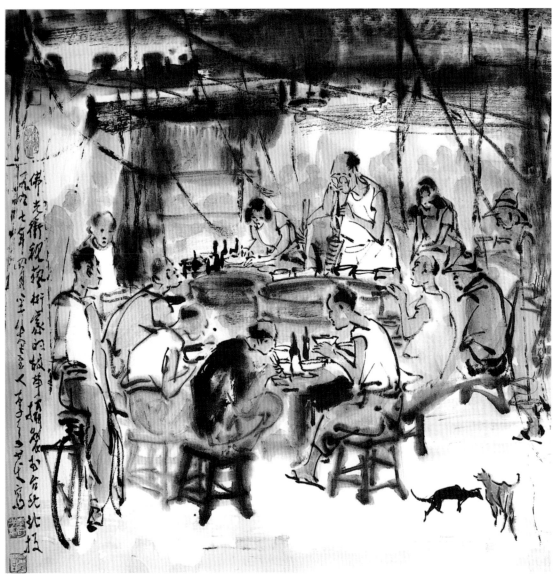

Night Market 夜市 1997 Ink on Paper 70×68cm

true masterpieces in the "northern China" vein, including *Catching Horses*, *Wrangler at Work*, and *Song of the Earth*. Both the human figures and the animals in these pieces are presented in vibrant poses and dynamic movement, with the style showing an eclectic mix of authentic realism and freehand improvisation, aimed at capturing the essence of the scene. *Liubai* areas alternate with vivid brushstrokes, and overall these pieces tend to lack the bustling familiarity of Li's nativist Taiwan paintings, but make up for it by a more lofty aesthetic appeal and a heroic quality well

Staying at Hongshulin 人在紅樹林 2014 Ink and Colors on Paper 69×138cm

befitting the harsher northern environment. A favorite both with critics and the general public is *The Falconer*, complete with falconer, trained bird of prey, slim horses, hunting dogs, and the vast expanse of the desert. The falcon is perched on the man's extended arm, its wings spread out wide as if just landing—or maybe about to take flight? Man and bird may be wearing very different expressions, but both are overflowing with the proud northern spirit.

By the 1980s, Li Chi-Mao's style had fully matured, and even stringent advocates of "modern

style painting" and avant-garde styles could not fail to recognize the unique charm and stunning originality of his work. In the June of 1988, Taipei's Primary Colors Gallery, a venue devoted to cutting edge art, held an exhibition of Li's works titled *Zhong Kui* 鍾馗 , thus acknowledging the fact that his style of ink and wash had infused the traditional genre with a distinctly modern form and meaning.

When Li took up a teaching position at the National Academy of Arts (now National Taiwan University of Arts), this also led to fresh breakthroughs and more freedoms in his creative work, a fact that is most evident in his series of works titled *Conceptual*, which bears witness to the artist's open mind and unfettered expressiveness.

Taiwan's postwar ink and wash painting can roughly be divided into three main "schools," which are:

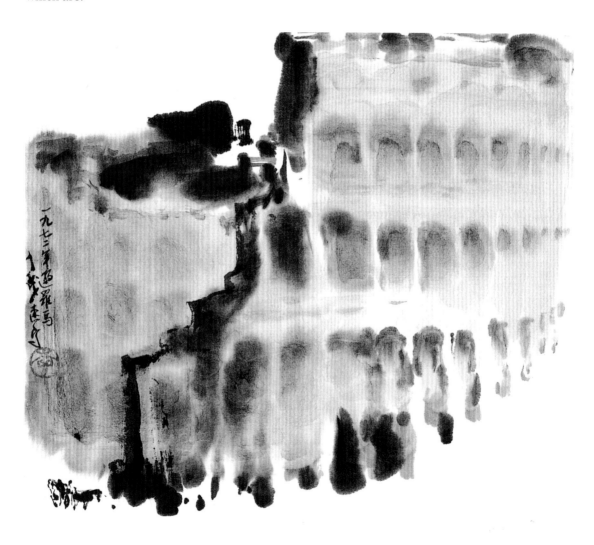

Rome 羅馬 1972 Ink on Paper 30×30cm

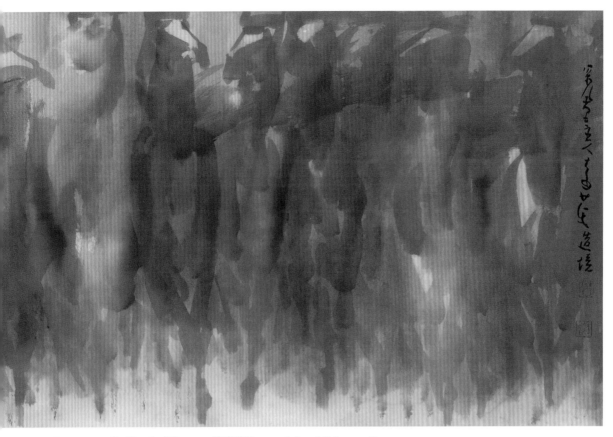

Imagery of a Herd of Horses 造境群馬 1995 Ink and Colors on Paper 45×70cm

1. The "Innovative School," also known as "New Ink and Wash," with its emphasis on "sketching from nature" or "painting from life."

2. The "Literati School," also known as "New Literati Painting," with a focus on traditional aesthetic appeal and picturesque charm.

3. The "Modern School," seeking a clean break with conventional aesthetics, and emphasizing compositional aspects and experimentation with different media.

In this context, it becomes obvious that Li Chi-Mao's career ran the whole gamut of postwar ink and wash development. Setting out as an avid "sketcher from life," then proceeding to absorb the finer points of traditional literati painting, and eventually embracing many features of the "Modern School," he successfully rounded off his individual style and established himself as one of the most brilliant and representative ink and wash artists, a legend shaped by the special circumstances of both Taiwan's and his own individual history.

Translated by David VAN DER PEET 范德培

*From _Diancang jin yishu_ 《典藏今藝術》 (_ARTCO Monthly_) Shanghai: 19, October 2015, 64-69.

Yuyu Yang
My Life as an Artist

楊英風藝術生命的自述

Yuyu YANG 楊英風

楊英風 (1926-1997)
Yuyu Yang (also Yang Ying-Feng)

Born in Yilan, in the East of Taiwan, Yuyu Yang spent his childhood with his parents in Beijing and went on to study architecture at the Tokyo Fine Arts School, before returning to Beijing to study in the Art Department at Fu Jen Catholic University. He returned to Taiwan in 1948 and studied at the Department of Fine Arts at National Taiwan Normal University. The architectural training in Japan, along with his exposure to Beijing's ancient cultural relics as well as his learning from the master painters at National Taiwan Normal University, have all had a profound influence on him. Yuyu Yang is an important Taiwanese sculptor and landscape artist renowned internationally, and is a pioneer of Taiwanese public art. He is known for his abstract composition, which he juxtaposes with modernism and the use of stainless steel materials to express Chinese-style artistic thinking. Yang received numerous awards throughout his life.

Some of Yuyu Yang's important early works were shown in museums and galleries in Osaka and New York. Yang has also inspired Ju Ming, another important contemporary Taiwanese sculptor. He has made stage props for the Cloud Gate Dance Theatre's *Legend of the White Snake*, which became a legend of contemporary Taiwanese stage design. In his late years Yang also developed an interest in the then newly developed laser art and computer printing techniques.

Yilan: The new frontier

I see my mother in a vision, once every few years. She is always beautiful to behold. The beautiful sight of my mom was my first primordial experience of beauty.

Where am I going to?

A distant land. It takes many days to get there by boat.

I was born in Yilan, on the northeast coast of Taiwan, in 1926. Taiwan was a colony of Japan then, ceded to Japan after the signing of the treaty of Shimonoseki in 1895 after the Sino-Japanese War. Apart

from the indigenous peoples of Polynesian origin, the inhabitants of Taiwan were largely Han Chinese from Fujian and Guangdong provinces who had emigrated to Taiwan from China during the Ming and Qing dynasties. Those that settled in Yilan toiled and sweated for hundreds of years, in the unique spirit of pioneers, cultivating for themselves a new life between heaven and earth on the fertile Lanyang 蘭陽 plains of Yilan.

My ancestor, Yang Pin arrived in Yilan from Fujian in 1729, during the reign of Emperor Yungzheng 雍正 of the Qing dynasty. Together with the pioneer Wu Sha, they poured their passion into developing this new land.

Having inherited this pioneering spirit, my parents entrusted me to the care of my grandparents and ventured into Changchun in northeast China to start a new business. Asia was in great turmoil at that time, and they saw opportunities in the upheaval.

They were going away to a faraway land. As a child in Yilan, I only knew that Yilan was

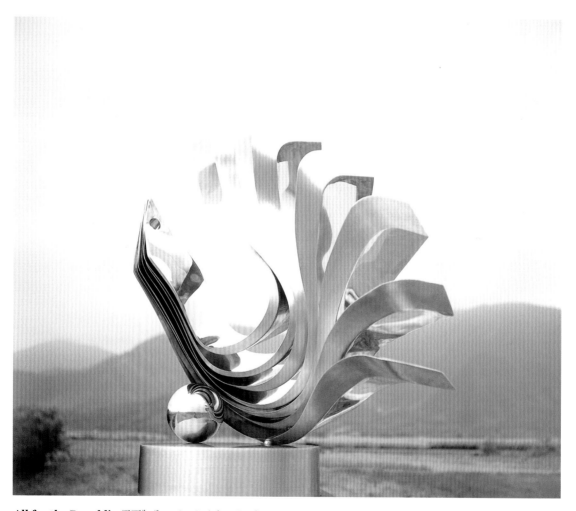

All for the Republic 天下為公 1989 Stainless Steel 92×66×40cm

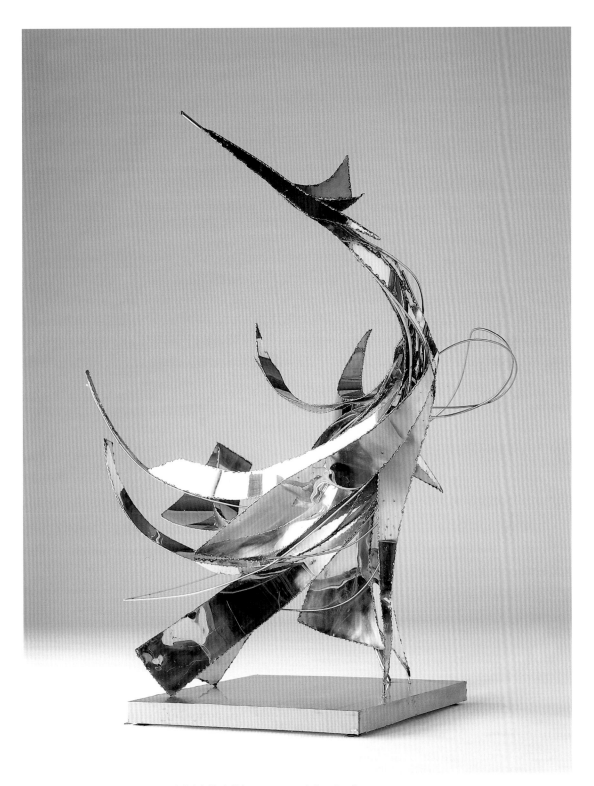

Advent of the Phoenix, No.1 鳳凰來儀系列之一　1970　Stainless Steel　104×125×70cm

flanked by mountains in the north, south and west, and that the Pacific Ocean was on the east. When I thought of my mother going away, my heart would be filled with remorse. Once, on a summer night, when she saw that I was in a pensive mood, she stretched her pale arms towards the moon and asked me:

Can you see the moon?

My gaze followed the direction of her pointed finger and I saw the bright and round moon.

I will be going to a place where the same moon can also be seen. Baby, you and I will be looking up at the same moon! Wherever I am, I will look up at the moon and think of you!

Her words made a great impact on me. As young as I was, I was incredibly moved by her words. From that day on, late at night, when it was all quiet, I would go out into the yard by myself and gaze at the moon. The moon would transform itself into a mirror and send my reflection to my mother who was faraway and also thinking of me. I also expected to see my mother's reflection on the moon. This sense of expectation filled me with happiness. In the moon, I could see my mother brushing her hair in front of the mirror. I could also see her wearing a graceful and elegant qipao 旗袍 , the dress worn by Manchurian women. She seemed to be a messenger sent to me by the moon. When I learned of the legendary phoenix, the first image that appeared in my mind's eye was the vision of my mother reflected on the moon.

My China Experience

After completing primary education in Taiwan, I joined my parents in Beijing. They managed the largest cinemas in Beijing and Tianjin then.

For someone like me who had grown up close to the mountains and the sea, Beijing, the city of emperors, was a sight to behold. Even though it was dominated by the Japanese warlords, it still had a heavenly grace. I could gaze out towards the horizon where heaven and earth met, merging into one straight line. I was dazzled by the magnificent view of the universe.

I attended middle school in Beijing, and started to explore the path of becoming an artist. My encounter with Yungang 雲岡 Grottoes by the cliffs of Wuzhou River in the Datong suburbs of Shanxi Province charted the course of my life from then on.

The sense of awe and amazement that I got from the Buddhist sculptures, not just from the sheer volume but also from how art and nature were able to blend into each other, can still bring me to my knees today, half a century later. When I was surveying artistic forms, the holy land that I returned to was to the feet of the Buddhist sculptures of the Yungang Grottoes. To me, they are beyond subjects of worship. Their existence is beyond existence. My experience with the Buddhist sculptures of the Yungang Grottoes is awash with wisdom and enlightenment.

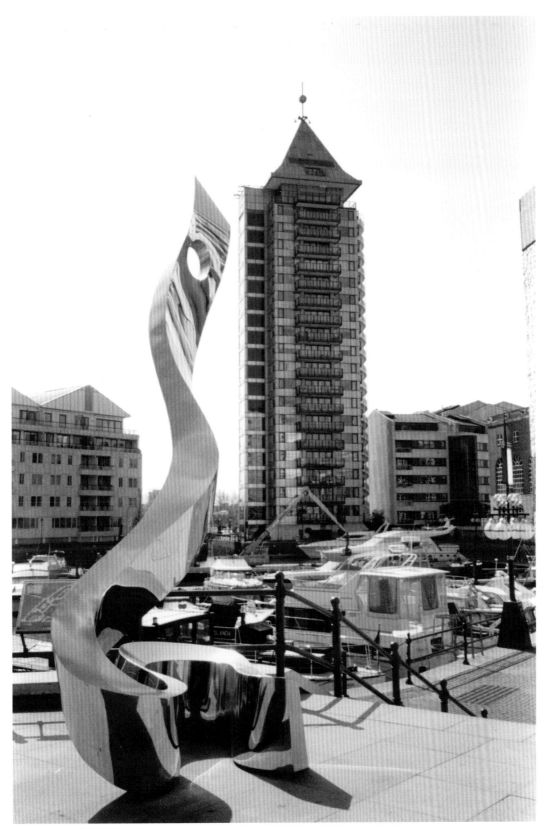

Dragon's Psalm 龍賦 1996 Stainless Steel 450×160×190cm

The Cradle of Aesthetic Awareness: Tokyo Fine Arts School

In 1943, before I could fully collect myself after the indescribable impact of the Yungang Grottoes, and with the looming uncertainty of war, I entered Tokyo Fine Arts School. Having just experienced the grandeur of the Yungang Grottoes in Datong, I decided to major in architecture, rather than fine arts or sculpture. I became a student of Professor Yoshida Isoya (1894-1974) who was making himself known in the art scene by reviving traditional Japanese architecture, such as refined Japanese-style tea houses. Professor Yoshida reminded us again and again that traditional Japanese architecture was a careful and deliberate imitation of Tang dynasty architecture. This proves that there is a universality to aesthetic appreciation. What I originally perceived to be Japanese aesthetics was actually global in nature. In addition, from the refined and micro-perspective of Japanese aesthetics, I was once again reminded of the grandeur of the Tang dynasty and the sense of awe that overwhelmed me when I first saw the Yungang Grottoes.

What was the spirit of the Northern Wei dynasty and the Yungang Grottoes?

With the demise of the Han dynasty and the end of the Three Kingdoms, the nomadic peoples from the north whom the Han Chinese used to despise and look down upon invaded northern China, injecting new vitality into Chinese culture. Even though historians guilty of Han Chauvinism claim that this period of time is the dark ages, the Northern and Southern dynasties,

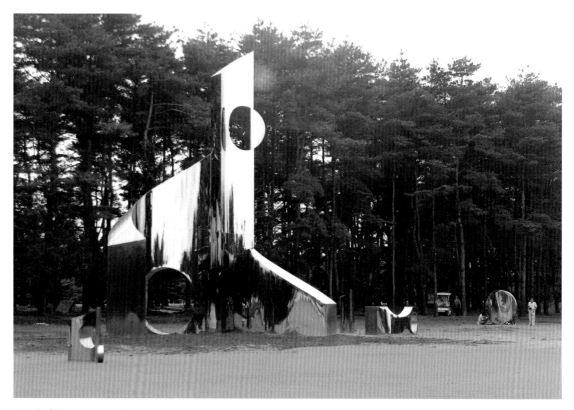

Birth 萌生 1992 Stainless Steel 220×166×92cm

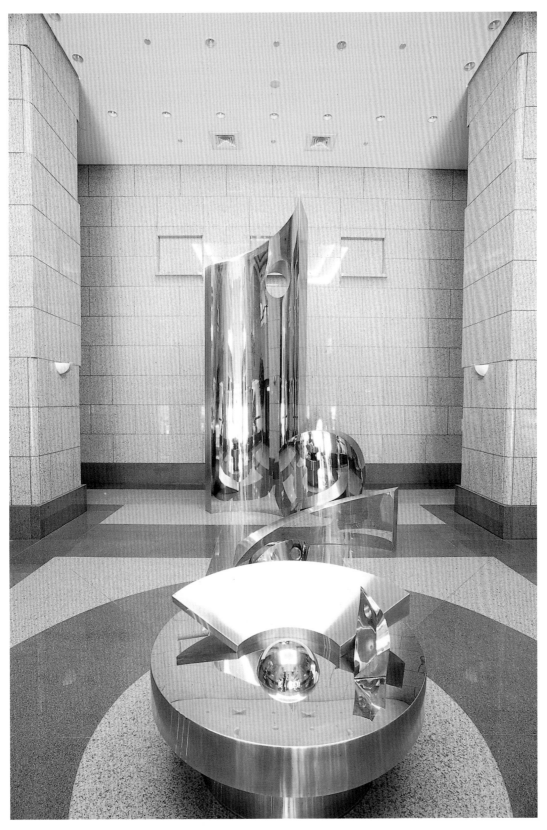

Great Universe 大宇宙 1993 Stainless Steel 500×250×450cm

with the influx of northern peoples, was actually a very vibrant period in history.

The Confucian scholars of the Han dynasty had become stifled with etiquette and formality. With the decline and end of the Han dynasty, new interpretations of the philosophies of Laozi 老子 and Zhuangzi 莊子 flourished, bringing about explorations into existentialism and cosmic contemplations.

Mahayana Buddhism: Prajna

The intellectual life of the Han people originated among the Daxingan Mountains in northeast China, and a revolutionary change took place during the Northern Wei dynasty (186-534) when northern China was united under the rule of the Xianbei 鮮卑 people. Buddhism, which had spread to China from India via the Silk Road became the national religion during the Northern Wei dynasty, and the common people sought spiritual support and sustenance from Buddhism. The Buddhist temples and sculptures of the Yungang Grottoes testify to that.

Women Musician of Ming Dynasty, No.3 明 樂女俑系列之三 1987 Bronze 147×171×78cm

March Forward 向前邁進 1988 Bronze 850cm

Stony Statues in front of Lishan Hotel 梨山賓館前石雕群 1967 Marble

The Buddhism that spread to China then was Mahayana Buddhism. The central thought of Mahayana Buddhism was Prajna, which encouraged people to remove internal obstacles and barriers, to define the relationships between and among all things, and to accommodate all with magnanimity.

The Mahayana Buddhist Movement was started after Siddhartha attained nirvana, when India faced aggression from the northern tribes and had slid into historical contradiction and conflicting values. Coincidentally, at the same time, China, transitioning from the Han to the Tang dynasty, was also facing ethnic clashes, conflicting values and cultural shocks.

Prajna thought, which encouraged people to be accommodating and magnanimous, took root and matured against this backdrop. In other words, for the first time in history, the Han Chinese acknowledged that Chinese civilization could thrive only if it were able to accommodate different cultures and different peoples. This planted the seeds of cosmopolitanism, the grand and accommodating spirit that enabled the Tang dynasty to thrive and prosper.

Heavenly Cliff 鬼斧神工 1995 Bronze 600×181×127cm

Emptiness: Expansive Freedom

Herein lies the true essence embodied by the Yungang Grottoes. The concept of emptiness, or sunyata, refers to freedom that is gained by the unbridled heart and mind. To not be limited by time nor space. Me, as a young child gazing at the moon, looking for the vision of his mother; me, as a student, standing in awe, in front of the Buddhist sculptures at the Yungang Grottoes; and the me who has returned to the rock sculptures half a century later—are all the same and relative to each other.

The clean and clear lines and the grand and symbolic gestures that delineate the Yungang Grottoes give me indescribable courage. The stone masons and artists of the northern tribes have chiseled their ways into history by carving the Buddhist sculptures. They have infused new vitality into a declining empire.

Inquiries into the Self

As a sculptor, when my two hands came into contact with the material to be sculpted, I found myself acutely aware of my sense of self. I could not help but feel my place in the universe. This very visceral experience is multi-faceted, coming from different levels of the self, and how one places oneself in one's landscape or mind-scape. This concept might be difficult for those following the principles of critical thinking or humanism to grasp.

As a sculptor, I do not lose myself fully in my work, but try to grasp the "lifescape" of my work by unconsciously shaping it with my sense of touch.

I do not place myself in the middle of the matrix. I do not see my work as an independent object. My perspective is present in my work, but its existence is empty. The meaning and value of a piece of artwork is created only when there is interaction between it, its lifescape, the sculptor, and spectators who span different generations.

The Spirit of the Northern Wei Dynasty: Magnanimity

Magnanimity is the spirit of the Northern Wei dynasty, the all accommodating generosity of spirit that was impressed upon me when I stood at the foot of the Buddhist sculptures at the Yungang Grottoes.

Works of art are not just manifestations of one's self, but should rather serve as "vessels" that contain universal truths. Vessels are meant to contain things, only when they contain meaning do they become meaningful. I look forward to a larger lifescape, an all-accommodating Mahayana view of the world.

How is an artist to take part in this lifescape? According to astrophysics, we are all dust particles in the universe. The dust particles spread out, come together and explode, creating energy that becomes life. We are all star dust in the dance of life, dancing to the benevolence of the

Ancient House in Wufeng 霧峰古厝 1959 Bagasse Board Relif Print 60.5×46.5cm

Matsu-Temple at Bei-Kang 北港朝天宮 Watercolor 47×37.5cm

Self-Portrait 自刻像 1950
Woodblock Engraving 11×11cm

universe. Dust particles are tiny and soft, yet capable of unleashing huge vertical force.

In each cosmic dust particle I can see the human ego. Each dust particle is a mirror that reflects the time, it also stands testament to the benevolence of the universe.

Vibrant times, ambiguous attitudes and the fear of decline all enable us to see hope, and the divisions between and among past, present and future. Only when the affirmative and negative merge as one can the illusion of the self disappear. When the divisions that separate us disappear, we will become cosmic dust particles that spread out, come together and release uncontrollable energy. If we add to this the accommodating generosity that exemplifies the spirit of the Northern Wei dynasty, we will be able to participate in the times with self-discipline, as lifescape artists.

It is my hope that we will be able to transcend our petty selves and individual perspectives, and become wider vessels, to jointly share this lifescape mirror with our contemporaries.

Translated by Michelle Min-chia WU 吳敏嘉

* From *Yuyu Yang Yingfeng zhan–dacheng jingguan diaosu*《呦呦楊英風展 —— 大乘景觀雕塑》(*Lifescape Sculpture of Yuyu Yang*), Hakone: Hakone Open-Air Museum, 1997.

Sun Chao

Sun Chao's Road to Ceramics

我的陶瓷之路

SUN Chao 孫超

Return from Paris, No.7 巴黎歸來系列之七　1990　Ceramic Slab　52×72cm

孫超 (1929-)

Sun Chao

Born in Jiangsu, China, Sun Chao came to Taiwan with the Nationalist government in 1949. He later majored in sculpture at the National Taiwan Academy of Arts and subsequently worked in the National Palace Museum, where he explored ancient Chinese glaze and ceramic-making techniques, leading to the development of two specialized techniques: the brilliant crystal glaze and the lyrical abstract expression. Sun Chao is Taiwan's first artist to produce high-temperature crystal glazes. *Enlightening Heaven*, the work he completed in 1996 measuring 6700×138 cm, is the largest porcelain painting in Taiwan.

Picking up the Paint Brush

My moment of enlightenment did not come until very late. In 1937, the Japanese army invaded my hometown of Xuzhou in eastern China, and many people fled to the countryside seeking refuge. I was only eight years old at the time. My nanny held my hand in the crowd, but the frenetic crowd soon separated us, and I couldn't find any of my family afterward. I roamed around the country alone. Two years later, I was lucky enough to be adopted by a farming family. I survived and lived on. During this period of time, besides farming, I also worked as an apprentice. I did not have any chance to study and I often cried over my illiteracy in secret.

The year before the end of World War II, I was 15 years old. Relying on my childhood memories, I found my way back home from hundreds of miles away. Although, my home had already been destroyed in the battles, I was able to find my grandmother's house where I would live for a while. At first, I could not read and did not have a school to go to. Seven years of wandering had also given me a strange accent and labeled me an outsider. So I just stayed inside the house all day, flipped through the old books and copied the pictures I found inside - for which I even received some praise.

The *Jieziyuan* Sketcher's Handbook 芥子園畫譜 (a copybook

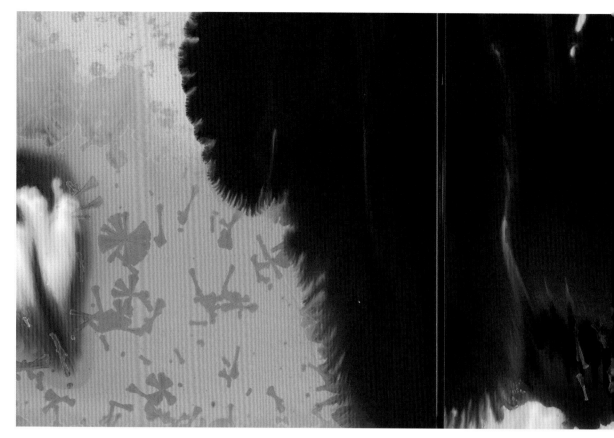

Mirage 如夢如幻 2013 Ceramic Slab 147×48cm

for aspiring painters) was my book of enlightenment. At the time, my grandmother had a tablet shop. My uncle wrote tablets and I helped him to draw patterns on the tablet holders. I also went to the village school for three months. After the first month, I was able to write letters to my foster parents who had adopted me when I was a refugee. After that, I finally went to an elementary school for the first time.

One of the few pleasant memories from my childhood was of an earthenware basin full of water in the front yard of my grandmother's house. Next to the basin, there was a writing brush and a big gray brick. People would practice calligraphy on the brick when coming in and out of the house. There was also an elementary English textbook with nice illustrations in my grandmother's house. I did not just draw the illustrations but learned how to draw the letters as well. Therefore, I was eventually able to pass the placement exam and enter the eighth grade.

The destruction of my home had left me with no immediate family. I wanted to study but I did not want my relatives to feel they had to use their meager resources to help me. At the time, the army was recruiting and encouraging students to devote themselves to serving the country. I thought that the military could offer me an education, so, caught up in a feeling of patriotism, I joined the Nationalist army after attending only a semester of eighth grade. Naïvely, I thought that

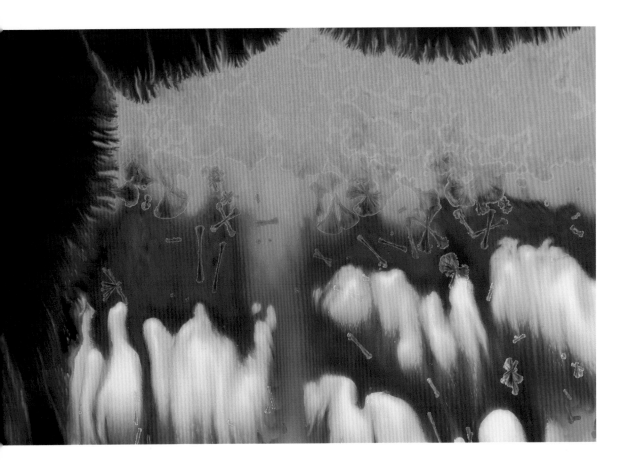

as soon as the country became stable, I could go back to school or go to work. I didn't know that the next sixteen years of my life would be wasted in marching.

In 1949, I came to Taiwan with the armored troops. Army life at the time was beyond harsh and crude. I was in anguish, and my spirit couldn't find relief. Self study was the only means of keeping me sane. Books, especially philosophy, gave me a sense of tranquility. I picked up the paint brush in 1958 during the war in Kinmen (Quemoy), an island in the Taiwan Straits. The battles started on August 23 and went on for months. The sound of cannons crackled in the sky. We could not leave the fort, and I had already finished reading the few books I had with me. Luckily, I had plenty of paper and started to draw. I drew nature and any kind of pictures I could find in the newspaper, in magazines, or even on lottery tickets.

After the war, I went back to Taiwan with the troops. One day, I saw a beautiful photograph of corn on a calendar. I said, "If only I could draw this." People standing next to me sneered, "If you can draw it, I will change my last name to yours." From that day on, I started drawing corn every day. Finally, on the 24th day, I could draw a solid kernel with one single stroke. In this stroke, I had trained myself to reflect both the contour and the texture of the kernel at the same time. I have always kept this sketch as a fun memory.

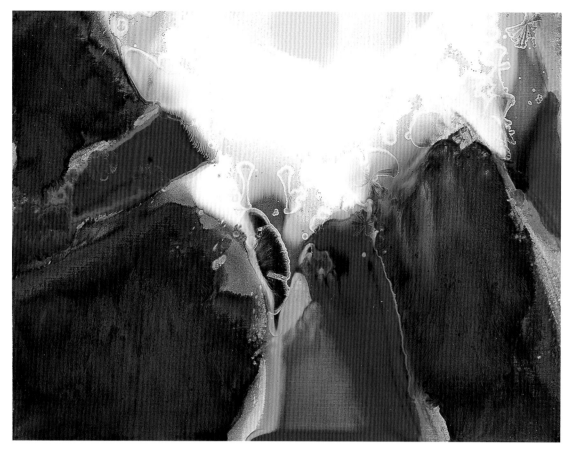

Emerging Moon 月出 1994 Ceramic Slab 53×69cm

Entering College

In 1962, I was finally discharged from the military and I wanted to go to school. With only a year and a half of formal education, I was not qualified to apply for college, so I made a fake high school diploma - stamped with a school seal which I carved out of a block of soap - and turned it in so I could sign up for the college entrance exam. Impressed by this evidence of my desire to learn, the chief of the Ministry of Education wrote on my fake certificate in red, in the manner of a true educator, "In recognition of this student's motivation to study, hereby, I give him permission to apply for college." I was exhilarated. A year later, I was accepted into the Fine Arts Department at the National Taiwan Academy of the Arts, entering the holy ground of my heart. Even though at the time I was already short on money for food and had no money at all to pay for tuition, my heart was filled with strength. With help, I found jobs such as painting frescoes or dyeing batik and managed to save enough money for the first year's tuition before school started. Because I had spent so many years in the army, I was already thirty-six when I entered college and became the oldest student in the school.

Back then, the Fine Arts Department was divided into three divisions: Chinese Painting,

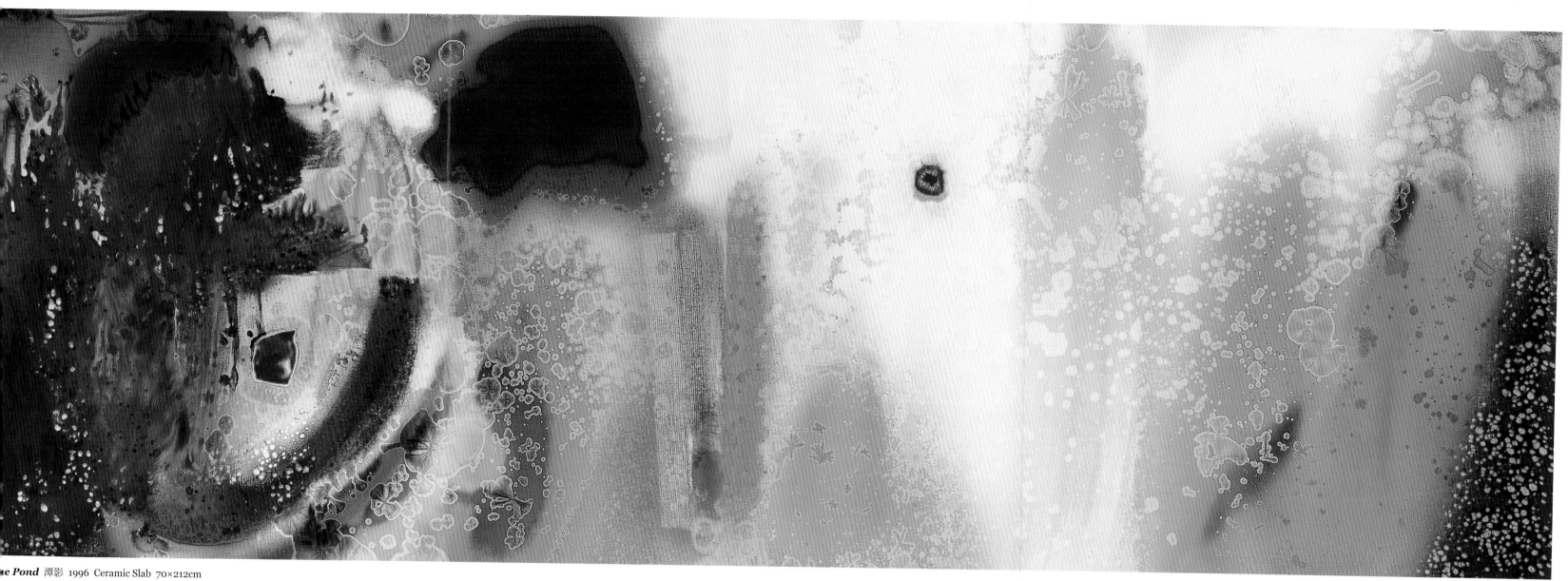

e Pond 潭影 1996 Ceramic Slab 70×212cm

Western Painting, and Sculpture. In deciding which division to enter, I considered the fact that one did not need any equipment to draw - a piece of board would be sufficient - while sculpture, on the other hand, requires tools and is learned more conveniently in a school setting. Thus, in order to fully take advantage of the school's equipment, I chose to study sculpture. This decision took me from working on a flat surface to working in three dimensional space. Aside from going to classes, I spent almost all of my time (including winter and summer vacations) working in the sculpture room. Often, businessmen would offer me paper on which to paint Chinese paintings for them to sell. This was how I paid for my tuition. One time, a man took the hundreds of paintings I had made for him without ever paying me. At the time I was quite angry because my daily expenditures depended on these earnings. Afterward, I thought to myself, on the bright side, someone had just given me a summer's worth of paper to practice my drawing.

Thinking back, school life was rich in friendship. When I was sculpting in the studio, friends who studied music would often keep me company while playing the flute or violin. Some of them even volunteered to be my models. In this artistic atmosphere, we influenced one another, nurturing an aesthetic living experience. The chef of the cafeteria would even call me in for dinner during winter and summer vacations - despite the fact that our meal plans were only valid during

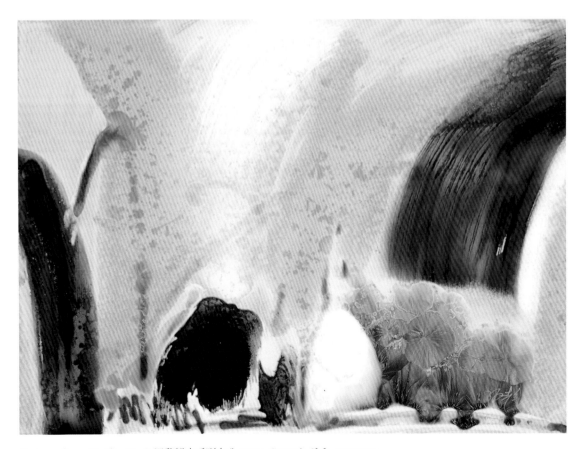

Return from Paris, No.8 巴黎歸來系列之八 1990 Ceramic Slab 52×72cm

school days.

Before the graduation exhibition, I made my first big group sculpture. After I finished it, I did not think it was good enough. So, I knocked most of it off and kept only a small portion as a portrait. Just by coincidence, the head of the Department was passing by. He was quite angry and said, "Even if it does not meet your expectations, at least it belongs to this period of your work. So what if you are not satisfied with your work… when was I ever satisfied with mine? If you keep knocking off all of your work, you will have nothing left to save." There was caring in his scolding, but I just cannot endure flaws in my work. In fact, when I started making ceramics later, my attitude never changed. The only complete, intact piece left from college is a portrait I sculpted during my sophomore year.

A year after graduation, I entered the National Palace Museum in Taipei because of the sculptures I made in school. By chance, I also sculpted a pair of giant bronze lions which were placed at the front gate of the museum after completion. This pair of lions was modified from the traditional style. I made the squatting hind legs in the shape of right-angles, forming a stair step that can be walked on. I also exaggerated the curls on the elbows of the front legs so children can

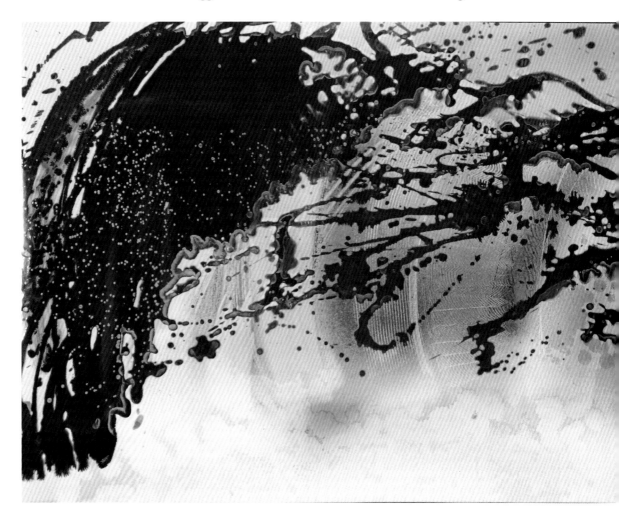

play and climb on the lions thus giving them an opportunity to have more childhood memories of their native land.

Experiments in Historical Ceramics

In the spring of 1969, I found a job at the National Palace Museum in Taipei caring for the ceramic and jade pieces. I was deeply attracted to the enormous collection. At that time, no one in the museum had any firing experience. We relied only on our eyesight to discern the period, the original location of production, and the authenticity of a piece. During this time, two incidents diverted my interest from lab research to studying Chinese glazes. The first incident involved a Hare's Fur tea bowl in the museum collection. At the bottom of the bowl, the streaks of the Hare's Fur leaned toward one side. Some specialists thought it was a counterfeit and said that the streaks were drawn onto the bowl. It became a joke among us because the slanting lines were actually caused by the uneven stacking of saggars (the containers that hold the clay bodies during firing). Another time, a colleague told me that a foreign visitor saw a Copper Red piece and said that based on his chemistry background he disagreed with the exhibition's description of "Copper oxide turns green in oxidation firing and may turn red in reduction firing." The statement is, in fact, true, but at the time we did not have a lab in which to conduct our own experiments for proof. Therefore, I started reading chemistry textbooks and studying the fundamentals. Friends often accompanied me on trips to kiln factories. Yingge 鶯歌 was the town that I visited most frequently because it was famous for its concentration and production of ceramics. I often met people who found joy in their own way, even in the most spartan studios.

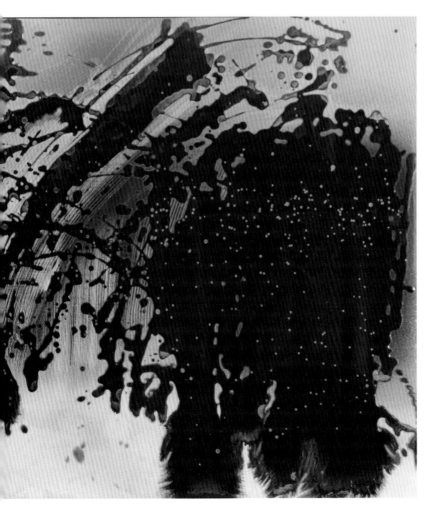

Rolling Thunder and Wind
風雷動 2009 Ceramic Slab
148×66cm

Return from Paris, No.4 巴黎歸來系列之四 1990 Ceramic Slab 52×72cm

I remember one time, an old man chuckled and said to me, "Yingge clay is sticky, it won't let you go." Most fortunate of all, I had my good friend Dr. Peter Liu making glaze recipes and firing the kiln with me. Back then, there were no glaze recipe references written in Chinese as there were in English books. Ms. Jane Kuan 關鄭 , a teaching assistant from National Taiwan University who later became my wife, translated quite a few English books for me. When friends came, I often gave each one of them a mortar and a pestle and we would talk while grinding the glaze. My friends contributed greatly during this process of endless experiments on different glazes.

Early on, since there was not enough space in my apartment, I placed the kiln I used for my experiments at a kiln factory and asked others to fire it for me. During the winter of 1975, I was able to relocate it to Peter's front yard. When I started the very first set of kiln fire by myself, I found that I was sweating profusely in the cold wind. This made me truly realize the gap between theory and practice. At the time, I was experimenting with Celadons. I wanted to show the green of Longquan 龍泉 and the elegance of Ru 汝 ware. Peter helped me make many recipes. We applied these recipes to test tiles. After gathering many of them, we loaded the kiln, and fired them all at once. At the time, we had to be thrifty with the equipment so we did not even have a pressure gauge for the gas kiln. It was really difficult to fire high temperature reduction since we could

only control the switch of the gas cylinder manually. If we put too much pressure on the handle, more gas would flow out and the kiln pressure would increase. Since the chimney was too short to exhaust enough air, the heat would turn the chimney shaft red due to the incomplete oxidation of the kiln and instead of increasing the kiln temperature, the temperature would actually decrease. As expected, I burned the chimney shaft red when firing for the first time.

During this period of time, I put the gas cylinder and kiln at the doorway. The pyrometer, on the other hand, was carefully placed inside the house. We would run in and out of the house to check on both ends. Once we ignited the fire, the kiln had to keep firing for 8 or 9 hours continuously, so we had to take turns to eat. Usually, one person would be inside the house, perhaps eating, while keeping an eye on the pyrometer and yelling if the gas needed to be turned on or off. Another person would stand outside the house, turning the switch a little bit more, or a little bit less, according to instructions. Pedestrians often looked at us funny, but we were, indeed, having lots of fun. The most intense moment would be when the gas had run for too long and lost too much heat causing the gas cylinder to start to freeze. As the fire started to disappear, someone would rush inside the kitchen and boil pots of hot water to pour on the gas cylinder. With the heat from hot water, the kiln fire would suddenly shoot up again and soothe my worries. This

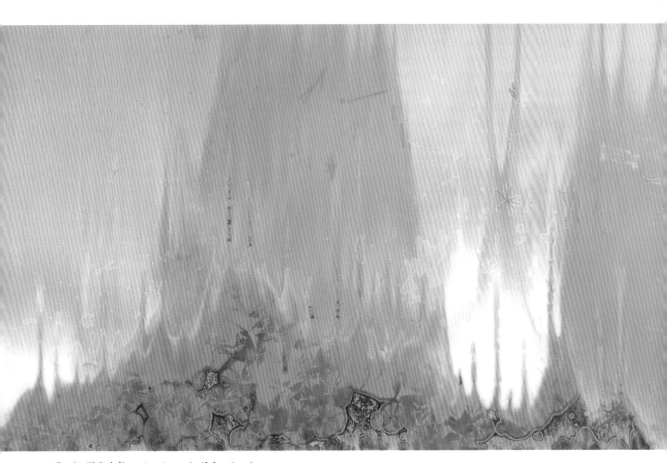

Gloria 天光山色 1989 Ceramic Slab 58×98cm

interesting period of time only lasted for a few months because Peter's family moved abroad. After that, I moved this small kiln around several times and continued using it to make thousands of test tiles. I also added a pressure gauge and improved the chimney until I was quite satisfied with it.

Working with ceramics is much harder than with any other type of art because it requires both artistry and technology. It includes aesthetics, chemistry, thermodynamics, and the use of machinery. For people who have only a background in studio art, it is not easy to conquer the technical aspect of ceramics. At the beginning of my first ten years of making ceramics, this part of my knowledge was very limited. In 1979, the second year after I left the Palace Museum, I built a 1 m^3 gas kiln that could connect more than a dozen gas cylinders at the same time and finally solved the problem of the old fuel system. Besides using the pressure gauge to check the pressure inside the kiln, I also designed other efficient ways to test the pressure. After years of training, I can tell the intensity of the pressure inside the kiln by looking at the color and length of the flame. I can also tell the temperature just by looking at the color of the flame. The brightness of the kiln fire changes from dark red to bright red, to even white radiance at much higher temperatures. I began to understand why the ancient ironsmiths demanded a pure white fire when forging swords. In reduction, the color of the fire is fuzzy; but in oxidation the color of the fire is bright and clear. Besides testing kiln pressure, I also made improvements on kiln leaks, the chimney,

Treading through Woods 林間行腳 1996 Ceramic Slab 70×212cm

and the chimney shaft. In 1982, I built another 1 m^3 electric kiln with an even more complete overall design. The temperature difference in the kiln could be controlled within 5□ when firing to 1300℃ , which was really helpful in gaining precision over sensitive glazes. My studio Tianxin Kiln 田心窯 was also built around this time, giving me a more quiet working environment.

Preparing different kinds of glaze recipes is a test of patience. Back then, I adopted the most scientific (but also the most tedious) method—the coordinate formulation—to calculate the ingredient proportion of each glaze, and began my endless trials in glaze recipes. I even bought a calculator to speed up the calculation process. These gadgets were rare and expensive in the 1960s and cost me two months of salary at the Palace Museum. Since each batch recipe for test tile weighs very little, only 25 grams, I use a micro-scale when preparing glazes. The amount of the ingredients must be precise; not one centigram more and not one centigram less. The amount of water that is used for milling the glaze should also be measured to keep the concentration constant. This attitude toward precision, which still continues today, has become as natural to me as breathing air. Ceramic art demands both liberation of expression and precision in operation. The two seem to represent conflict and yet are one. In fact, the lack of caution and precision can be quite dangerous in any step of the process. This is what makes it so different from any other kind of art. I was once burned by the kiln fire and I have been poisoned twice from inhaling too

much carbonic gas. I was burned because I was standing too close to the gas burner when igniting the gas kiln. My hair and eyebrows caught fire immediately. Luckily, Dr. Peter Liu was there and he knew that zinc oxide combined with fat was excellent for curing burns, so we grabbed some zinc oxide and rushed to the kitchen where we mixed it with a little vegetable oil and applied it to my face. However, my burned hair and eyebrows looked quite comical for a few days. The poisoning experiences were the result of staring at the kiln fire for too long while breathing in too much carbon monoxide. I had to stay in the hospital for a couple of months to regain my health.

In my journey of learning ceramics, I began by studying the whole Chinese ceramic history starting with Neolithic painted pottery, and then all the other traditional glaze firings. I mainly focused on Tang Tri-Color, Celadons, Black Glazes, and Chuns 鈞窯 during the Song Dynasty and Yuan Dynasty, and Copper Reds and Underglaze Blue from the Ming Dynasty and Qing Dynasty. Finally, I extended my research to Zinc Crystalline glazes, a new type of glaze that was first discovered by the Europeans during the 19th century. It aroused my enthusiasm to go beyond the traditional. However, the process of advancing from the cultures of former times and building a style of my own was filled with hardship. Over the years, I have opened the kiln countless times, always full of hope. However, I have destroyed about 90% of the pieces after opening the door. At the same time, flawed work always offer me insights for improvement and, consequently, I started to say, "It's alright, the next one will be better."

Developing My Personal Aesthetics

Looking through the history of Chinese art, one obviously finds that the representative glaze of each dynasty has always gone beyond that of the prior dynasty, not only reaching a new summit of achievement but also reflecting a different aesthetic. Due to the complicated production process and the considerable size of the kiln, firing ceramics has always been a work of collaboration, passed from generation to generation. The emerging products therefore lacked individual traits. This is why, despite the prominence of Chinese ceramics, traditional potters were not able to show very much individualism in their work.

However, modern pottery has changed completely in this aspect. It has freed itself from the artisan characteristics and become a new form of art. With the help of modern technology, tools, and materials, it can finally yield to the artist himself. Pottery thus approaches a pure art form. The imprints of the melted glaze left on the clay body during firing represent a new expression of art. That is to say, the troublesome production process no longer constrains individual traits. Clay and glaze become the medium of modern art; through firing, the creator's aesthetic beliefs are revealed. Even though it is not as convenient a medium as water color or oil painting, ceramics has its own particularities. It has both sculpture's solidity and painting's format. These distinctive characteristics are the reason why clay and glaze continue to be an independent medium.

I am interested in ceramics because it presents the sort of beauty that other media cannot,

Evergreen Portrait of Flowers 繁花翡翠 2009 Ceramic Slab 105×46cm

such as the coloring effect due to high temperature firing, the natural formation of the texture, the jade-like quality, and the subtlety in the variety of the tints of glaze colors. In the field of high temperature firing, I have created the most expressive paintings and detailed color variations by combining crystalline and non-crystalline glazes as my medium. Non-crystalline glazes cover a wide range and they can be used with crystalline glazes at the same time as long as the maturing temperatures, kiln atmosphere, and firing conditions are well coordinated. Crystalline glazes are the crystallization of metallic oxides on the glaze surface after firing. Of all glazes, they are also the only kinds that have variations of crystals, enriching the depth of the glaze.

The primary beauty of crystalline glazes is the glittering crystals - full of radiance and grandness. This is also what I strived to show on wares produced during my early years. However, after perfecting the skill, I did not want to continue practicing the same style. Thus I started to apply glazes combining both crystalline and non-crystalline glazes layer by layer. I sought to explore the effects of the flow and dynamics of glazes which are expressed especially in the composition of dots and lines. From vibrant to calm, from luxuriant to tranquil, my style changed along with my philosophical beliefs. Thus I started to make ceramic slab paintings in 1986. The technical aspects of making the ceramic slab - such as its size, evenness, and firing - were an even greater challenge. Meanwhile, the most important turning point for myself was the visit to Frantisek Kupka's exhibition in the Paris Modern Art Museum in 1990. From Realism, Symbolism, Fauvism, Cubism, Constructivism, and finally to Abstract Art, Kupka never stopped experimenting with new styles. Moreover, he always switched to a different style when the current style had reached its peak. His life-long curiosity and exploration moved and inspired me. After returning from Paris, I started to express myself freely and in an impromptu manner by

Spring Gala 春天的饗宴
2013 Ceramic Slab
216×66.5cm

spraying, brushing, sprinkling, and pouring glazes. Crystalline glazes are a medium that has strong possibilities as the vivid crystals grow and evolve continuously in the kiln fire. This unpredictability breaks through the fettered traits of traditional ceramics and proves its capable connection to modernism. Even though the tools and techniques used for glaze paintings are different from water, ink, or oil paintings, the aesthetic elements are applicable to all. In addition, the individual's projection, composition of the painting, and search for poetry can all be expressed by using this kind of abstract art language.

My independent study of painting during my army years and the study of sculptures during my college years were the origins of my art skills. Starting from the most simple steps, such as the mechanical practice of artistry, or the direct application of ideas, to the aesthetic training of two and three dimensional space, all were applied to the manipulation of clay and glaze. From the years of ignorance to my sudden understanding of clay and glaze, I experienced the echo of nature's vitality in the burning of fire, glitter of crystals, and the unexpected variables. The ability to express a state of mind or the essence of nature is the result of steeling myself and conquering the obstacles of tools, materials, and techniques. In my philosophy, this kind of art is just like the wisdom obtained after experiencing the tribulations and agonies of life. It is the highest form of liberation: emancipated nature.

Translated by SUN Yilin 孫逸齡

* From Sun Chao's 孫超 collection of works *Yao-huo chung te chuang-tsao*《窯火中的創造》(*Born by Fire*), Taipei: Yingge Ceramics Museum, 2009, 27-43.

Liu Kuo-Sung
Master of Modern Chinese Ink and Wash

劉國松：
中國水墨
一代宗師

LEE Chun-yi 李君毅

And Down Goes the Water 臨流直下 1967 Ink and Color on Paper 60.4×93cm

劉國松 (1932-)
Liu Kuo-Sung (also Liu Guo-Song)

Born in Anhui, China, Liu Kuo-Sung arrived in Taiwan in 1949 with the Nationalist government. After graduating from the Department of Fine Arts of National Taiwan Normal University in 1956, he founded the "Fifth Moon Painting Society" and devoted himself to innovating traditional ink-and-wash painting. He has been honored as the "Father of Modern Ink-and-wash Painting" and is one of the few Chinese artists whose work is collected by art museums such as The British Museum and Beijing National Palace Museum. Liu Kuo-Sung has been awarded a number of honors in Taiwan, including the National Arts Award and the Executive Yuan National Cultural Award. In 2016, he was elected academician of the American Academy of Arts and Sciences.

Liu Kuo-Sung's groundbreaking work transcends the existing concept of Chinese painting. He constantly goes beyond traditional techniques as well as materials. In recent years, he has experimented with different kinds of paper, tearing off paper fibers and utilizing various methods to develop unprecedented aesthetic effect. He is one of the boldest and most innovative contemporary ink-and-water painters in Taiwan.

Liu Kuo-Sung is widely revered as an influential artist and educator who has played a pivotal role in the development of modern Chinese painting, a fact reflected in the many accolades he has received over the years. In 1984, not long after mainland China opened up to the world, both Liu and fellow painter Li Keran 李可染 were honored with special awards at the Sixth National Exhibition of Fine Arts. Other

honors include the Republic of China's 12th National Arts Award, the 36th R.O.C. National Cultural Award, and the prestigious Lifetime Achievement Award at the first China Art Awards. In the fall of 2016, he was made a member of the American Academy of Arts and Sciences (AAAS), and numerous seminars and retrospectives showcasing his work have since been held at the National Taiwan Museum of Fine Arts, the National Museum of History (Taiwan), the Hong Kong Museum of Art, the Palace Museum in Beijing, the National Art Museum of China, and the China Art Museum in Shanghai. Public lectures at Harvard and Stanford further underline Liu's international standing. In his native Shandong Province, the Shandong Museum in 2013 devoted an entire wing to his work. Named the "Liu Kuo-Sung Modern Ink and Wash Gallery," this venue hosts regular exhibitions and academic events to highlight the artist's outstanding contributions to modern Chinese art. Without any doubt, the current popularity of the ink and wash genre both in academic circles and on the global art market is in no small measure due to Liu Kuo-Sung's untiring work over the years, both as a painter and a teacher.

Liu first began to explore modern approaches to painting in the 1950s. Freshly graduated from National Taiwan Normal University's Fine Arts Department, he immediately set out on a path of experimentation and innovation. In 1956, he became one of the founding members of Taiwan's Fifth Moon Painting Society 五月畫會 (also known as the Fifth Moon Group), which was committed to introducing Western styles, techniques, and concepts into local art circles then dominated by conservative values and perspectives. Liu wrote a large number of articles and essays that were sharply critical of traditional-style painters and their work, while at the same time espousing modern ideas such as abstractionism. Consequently, he quickly became one of the leading figures of Taiwan's fledgling modern art movement. Writer Yang Wei 楊蔚 , who shared many of Liu's goals and notions, even called him the "standard bearer" of new forms of artistic expressions.

However, Liu's strong sense of national identity and his innate cultural pride gradually led him to question the wholesale adoption of Western techniques and values. By the early 1960s, he had begun to resent the dominance of American and European approaches in modern art, and was favoring a return to traditional Chinese styles, a process tempered by his highly critical and rational mind. His particular focus was on ink and wash, brimming as it is with many essential elements of Eastern art, and his goal the creation of a new Chinese tradition that would combine the conventional with the innovative, and the specific with the universal, thus injecting new meaning into a highly revered form of artistic expression. During the 60s, he developed a semiabstract style of landscape painting featuring fluid brushstrokes and his renowned "cracked paper" technique (also known, in his own words, as "stripping the tendons and peeling the skin") for an overall visual effect that was both genuinely Chinese and eerily modern. Around 1970, inspired by the first landing on the moon, he started work on his *Outer Space* series of paintings, showing heavenly bodies and other cosmic images in a style transcending the narrow confines of both oriental and occidental art. By the mid-1970s and 1980s, Liu's art had matured to the point where his subtle

Mountain Light Blown into Wrinkles 吹皺的山光 1985 Ink on Paper 40×26.5cm

Meandering Landscape 峰迴路轉　1966　Ink and Color on Paper　86×59cm

Natural Meshy White Lines of Snow Mountain
雪網山痕皆自然 2013 185×372cm

skills served to produce a kind of "naturalist expressionism," further amalgamating traditional and avant-garde elements through splash and stain techniques ("water rubbing" and "steeped ink") that allowed him to generate a broad aesthetic appeal while at the same time communicating environmental awareness. For many decades, Liu has been blazing new trails in order to realize his main purpose: to thoroughly modernize traditional Chinese ink and wash painting—something he has achieved through incessant experimentation, both in terms of form and content. In a way, he has managed to continue the great tradition of literati art by constantly pushing its boundaries, reviving the spirit rather than the formalistic aspects of conventional Eastern painting.

In 1968, on Chinese Cultural Renaissance Day, Liu established the Chinese Ink and Wash Society, a move through which he and his colleagues hoped to promote the "modernization of Chinese painting." The very term "modern ink and wash painting," which was at the heart of their efforts, stressed the importance of remaining firmly rooted in China's cultural traditions when setting out to modernize Chinese painting. In 1971, Liu took up a teaching position at the Chinese University of Hong Kong, offering classes in "Modern Ink and Wash Painting" both at the University's Fine Arts Department and in other non-academic venues in an attempt to reach as many potential young artists as possible. A very patient and attentive teacher, Liu frequently encouraged his students to set up their own painting clubs and societies to learn from each other, exchange their individual experiences, and broaden each other's horizons. The Hong Kong

Liu Kuo-Sung signed his name on AAAS's registry on October 8, 2016 劉國松 2016 年 10 月 8 日
在美國文理科學院院士冊上簽名

Modern Chinese Ink Painting Association, founded by some of his students at Liu's suggestion, remains active to this day, looking back on a proud history of more than 40 years and featuring a large number of now famous members, including Guo Hanshen, Liu Jinzhi, Liang Dongcai, Zhong Likun, Chen Junli, Chen Chengqiu, and Yang Guofen.

Since Liu devotes much of his energy to fostering a younger generation of modern ink and wash artists, and has always placed special emphasis on promoting the genre in mainland China, he viewed the National Art Museum of China's 1983 invitation to hold a solo exhibition of his work as the perfect opportunity for advancing his artistic theories and ideals in his native country. At that juncture, he had already signed a contract for an exhibition to be held at London's Hugh Moss Gallery at about the same period of time. Yet Liu considered the chance to see his work showcased in China more important, so he cancelled his commitment to Moss, readily shouldered the financial loss, and had the collection of works shipped to Beijing instead. Between 1983 and 1986,

Midnight Sun No.3 午夜的太陽 III 1970 Ink and Color on Paper 139.7×375cm

Liu had two traveling exhibitions visiting practically all the major cities of China, with himself making regular appearances for public speeches at the different venues. He was also invited to hold lectures or give master classes at many renowned art schools and other academic institutions. These series of events made a big splash in the Chinese art world, and inspired countless burgeoning artists to explore new creative avenues, allowing them to throw off the shackles of conventional literati painting and enter a new era of artistic awakening and stylistic variety.

Liu Kuo-Sung is known for a number of rather stunning and widely influential views on creativity and aesthetics, such as his belief that "originality comes before skill" or his metaphorical notion of "the pursuit of painting as a multilayered skyscraper." One of his most talked about concepts is "a revolution against the brush, a revolution against the center," initially harshly criticized by curator and educator Han Pao-teh 漢寶德 , but later praised by Han as "the insight of an extremely prescient mind." Meanwhile, Liu's often quoted statement that "the painter's studio

is an artistic laboratory" has been cited as a major motivating force behind the rapid development of "experimental ink and wash" that China has witnessed in recent times. Liu's own oeuvre, which has reached an impressive size during a career spanning more than six decades, shows his innovative ideas at work. Take for example the 1983 long scroll landscape painting *Sixu Shanshui* 四序山水 which displays all his trademark techniques, such as steeped ink, water rubbing, and cracked paper texturing: it marks a complete departure from the principles of conventional *cunfa* 皴法 as employed in traditional Chinese landscape painting, as well as from the formal division into four distinct screens, or scenes, for the depiction of the four seasons—Liu opted to show spring, summer, fall, and winter in one single panoramic view. It comes as no surprise, therefore, that Li Keran spent a long time perusing and admiring this particular painting when visiting the big Beijing exhibition that put Liu on the map in Chinese art circles. It is no exaggeration to say that Liu Kuo-Sung's *Sixu Shanshui* is a masterpiece that has breathed new life into the ancient art form of Chinese landscape painting, and that its importance in the history of Eastern ink and wash is quite on par with that of Yuan Dynasty painter Huang Gongwang's 黃公望 *Dwelling in the*

Tianzishan in Summer 天子山盛夏　2006　182.3×45.3cm

Fuchun Mountains 富春山居圖 .

In 1992, at the age of sixty, Liu retired from his teaching position at the Chinese University of Hong Kong to return to Taiwan, where he has lived ever since. Even after retiring from his official posts, however, Liu still continued his tireless efforts to cultivate channels of exchange between ink and wash artists, critics, and connoisseurs in China, Hong Kong, and Taiwan. Traveling quite extensively between these places, he helped to organize a number of symposiums and academic meetings, such as the 1994 Modern Ink Painting Exhibition and Seminar at the Taichung Museum of Fine Arts, an international event that brought together dozens of painters and academics to discuss the latest developments in ink and wash. In the following year, Liu and a group of his friends and colleagues founded the 21st Century Modern Ink and Wash Painting Society. With Liu himself at its helm, the Society continues to promote modern concepts and approaches to the genre, and it is worth mentioning that Liu's efforts are by no means limited to the meticulous planning and organizing of various events: he is also more than willing to provide ficial support

to sponsor large exhibitions and related events. In fact, personal gains or losses are not an issue for Liu when it comes to pushing the project closest to his heart, and he helps with pretty much everything, from the collecting of works to the design of exhibitions, from hanging up paintings to receiving guests and visitors, from writing critical essays and promotional blurbs to mailing leaflets and invitations. At the same time, he spares no efforts in fostering and supporting promising young talents from China, Hong Kong, and Taiwan, many of whom he has introduced to galleries and museums, helping them to get a spot in exhibitions. Liu has even been known to carry some up-and-coming artists' work to galleries for numerous art dealers' perusal, or to write articles for newspapers or magazines to introduce new painters and their work to a wider audience. No one could possibly question his passion and enthusiasm when it comes to giving newcomers a much-needed boost.

The truth is, Liu Kuo-Sung loves modern ink and wash painting with all his heart, and

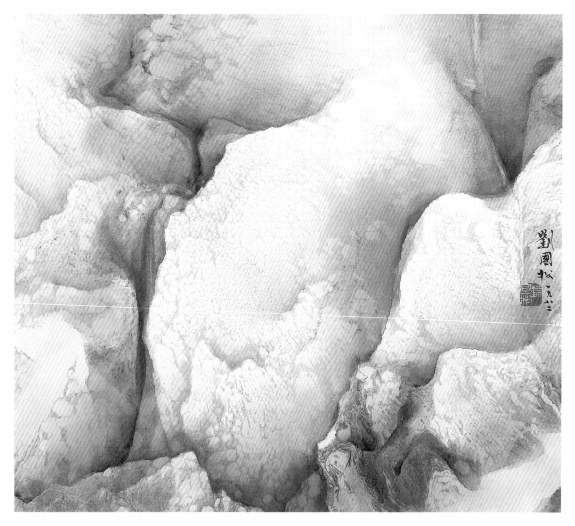

White Snow is White 白雪是白的　1982　39.2×44.5cm

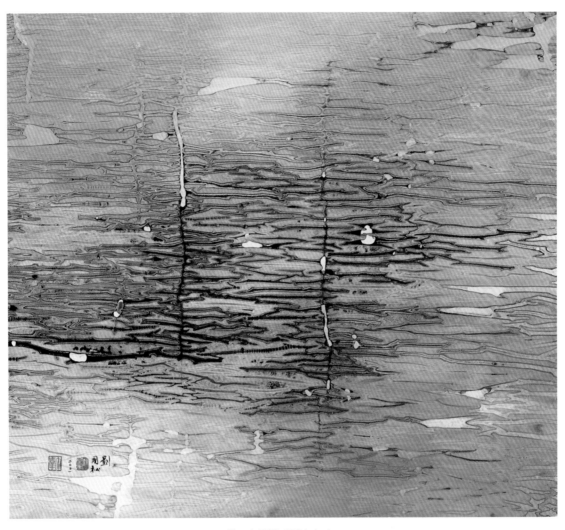

Ripples: Jiuzhaigou Valley Series No.13 漪一九寨溝系列之十三 2001 71×79.5cm

promotes the genre with a zeal and persistence that remind one of a missionary's religious fervor.
Having devoted his entire life to creative work and art education, he hopes to reach out to as many
people as possible, always eager to win new hearts and minds that can make a contribution to
the modernization and development of Chinese painting. His utter commitment to this goal is
such that his wife, Li Mohua 黎模華 , often, and only half jokingly, refers to her husband as the
"Missionary of Modern Ink Painting." The truth of her words is underlined by the fact that even at
an advanced age, Liu is not slacking off at all: he still teaches painting at various venues, such as
the National Taiwan Arts Education Center, the Sun Yat-sen Memorial Hall, and the Chiang Kai-
shek Memorial Hall, undaunted by the return trips from Taoyuan to Taipei these lessons entail.
In order to cultivate young talent, he also organized the "Tension of the White Line" exhibition,
which showcased the best works from his own students together with the paintings of famous ink
and wash artists from the greater China area. In 2010, when his alma mater, the National Taiwan
Normal University, appointed him visiting chair professor, Liu was very happy to accept a position

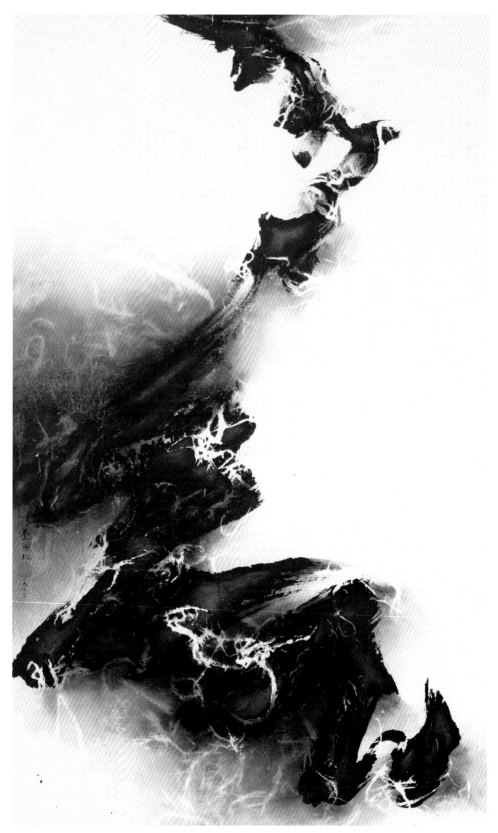

Up to the White Unknown 升向白茫茫的未知 1963 Ink and Color 94×58cm

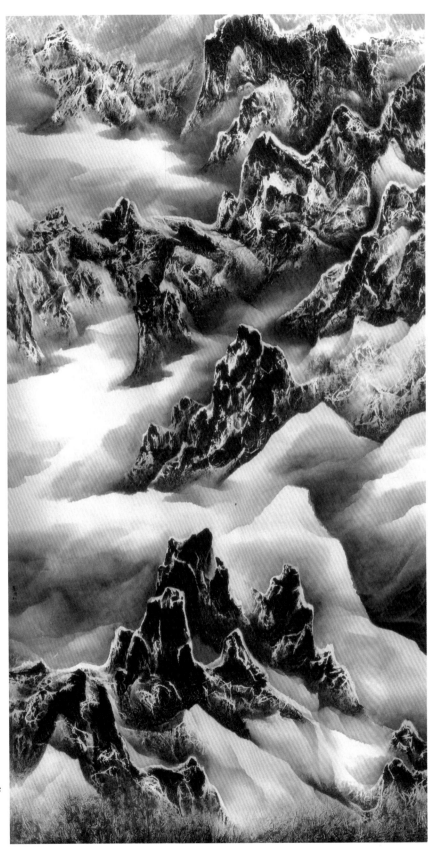

***Clouds and Mountains
in Play*** 雲與山的遊戲
2003
Ink and Color on Paper
346×183cm

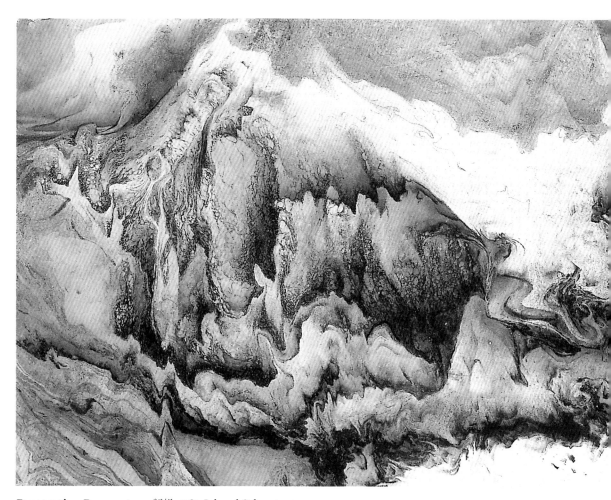

Penetrating Promontory 歸帆 1981 Ink and Color 42×91.5cm

Long Sea's Large Waves: Jiuzhaigou Valley Series, No.127 長海波瀾－九寨溝系列之 127 2008 Ink and Color
69.7×135.5cm

that offered him yet another channel for spreading his gospel. The money he earned as an occasional guest lecturer at his alma mater Liu donated to the National Taiwan Normal University's Fine Arts Department, and it was used to sponsor a variety of ink and wash activities and events. Liu also made a big contribution to the fundraising for the construction of a fine arts gallery on the university campus, donating two of his large-format paintings for auction in 2012, with the proceeds going towards the gallery project. Liu also donated 5 million NT dollars to establish an ink and wash scholarship. Also in the same year, he donated the 25 million NT dollars that came with the China Art Award's Lifetime Achievement Award to the Shandong Museum, to be used as a special budget for the promotion of ink and wash painting.

Throughout his life, Liu Kuo-Sung's philosophy was rooted in the Confucian tradition of "cultivating oneself so one may cultivate others," a fact that is poignantly reflected in the way he was always an ardent participant and supporter of charitable activities—something he somehow found time for in spite of having a busy career as one of the great pioneers of Chinese modern painting. An orphan from a young age (his father died in the Second Sino-Japanese War), Liu did not have what you would call an easy childhood. Yet this was probably one of the reasons why he was always able to sympathize with society's weak and disadvantaged groups. Having suffered hardships growing up, he felt it was his duty and honor to help others wherever and whenever he could, be it in the form of financial support or by contributing knowledge, time, and effort. In particular, he has lent a helping hand to many religious and charity groups, but also supported disaster relief work and educational projects in mainland China. Born and bred in China, Liu received his higher education in Taiwan and grew up to be a paragon of integrity and a genuine artist. He is a model Chinese intellectual and a modern grand master of ink and wash painting.

Translated by David VAN DER PEET 范德培

Cheng Shan-Hsi

No Art Without Color:
Joie de Vivre in the Works of
Cheng Shan-Hsi

丹青妙手鄭善禧

LIU Jung Chun 劉榕峻

Village by the Sea 臨海村舍 1974 Ink and Color 60.3×60.5cm

鄭善禧 (1932-)

Cheng Shan-Hsi (also Zheng Shan-Xi)

Born in Fujian, China, Cheng Shan-Hsi came to Taiwan in 1950. He graduated from the Department of Fine Arts at National Taiwan Normal University and is one of Taiwan's most representative ink-and-water painters. He has won important recognitions such as the National Award of Art and the Executive Yuan National Cultural Award. University-trained and educated, Cheng Shan-Hsi continues the spirit of traditional Chinese painting wherein the painter must possess elegant brushwork and master the history of painting, as well as the four iconic arts: poetry, calligraphy, painting and seal cutting. On the other hand, Cheng Shan-Hsi is also down to earth and a practical artist who diligently draws sketches. His creations are often drawn from contemporary local life. They are potent folk art, full of vitality. Taiwan is the main subject of Cheng Shan-Hsi's ink wash paintings and he has created his own style while employing intense colors. He has been specializing in painting porcelain, and is a multi-skilled painter with a distinctive personal style.

"Life's all about finding fun and delight—without these, what's there to live for?" Whether in his career as an elementary school teacher or a university professor, as an arts and crafts instructor or a renowned painter and sometimes printmaker, "finding fun and delight" has always been, and continues to be, the core concept of Cheng Shan-Hsi's creative drive, as well as the basic principle of his pedagogy. His artistic genius employs traditional ink and wash techniques to depict airplanes, cars, skyscrapers and even Orchid Island aboriginal thong pants, not to mention Taiwan's bustling festivals, lively operas and puppet theater, and a host of other local cultural events. He

Yehliu 野柳風光 1980 Ink and Color 70×136cm

has created a series of images showing the twelve signs of the Chinese zodiac, and painted a lasting record of Taiwan's most beautiful and impressive sights and sceneries: lush green mountains under a scorching tropical sun and wild vistas contrasting with intricately designed landscapes. Young at heart as he is, Cheng manages to temper his almost childlike innocence with finely honed brush and compositional skills. His cheerful temperament allows him to portray virtually anything, from pets and toys to cartoon characters such as Doraemon or Mickey Mouse, reminding us that beauty and delight can be found even in the most mundane things.

"Watching" as Root of the Creative Process

Cheng Shan-Hsi was born in Fujian Province on the southeast coast of China. Cheng 's father was a merchant dealing in grains and other local produce, and the family's relative wealth meant that they could afford to send the young boy to private schools for a comprehensive education in the Confucian classics. To this day, Cheng is perfectly capable of citing entire passages from the ancient classics *Four Books* 四書 and *Five Classics* 五經 , or declaiming lines of classical Chinese poetry. As a child, he also loved to watch performances of traveling folk opera troupes, or observe craftsmen such as painters, carvers, and carpenters busily drawing murals and door gods, shaping figurines and statues, creating rockeries with bas-relief decorations, or carving statues of deities in temples near his home. Puppet theater was another of his interests, whether watching the process

of making the puppets or seeing them "in action." From early on, then, "watching" others engaging in creative activities was a main staple of the informal part of the artist's education, providing a lasting source of inspiration and food for his artistic imagination.

The year 1950 saw many changes and upheavals in Taiwan, and it was at this juncture that the 18-year-old Cheng Shan-Hsi first came from mainland China to his future home. From Taipei he soon moved to Tainan, where he passed the entrance exam to the Tainan Teachers School and enrolled in their fine arts program. This was a crucial turning point in his life, because it meant that he could settle down to doing what he liked best and make a living off it, too. In 1957, he got accepted into the island's most prestigious institute of higher art education, enrolling in the National Taiwan Normal University's Fine Art Department. At a time when many became separated from their families and were struggling to make ends meet, Cheng knew how lucky he was to have the opportunity of getting a higher education, and he devoted all his efforts to study very hard what every teacher and each subject had to offer. At National Taiwan Normal University, he studied under various great masters, including Pu Xinyu 溥心畬, Lin Yushan 林玉山, Liao Jichun 廖繼春, and Li Zefan 李澤藩. Looking back, Cheng says, "Pu Xinyu kept exhorting me, 'You need to study,' and I'm studying to this day; Lin Yushan kept telling me, 'You need to sketch from nature,' and I'm sketching from nature to this day; Liao Jichun always said, 'You need to make good use of color,' and to this day I place the greatest emphasis on color." Cheng seems to recall everything his teachers ever taught him, and has made it a lifelong pursuit to live up to their expectations. But no one influenced Cheng and the development of his own style more than Lin Yushan with his firm focus on painting from life: this was very much to the burgeoning artist's own taste and instinctive inclinations, and sketching from nature became the foundation of his entire creative impetus.

Folk Deities 三太子保庇保庇 2013 Ink and Color 70×136.8cm

Reverie 少女沉思 2012 Ink and Color 51×35cm

Cheng Shan-Hsi's predilection for sketching from nature follows logically from his habit since early childhood to watch other artists and craftsmen at work. Over time, he developed an ever keener eye and appreciation for their skills and techniques, and once at the Tainan Teachers School and at National Taiwan Normal University, Cheng did not confine himself to copying model calligraphies and paintings (the traditional way of learning literati painting), but spent much time making sketches in the streets, forever drawing on the world around him for fresh subjects. He also regularly visited galleries and mounting shops, and, driven by an inexhaustible thirst for knowledge, liked to collect old books, magazines, and newspapers, in particular those containing foreign paintings and cartoons—early on, Cheng found that he was particularly attracted to comics and similar visual genres. The young man's wide reading and interests ensured that his studies never suffered from the sometimes narrow confines imposed on students by conventional academic curricula. Instead, he amply supplemented his formal education with popular culture and folk crafts, nourishing the rich soil of his artistic imagination and laying the groundwork for his own unique creative style.

Rich Colors and Thick Brushstrokes: Painting Taiwan's Mountains

That style is best known for its generously applied colors and thick, firm brushstrokes, and it has often been described as "typically Taiwanese," both in terms of its visual appeal and the subjects portrayed. "Ink and wash with native themes" is another common moniker. Cheng's preference for bright colors may well originate in his youth, when he spent so much time observing folk artists and craftsmen at work, but it was further fed by his studies at National Taiwan Normal University and his travels abroad. In other countries, he enjoyed firsthand experience of Western

Wind Lion Lord 風獅爺 2015 Ink and Color 70×137cm

painting and color composition, which enabled him to transcend the limitations of traditional black-and-white ink wash painting. Furthermore, Cheng frequently went for hikes in Taiwan's mountains, finding them to be quite different from most mountain ranges in mainland China. More specifically, the island's ranges less often displayed the misty, mysterious qualities found in many of China's holy mountains, but generally sported lush green foliage and comparatively gently rolling hills, especially at lower altitudes. The term "Taiwan Mountain Scenery," which at first was used in a somewhat ironic way by those accustomed to supposedly more majestic panoramas, gained wider and more positive currency in the 1970s as part of the nativist movement in arts and literature. Cheng's oeuvre also underwent a sort of reevaluation in those years, gaining more acknowledgment and praise from critics and the public as people realized that he had been at the

cutting edge of avant-garde movements all along, intuitively anticipating the blossoming of more localized, community-centered forms of art.

The 1974 painting *Village by the Sea* shows a mountain in the foreground, executed in a variety of hues ranging from azurite and indigo to bright green and darker blue tones, its spatial structure outlined and accentuated with firm black ink brushstrokes to give an overall impression of brilliant massiveness. To the left, at the foot of the range, lies a little village of white houses with red roofs. The mountains in the background, across a body of water, as well as most of the rocks and trees, are executed in more somber shades, while the composition as a whole is dominated by a fairly marked contrast between green and reddish tones without descending

Ferry Crossing the River at High Tide
渡口潮漲溪面寬
1994 Ink and Color
59.8×30.4cm

into the realm of kitsch. In *Rustic Happiness* (1994), calligraphic lines and hooks are used for the contours of people, animals, and objects, while a bold and vivid palette combines with a long inscription in the painting's top left half to create a lively, attractive image of rural life. The 1994 work *Ferry Crossing the River at High Tide* deliberately harks back to Yuan Dynasty "river bank compositions," with fresh, verdant hills rendered exceedingly lifelike through *cunfa* 皴法 , the "wrinkle method" borrowed from literati painting. The dense layers of luxuriant vegetation typical of Taiwan's mountains are juxtaposed with compositional elements from traditional Chinese landscape painting, such as tiny people "lost" in the landscape, houses, trees and pavilions, yet the overall effect is one of genuine harmony and natural tranquility, a scenery brimming with the charm and simplicity that Cheng Shan-Hsi saw as the main characteristics of Taiwan's natural landscapes. Adhering to the long-standing Chinese concept of merging poetry and painting, the artist has created a vista that appeals both to popular and highly sophisticated tastes.

With regard to his rather lavish use of color—at least by conventional ink and wash standards—Cheng has remarked, "Consider the flower blooming season on Yangmingshan, when spring brings forth green shoots and colorful blossoms wherever you look, a true riot of color and fresh growth. Or look at popular folk festivals, such as the Matsu processions or the Burning of the King Ship, both accompanied by festive decorations and marked by streets dressed up with buntings and jammed with people carrying deity palanquins, banners, pennants and flags—not to forget the fireworks—and you will agree that a plain black and white ink wash painting could never do this kind of thing justice. No, only a vibrant palette can convey such flamboyance, such joie de vivre!" For Cheng, traditional ink and wash was only the starting point of a journey that led, via long practice in sketching and drawing from life, to a consummate skill and a nonpareil style whose hallmarks are rich colors and powerful brushstrokes: a truly local style that gives authentic expression to all things Taiwanese.

A Young Heart and the Soul of a Painter

There is no painter that Cheng Shan-Hsi admires and even worships more than Qi Baishi 齊白石 , and clearly no other artist whom he has tried harder to emulate, or who has had a greater influence on his style. In what is arguably his most famous statement on art theory, Qi once declared, "The beauty and wonder of art lies in striking the right balance between lifelikeness and subjectivity: if a painting resembles reality too closely, it is little more than vulgar kitsch, but if it doesn't resemble reality at all, it is sort of cheating the viewer." Cheng expressed much the same view in different words when he said, "A painter should not be overly concerned with photographic authenticity, but rather attempt to be true to his subject's essential nature and inherent charm." His 1974 painting *Majestic Cat* shows a black cat with white paws sitting in an upright posture. The animal's body is done in various shades of black to dark gray, and its eyes sparkle with the slightly mischievous and mysterious spirit usually found in cats. In other words, while the depiction is far from realistic in the narrow sense of the word, it yet manages to capture its subject's quintessence

Majestic Cat 雄姿挺立－黑貓 1974 Ink and
Color 90.9×34.7cm、20.3×34.7cm

A Lonely Singer 不惜歌者苦 1984 Ink and Color
75.5×26.5cm

Glove Puppets: Kong Ming, Liu Bei, and Guan Gong 布袋戲偶－孔明劉備關公 2014 Ink and Color 45.3×69.8cm

while also exuding a naïve and childlike charm. Similarly, the 2014 work *Glove Puppets: Kong Ming, Liu Bei, and Guan Gong* focuses on conveying as convincingly as possible the temper, personality, outward expression, and typical posture associated with these three important characters of Budai Opera 布袋戲 (puppet show). Cheng succeeds admirably, with the red, purple, green, and gold dominated "puppets" perfectly encapsulating the exuberant folksy style of glove puppetry.

Qi Baishi was renowned for the wide range of subjects found in his paintings, from people and landscapes to flowers and insects, and from birds and beasts to fish and other aquatic creatures. If anything, Cheng Shan-Hsi has further expanded the thematic possibilities of the modern ink and wash genre, including a very wide variety of subjects in his oeuvre: folk festivals and religious holidays, rural scenes and bucolic vistas, urban sights and street scenes, slices of everyday life and impressions from various journeys, aboriginal motifs (especially of the Tao people), and even distinctly contemporary objects such as skyscrapers, cars, or airplanes. During his time as an elementary school arts and crafts teacher, Cheng came to appreciate the ingenuous and deeply refreshing qualities of children's art, and the insights he gained as an educator became one important factor helping him to overcome the overly strict constraints frequently placed on

**Memories of Orchid
Island**
蘭嶼之憶 1979
Ink and Color 135×69cm

the artist in traditional Chinese painting. The painting *Memories of Orchid Island* (1979) features a deliberate throwback to Yuan and Ming Dynasty literati painting, with the offshore island's green hills and mountain ridges rising like giant beasts from the rugged coastline, and the tiny figures of scholars interspersed among the scenery replaced by indigenous people of the Tao tribe, wearing thong pants and hunting for fish in an almost primeval environment. In the 1995 painting *National Taiwan Normal University Intersection*, Cheng depicts a street scene as seen from the University's Fine Arts Department's veranda, combining modern high-rises, cars, and road trees into a mundane yet distinctively Taiwanese image. A series of works that includes, among others,

Little Tiger 玩偶－小虎弟 1998 Ink and Color 55×18cm×2

Little Tiger (1998), *Little Tiger Good Luck Charm* (2010), and *Enjoying the Arts in the Study* (2012) features some of his children's stuffed toys and dolls, as well as the implements found in his studio, creating an eclectic mix that serves as a reflection on the pleasures and enjoyments of life, ranging from family to profession, and from everyday life to artistic pursuits, a point that is also poignantly made in the paintings' poetic inscriptions.

The Older the Merrier: A Creative Well That Doesn't Run Dry

Whether in life or in art, the maxim "Live and learn" certainly holds water for Cheng Shan-Hsi. Never one to set limits for himself, he has started to experiment with new media and genres late in life. At the invitation of the Taipei Fine Arts Museum, he created prints of the twelve signs of the Chinese zodiac to be used as Chinese New Year posters. At the same time, he is working as a calligrapher and ceramic artist who also likes to fuse different media, for example by painting or inscribing poetry on porcelain. Since calligraphy and painting both utilize the same tool, a writing brush, it is easy to see, so argued Cheng, that they both trace their origin back to the same source. Therefore, it doesn't come as a surprise that the four arts of poetry, calligraphy, painting, and seal making are considered an organic whole in Chinese art, and indeed are often found to be united in a single painting. Artists who excel at composition and design are often masters in the calligraphic art, since Chinese characters as elements of art are all about the aesthetically pleasing arrangement of lines in space. Painting on porcelain also came naturally to Cheng, who loves the texture and simplicity of ceramic and pottery artifacts, so congenial to his own temperament. It was his colleague Chen Jingrong who first introduced him to the delights of porcelain painting, also known as china painting, and Cheng quickly became as adept at this genre as at practically anything else he tried his hand at.

From early childhood, Cheng had always been good at observing artists and craftsmen at work, and from this love of "watching" grew his interest and skills. Every time he goes back to Tainan he will visit the Koxinga Shrine 延平郡王祠 to enjoy another look at Qing official Shen Baozhen's 沈葆楨 calligraphy couplet, which reads, "An outstanding leader of many talents who came to the wild lands of Taiwan and began to cultivate them for future generations of his fellow countrymen. His life was filled with setbacks and regrets, yet refusing to buckle he focused on the beautiful mountains and rivers of his new home—he was a true pioneer and a man of perfect integrity." Full of praise for these lines, he copied them reverently and borrowed them for use in his previously painted work *Portrait of Koxinga* (1994), thus expressing his deeply felt admiration for this great historical figure with whom he shares the same family name. Cheng feels that the flat brush script, or *qishu* 漆書 , invented by Qing Dynasty painter and calligrapher Jin Nong 金農 and largely based on the clerical style of Chinese writing, is the most creative and original of all calligraphic styles. Says Cheng, "Whenever I make an inscription on one of my paintings in *qishu*, I feel that the spirit of Jin Dongxin 金冬心 is flowing right through me, and the characters are flowing from my pen almost without effort, dancing like a dervish on the paper. Just like a jitong imploring the

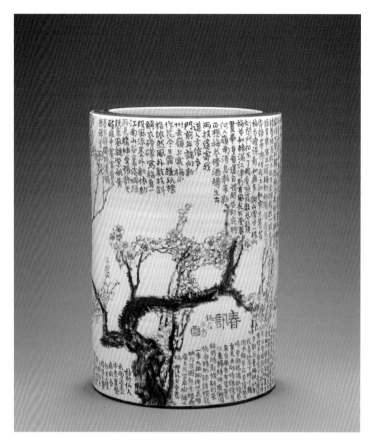

Plum Blossoms 梅花圖　2007　Ceramics　52×37.3cm

gods may be muttering incessant incantations, calling on Guanshiyin or the sea goddess Matsu for answers, so I will be calling on Jin Nong to guide my hand in writing." Most of his work in the ceramic medium involves calligraphic inscriptions, as of poetry, on porcelain plates, bowls, or vases, usually based on rubbings from ancient stone inscriptions or other model writings by both ancient and modern calligraphy masters. The piece *Zhu Bolu's Maxims for Managing the Home* (1993) shows Cheng's engraving skills on ceramics at their very best, while also bearing witness to his strong belief in Confucian philosophy and its focus on this world and how to run it properly. The calligraphic style on display subtly reflects the ingenious blend of practicality and aestheticism that is one of the hallmarks of his belief system. The exceedingly long inscription found in *Plum Blossoms* (2007) serves as a foil to the liubai areas surrounding the plum tree, and the entire composition is brimming with an elegance and poise that are further underlined by the decorative spacing of the characters. All in all, a superb mélange of painting, calligraphy, and ceramic art.

　　In retrospect, Cheng Shan-Hsi finds that he has always followed the "middle path" 中庸之 道 . This was largely due to his personality: while many of his contemporaries eagerly participated in avant-garde societies such as the Fifth Moon Group or the Eastern Art Association, Cheng followed a more cautious approach, carefully finding his own way between uncompromising modernism and exaggerated conservatism, between complete "Westernization" and amalgamation

Cheng Shan-Hsi painting a portrait. Photo taken in 2008. 繪製于右任像 2008 年

of Occidental and Oriental elements. In a rather eclectic fashion, he absorbed and adapted to his own needs all the techniques and components he found useful, applying them in a flexible and innovative way very much in sync with his basic Confucianist outlook. "Only adopt the new if it's good, and only make changes where they lead to improvement" is his motto, declaring that he doesn't dare to "become a rebel lightly" or to "revolt without good reason." Essentially, then, his work is rooted in tradition and careful observation.

Cheng Shan-Hsi's creative credo was "Learn the basics and apply them in practice, but be flexible and open-minded at the same time; study the old masters and make good use of their wisdom." Or, as he once put it, "My painting is an artistic version of the Three Principles of the People!" This statement may leave many people a bit dumbfounded at first, but what Cheng really means is that just like Sun Yat-sen's political philosophy, his art can be seen as a combination of venerable Chinese traditions and the best elements of Western approaches, all fused into an organic whole through his unique individual ideas. For Cheng, art is to be found in everything, and the challenge is to find it, make it your own, and then sublimate it into something new and original. We are all part of something bigger, and the universe is full of miracles and surprises that we can encounter everywhere, even in our everyday lives. And when we do, we may well be inspired to do something creative. That is the way of the artist.

Translated by David VAN DER PEET 范德培

*From *Xin Huoshui*《新活水》(*Fountain of Creativity Bimonthly*), 55, August 2014, 6-11.

Ju Ming
Thus Speaks Ju Ming
朱銘曰

PAN Hsuan 潘煊

Living World Series-Painted Wood
人間系列－彩繪木雕 1995
Wood 471×84×141cm

朱銘 (1938-)
Ju Ming (also Zhu Ming)

Born in Miaoli, Taiwan, Ju Ming is the most important carving master in contemporary Taiwan and is known for his unique creations. Ju was born in a poor farming family. He learned woodcarving in his early years and later learned the modern sculpting techniques from Master Yuyu Yang, also featured in the present volume. Started as a young lad relying on woodcarvings and craftsmanship as a means of subsistence, Ju developed into an established artist, taking art as his conviction of life

Ju Ming has won important honors such as the National Award of Art and the Executive Yuan National Cultural Award. His famous works include the *Nativist* Series, the *Taichi* Series and the *Living World* Series. He never stopped experimenting different materials and techniques; wood, pottery clay, sponge, bronze and stainless steel are all used. The subject matter of his work includes the lives of all sentient beings. In 1999, the more than 10 acre Juming Museum, which he personally planned and constructed, was established in Jinshan, Taipei. It is arguably the biggest art work of his life.

Internal Metamorphosis

Creation is something totally from within.

Like spring water, creativity bubbles up from the deepest source. You cannot trigger off an endless outflow by just throwing a few stones into the water. Art must gush forth from the wellspring of the self.

Learning is an imitation, imitating a precursor or embracing some master. Like a sapling growing on a big tree, it receives nourishment and support that way. From

111

Taichi Series-Single Whip 太極系列－單鞭下勢　1986　Bronze　467×188×267cm

a distance the whole thing may look like one big tree, but it's just an illusion. A detailed look will reveal that they are in fact two separate lives.

In art, no matter how you imitate a master's painting style, lay-out or palette, you and the master will always be distinct individuals: You are you and he is he. If one aims at comparing with a master only superficially, one would never reach the stature of the master. Only by dropping imitation and attachment, by coming out of the shade into the sun and imbibing moisture in the air can you grow and mature, and find the strength to stand on your own. Standing on your own in the middle of the forest, you will finally be seen as a big tree.

Ju Ming has a long history of "learning." Along the way, he has both "learned" and "discarded."

At the young age of sixteen, he started learning under the tutelage of Li Chin-chuan.

Fifteen years later, he abandoned all the techniques he had accumulated, visible and invisible, to learn again as a protégé of Yuyu Yang 楊英風 .

At that time, this student didn't learn how to "obtain." Instead, he learned how to "discard."

That's what he received from Yang Ying-feng, who stood as a blazing torch in his artistic career. It was a torch that was to illumine a passageway he had to go through—the passageway of "discarding."

Thus he discarded all trivial details, all those hand-cuffing techniques, all forms that remained in his memory. Reverting to what is simple and true, he combined audacity with his own thoughts and character. With every blow of his ax, chunks of wood broke off, together with bits of techniques and skills. By giving up form, he retained spirit and semblance.

For a keen artistic soul, Mother Nature is a teacher, who gives classes through student self-cultivation.

Although a willow tree dropping down along the edge of a ripply lake may appear merely standing there, it is a lesson it itself. Words are not needed to explain how a faint breeze touching the tree of soft branches sketches awe-inspiring arcs in the air. Words are not needed. And if someone inspired by such beauty were to write a poem, compose a song or paint a picture, that would be learning from Nature. His heart would be filled with instructions flowing freely from heaven and earth.

For Ju Ming, something as simple as the rain has an indescribable hidden message. "Every time it rains, I like to sit by the window to enjoy it." He finds delight in the pitter-patter of raindrops bouncing off roof shingles. He liked the silvery brightness of the sky decked with raindrops. It is Nature in creation – such surging power so torrential the momentum! "How beautiful the rain is. It would take countless men to create such rain, such a beautiful scene."

"Once I let myself go, everything I create is an expression of my personality: a hen laying an egg would never worry that she'd lay a duck egg. That's because the formation of an egg is like a chemical factory process. All the physiological condition, cell division, genetic engineering and others are preparatory to the formation of a chicken egg. The same can be said of an artist. When all the conditions of cultivation are met, he can pick up a brush or a blade; there's no need to give it much thought because creation has always been there. Like the laying of an egg, it requires no consideration. It's so natural one cannot reject it."

Translated by Carlos G. TEE 鄭永康

The Artist's Ten Commandments

Artistic cultivation may sound abstract but can actually be practiced in life. Ju Ming has blazed a trail and follows it one step at a time. Below are ten principles to follow along the trail, and each of them is a precious principle that leads the follower to artistic creativity.

1 Planting artistic seeds in life

The concept of "seed" is the core of Ju Ming's philosophy. A seed may be small, but it contains the totality of all areas of a life and the beginning of everything.

The same is true for artistic creation. Ju Ming once wrote, "You can't mark down one idea at a time or learn to do one thing at a time. You have to plant an artistic seed in your heart. When the seed begins to sprout, art takes over your entire self; that is, art controls your every move, and you are completely transformed. Your every movement is artistic as you break down the confinement

Taichi Series 太極系列　1996、1998　Stone　142×85×140cm (Left)　110×96×145cm (Right)

of worldly concerns. You can do everything at ease now that you are no longer limited by raw materials. And you will be endlessly creative. Artistic cultivation is the only way to get your artistic seed to sprout."

Ju Ming has emphasized that when an artistic seed begins to sprout, an artist's creative works, regardless of the materials he chooses to use and regardless of the subject he chooses to present, will be enveloped by the unique nature of the seed.

2 Distinguishing art from skill

The works of certain individuals can only be deemed skillful rather than artistic if they believe it is sufficient that details alone give their sculptures a beautiful appearance. This is a misconception. When a sculptured work is overly done, it shows nothing but triteness, whereas when it's lacking in finish, it fails to fully express its spirit. It is not easy to reach the precise point of completing a work of art. But it is necessary to reach it to distinguish artistry from craftsmanship and grasp the true essence of art instead of being limited by skill.

Taichi Series 太極系列 1997 Bronze 460×221×212cm

3 Living for challenges

Ju Ming works in the media of wood, porcelain, stainless steel, and sponge. He reflects thus on this versatility: "During the process of artistic cultivation, one has to remind oneself of the need of continuous creation, of not ever giving in to complacency so as to be able to make consistent progress. If I had limited myself to wood carving, I would not have given myself the chance to enter the world of porcelain, the world of stainless steel, and the world of sponges. I would never have seen these media as part of my life. If I hadn't used my hands to feel their texture, all of these worlds would have passed me by."

"When I reached a point of excellence in woodcarving, I no longer was compelled to do it. If I do continue to work with wood, it is merely as a source of income. It became meaningless to me as a creative artist. More importantly, I move on to a new material and embark on a new journey to look for new answers."

Ju Ming insists that artists must have the spirit of challenging themselves. "Challenging yourself is to look for subjects you have never undertaken, to connect disparate things existing between heaven and earth and present their touching relationship to the world using different materials, different tools, and different procedures...These previously unknown experiences enter your existence through feeling, seeing, and touching and bring to you fresh creative resources. Thus, the more experiences you accumulate, the more wisdom you will attain; your thinking and judgment will be more precise and your creative energy will be replenished.

4 Living with focus

In Ju Ming's idea, the concept of "purity" encompasses every aspect of life and every aspect of the creative process. It is as clear as the night sky after a rain shower, free of blemishes. If your heart is covered with clouds or mist, you certainly cannot see the moonlight inside yourself.

He firmly believes that the life mission of an artist is endless creativity. Nothing else matters. Through artistic cultivation, the artist clears away life's unavoidable chaos and clutter. "My life is really filled with so many worries and concerns, but, that's all right."

All obsessions crumple down like high walls, and your heart becomes so clear and free of impurities. Only then is it possible for pure light to emanate inside you as the brightly shining moon rising in the boundless sky of creativity.

5 Living in truth, goodness, and beauty

Ju Ming has always believed that an artist can only appreciate "beauty" after he truly comprehends the importance and nature of "truth" and "goodness." "What is truth? Truth means a person has to find his own true nature, face what he does and live within his true self, treat others with sincerity and honesty, discover his calling and do what he needs to do. Goodness means

getting along with others and treating them with kindness. When you are in a buoyant mood, your creativity naturally surges. When you are able to discover truth and goodness, you can create without any hindrance to produce works of beauty, and you will certainly enjoy a life of beauty.

"Most people look at works of art without noticing the artist. This is not right. The artist's character is vital. Works of art come from an individual's character. If a person lives outside truth and goodness, how can he present anything of beauty? In aesthetics, it is highly unlikely for a person lacking moral virtue to become a great artist since his creations are merely superficial bereft of essence. Any conscious artist must have such self-awareness."

6 Living in tune with an artistic mission

"Innovation brings more space for creation. An example can be seen in the history of Modern Western Art: Matisse influenced Duchamp, Duchamp influenced Dada, and Dada influenced Pop Art. The value of a school of art lies in its influence on those who come later. Innovation brings

Living World Series-Painted Wood 人間系列－彩繪木雕 1981 Wood 7011×4667cm

new associations, and sparks appear one after another just as a new creative space is developed one after another." Ju Ming believes that this is the nature of an artistic mission.

"The world keeps changing. Don't think that a window pane stays the same: it changes by the minute, though in very subtle ways. Only after 20 years have passed can one see any obvious difference: it has lost its previous smoothness. On a scale as vast as the universe, or as small as a window pane, change is prevalent and continuous. Nothing in the universe is static. For art, therefore, constant innovation is a necessary principle. New ideas come with change over time."

"I don't think that an artist necessarily has to possess carving skills or know how to paint. Most important is his ideas. He has to make use of new ideas to release himself from the confinement of old ways of thinking. Unlimited release leads to unlimited discovery."

"An 'old' thing becomes a topic for researchers. But an artist's responsibility lies in the 'new.' If a contemporary person learns to paint like Tang Bo-hu 唐伯虎 from the Ming Dynasty, he is merely 'copying,' not creating."

What Ju Ming emphasizes here is that artistic creation is a record of reality. Only those who live in the present can record the present. "I am the product of this era. I understand and most

Living World Series-Painted Wood 人間系列－彩繪木雕　1996　Wood　479×72×129cm

strongly feel what is current and on-going. So it stands to reason that I create works based on my understanding of and feelings for the real world to express the spirit of the era."

Ju Ming has the courage to innovate: "It is reasonable that people find it difficult to accept what is new right away. But as long as you know what you're doing, it's fine."

7 Living in the moment with an open mind

Each day when Ju Ming sits down in his studio and picks up materials, he starts working on a creative project without giving it much thought. "When I was working on the *Living World* Series and was tying up sponges, for example, my mind was blank. I didn't anticipate what shapes would appear from the tying. If I tied a sponge tightly, it would become a slender young lady. If I tied it loosely, it would become a plump middle-aged woman. This is what I mean by letting nature take its course, what I mean by keeping an open mind."

"Certainly people may think differently. They might think the works are merely accidental effects of this kind of method and are consequently of no value. But don't forget that such 'accidents' are shaped by the creator with his hands. The instinctive choice of the artist appears to be a simple

movement, but it is the doing of his cumulative aesthetic cultivation, his sensuous instinct, his creative force, and his artistic view. Such creativity is not something you can pick up from along the roadside; rather it is a product of the artist shaped by his style and his nature, making it the only one of its kind in the world. Therefore, it is endowed with precious inherent value."

For the creative artist, a spontaneous chance product is not a carelessly twisting roadblock, but a profound reflection of his aesthetic instinct.

An open mind thus serves to create new sources of artistic creation... You can only attain insight into the true essence of things with an open mind.

Living World Series 人間系列 1987 Bronze 90×195×220cm

Living World Series 人間系列 1999 Stainless Steel 62×78×120cm

8 Living with the spirit of letting go

"When you're obsessed with something that you possess, you become trapped by it." This is Ju Ming's warning to himself.

The first major "letting go" of Ju Ming was when he let go of his *Nativist* Series, which had brought him great fame in a rush. The objections of many well-intentioned individuals notwithstanding, he let go of the *Nativist* Series and reached a new interior high point by entering a new artistic phase, the *Taichi* Series.

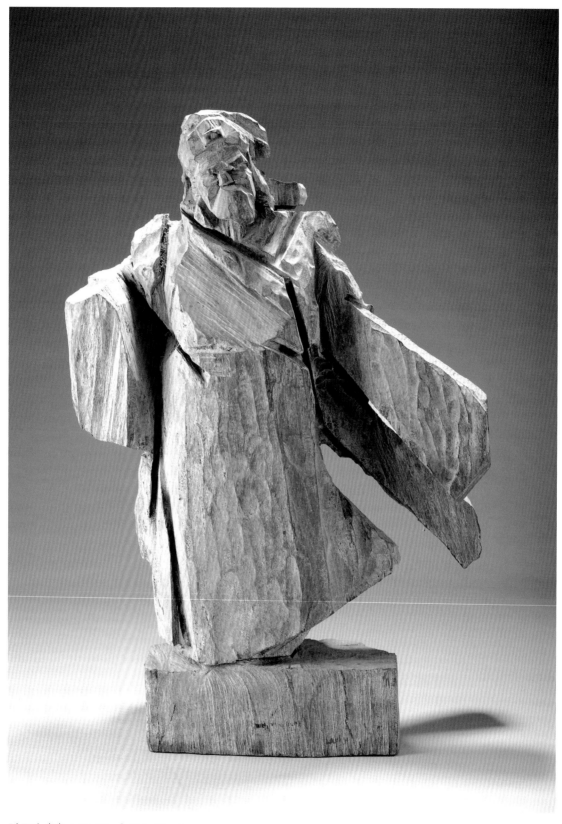

Li Bai 李白　1982　Wood　27.3×25×73cm

"I feel that the concern for profit is most harmful to the artistic life. But it takes so much courage and sacrifice to leave it behind…This, however, is a necessary step for the artist to embark on a new journey."

Letting go does not mean feeling lost or becoming deficient. Ju Ming explains, "The process of life is like the process of learning. When you reach a goal, you may gain both visible and invisible achievements. Visible achievement is confinement and trouble, but invisible achievement is wisdom and strength. When one knows enough to throw away the trouble and retain the wisdom, one reaches the moment of fulfillment."

Fulfillment for an artist certainly does not lie in financial profit or complacency with his creations. There's no limit to creativity. When one reaches a goal, one has to "break through." More goals are reached followed by more breakthroughs and more new beginnings. It is like the constant waxing and waning of the moon. After it wanes, the moon gradually waxes, and each cycle is a new demonstration. So every newly waxing moon is called a crescent. Natural creation is endless fulfillment, just as artistic creation appears in different degrees of light.

Endless changing comes with the spirit of letting go.

9 Living by immersing oneself in art

"You can lead a horse to water, but you can't force it to drink." This is a most proper description of Ju Ming and his disciples. He does not ask his students to keep on carving or painting. He does not order textbooks for his students to keep studying or memorizing from them. "Why don't I teach them in such ways? Because this would only do them harm!"

He exercises an invisible, formative influence on his students by his own example. He is like an artistic vat used for dyeing in which his students immerse themselves in the wisdom of life, thereby taking on the artistic attitude, creative force, bearings, and radiance of the master. The students soak in the waters of this mixture, bathe wholeheartedly and absorb freely, and through this they learn what to accept and what to reject and complete their transformation with the circulation of the elixir. In the end, every part of their lives has become translucent and radiant with its own nourished fragrance.

10 Living mentally transformed

This is the final stage of fulfillment based on the ten principles of Ju Ming's artistic cultivation. "This is the core of all of the principles. All structures and details are pre-determined and proceed to fulfill the goal of mental transformation."

Ju Ming emphasizes that you should live in a state of constant mental transformation; that is, you need to keep your mind active and alive. An artist has to remind himself to be constantly engaged with art to avoid getting sidetracked from devotion to the principles of cultivation and

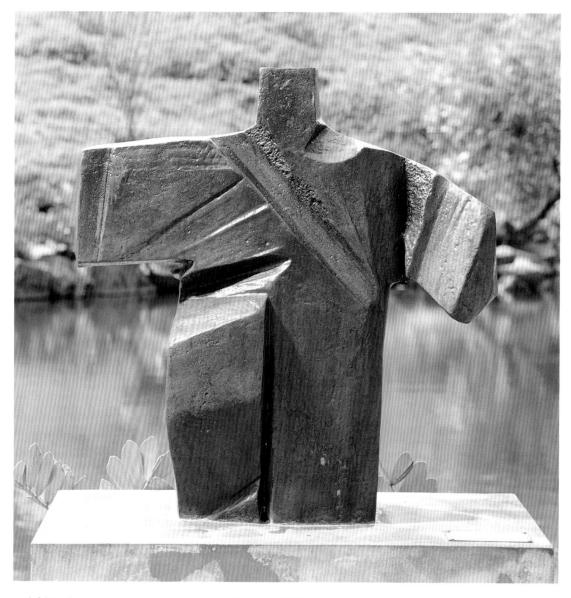

Taichi Series-Preparation for Underarm Strike 太極系列－十字手 1993 Bronze 77×36×82cm

to revert to the old learning model, and to often reflect and discern if he has truly planted the artistic seed in his life, if he can tell the difference between art and skill, if he constantly challenges himself, if he lives a focused life, if he lives in accord with truth, goodness, and beauty.

Each and every principle aims to turn over a new leaf in life. Cultivating the principles creates a new force to clarify the polluted waters of one's heart and turns them into a flowing spring.

With water flowing outside and the spring surging inside, the creative wellspring will never go dry but instead will draw upon the ceaseless circulation of each. "Calling back one's self" is the

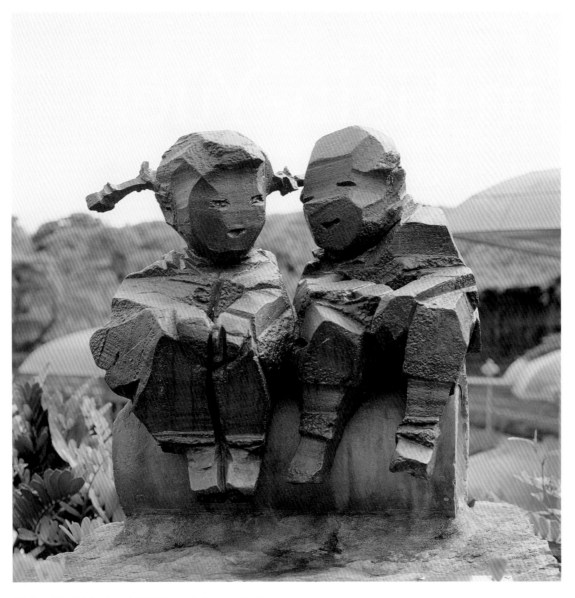

Living World Series 人間系列 1996 Bronze 88×60×92cm

final task of this transformation project. Ju Ming says, "The solace of every creative artist lies in the fact that he is a distinctive individual."

Translated by Yauling HSIEH 謝瑤玲 and Joel J. JANICKI 葉卓爾

* Excerpted from *Zhonghuo Yishu de Zhongzi—Zhu Ming Meixue Guan* 《種活藝術的種子──朱銘美學觀》 [Ju Ming on Art] by Pan Hsuan, Taipei: Commonwealth Publishing Co. (天下遠見出版公司), 1999.

Lin Hsin-Yueh

Lin Hsin-Yueh's Focus on the Motherland

林惺嶽畫作的
母土凝望

Chao-yi TSAI 蔡昭儀

Mountain Valley 山谷 1991 Oil on Canvas 129.5×193.5cm

林惺嶽 (1939-)
Lin Hsin-Yueh (also Lin Xing-Yue)

Born in Taichung, Taiwan, Lin Hsin-Yueh is one of the important contemporary Taiwanese painters showing a particular interest in exploring Taiwan's natural terrain. By visiting the high mountains and valleys, Lin creates magical landscapes with abundant originality displaying both the emotions of the individual and the land.

After graduating from National Taiwan Normal University's Fine Arts Department, Lin gravitated towards European paintings techniques. His early painting style tended to be mysterious and surreal, gradually returning to figurative expression. His works are massive and realistic.

Apart from painting, Lin has also been engaged in art education, writing cultural commentary and art history. He has presented unique insights on many important events in Taiwan and profoundly influenced various stages of Taiwan's modern art movement. Lin Hsing-Yueh is the author of *The History of Chinese Oil Painting* and *40 Years of Taiwan's Fine Arts*.

Of Lin Hsin-Yueh's spectacularly large body of works, *Returning Home*, created in 1998, occupies a rather important status among his paintings. *Returning Home* takes as its subject matter the tens of thousands of salmon that retrace hundreds upon hundreds of miles from the sea returning to their place of birth in Canada's Adams River. Then it uses this as allegory for the many dissidents residing abroad, who were not afraid to face the risk of imprisonment and follow their heart's path, and bravely return home to make a contribution, both before and after the lifting of martial law in Taiwan.

Being that "returning home" is the main theme of this painting, at the same time, it also implicitly carries the

expanded metaphor of identifying oneself with the land and tracing back through history to seek out the significance of returning home.

According to Lin, the route of "returning home" is an explorative journey to follow our spiritual instincts. Lin's intense passion towards the motherland has obviously profoundly affected his orientation and his method for emotional expression, and it is also the underlying structure of his development of thematic exposition and awareness of issues.

Lin's "Enchanting Taiwan," a straightforward theme full of cultural nuance, is how he christened his fifty-year creative career, and this not only makes the rich and fertile existence of his native land more prominent, it is also simultaneously depositing a necessary renewed historical introspection and the requirements for a deeper understanding of the island's life essence.

It can be said that the twentieth century of Taiwan's long river of history was the hundred

years of the most undulating, unpredictable changes. Lin Hsin-Yueh was born, grew up, and evolved in this century. His artistic life reflects the variations of Taiwan's historical wounds and the vestiges of its evolutionary scars. Lin was born in 1939 when Taiwan was still under Japanese colonial rule. Before he was born, his father, sculptor Lin Kun-ming, had already met a youthful demise due to suffering from typhoid. Moreover, his mother also contracted malaria and thus suddenly passed away when Lin was five years old. In 1945 Taiwan was liberated from Japan and in 1949 martial law was imposed, followed by the period of White Terror. This was Lin's first taste of reality and all its aspects—a period of arduous growth full of lonesomeness.

In 1965, after graduating from the Department of Fine Arts at National Taiwan Normal University, Lin started to develop a surrealist style that he built from a mysterious atmosphere. His artworks were poetic wastelands fully flavored with dejection, depression, and desolation. In 1975, he decided to visit Spain to travel and paint. This far journey of deliberate intent was his

All Quiet 寧靜的山谷 2009 Oil on Canvas
210×420cm

independent life choice to lead a wandering existence and it actually made it possible for him to step out of his former boundaries and into the larger world. He personally experienced the surge of popular feeling during the process of Spain's democratization following the death of the dictator Francisco Franco. And this provided him with no small amount of stimulation and enlightenment, motivating him to carry out examination and reflection directed towards Taiwan's historical past, its present, and future.

In 1978, he went to Spain to arrange an exhibition for a contemporary art exchange. During the return home, he rode a Korean Air flight which accidentally entered Russian air space and they were forced to land. Upon returning from this adventure, where his life hung in the balance, Lin began to use audacious and incisive brushstrokes that were unbridled and without limits. In the realm of art commentary, he devoted himself to establishing a native perspective which was both reflective and critical. His path of creating oil paintings also began in the first part of 1980. He gradually transitioned from the fantasy land of surrealism to a new subject matter of realist Taiwan landscapes. In the second half of 1980, he also started to present Taiwan's cascading vitality by rendering majestic mountains and rivers, waterfalls, and wild streams on large-size canvases.

Lin's surrealist artwork basically spanned from 1960 through the beginning of 1980. His creative technique was influenced by the mind-opening frottage ("rubbing") method of Max Ernst, the German surrealist. Even though he used his imagination to delve into an enigmatic world and

River Valley 溪谷 2005 Oil on Canvas 130×194cm

ing Home 歸鄉 1998
anvas 210×419cm

Spectacular Mountains 橫臥大地 1998 Oil on Canvas 210×419cm

he utilized the vision of the dream to liberate reality, the methods Lin used to form his artworks were interpretations produced by rational thought processes. Additionally, he especially strived at building a space for tranquil contemplation which is made possible by the artist himself in his painting workspace.

The surrealist concepts along Lin's chosen path grasp onto that "autonomous freedom of choice" and are also an extremely important foreshadowing of his future creative will. This style not only enables the painter to seek a permanent hope in the realm of fantasy because there's virtually nothing else to depend on, but also gives one the means to adopt a posture of resistance when facing the popular atmosphere of the art world and the current political, social environment.

In 1949 after the national government moved from the mainland to Taiwan, the great Chinese tradition of ink wash painting took center stage. Being within the existing historical structure of the Cold War, Taiwan became a strategic American military stronghold in the Pacific for resistance against the Soviet Union. In this culture of American aid the contemporary transplant of "Modernism" from the West popularized the concept and discussion of "merging east and west." Under the promotion of The Eastern Painting Group (1956-1971), The Fifth Moon Painting Society (1957-1972), and other various art circles the "abstract" painting form of expression was marked as possessing the most representative form of an avant-garde philosophy by art circles of that time.

A Winter Stage 冬祭的舞台　1973　Oil on Canvas　130x194cm

Broken Dreamscape on the Shore 海邊殘夢　1972　Oil on Canvas　89.4×130.3cm

The young Lin couldn't accept the trend towards empty formalism in paintings and he believed that the appreciation and popularity of abstract aesthetics was the result of official management. And given that the surrealist style contains the characteristics of breaking down realism, not binding space and time, and directly exploring the imaginative world and spiritual instincts, this allowed him to freely pastiche a concept of realism and find a way out for his life through a kind of absolutely personal artistic language. Besides that, he adopted an independent posture towards this capricious world and the authoritative power that, in fact, brought about his lonely lot in life. At this stage, you could already get an inkling of Lin's creative insistence of non-conformity and self-established style.

In the period following the year 2000, Lin traced the sources of surrealist painting again and also used his own thinking on the complexities of Taiwan's history to create a large-scale structure in the style of an epic poem. *In Specter in the Dead Forest* (2006), *The Silent Heavens* (2007), and other various works, there is still a feeling of desolation and loneliness and yet, having passed through the settling and understanding born of his experience, the desolation and loneliness in

Quiet Valley 清境幽谷 2014 Oil on Canvas 182×227cm

the paintings morph into that unique perspective by which Lin views his own soul and the spirit of Taiwanese culture. Furthermore, they emit a strong life energy in the midst of the silence. During his painting career, Lin's surrealist style appears and reappears several times. In fact, this is the deliberate choice especially applied from the artist's heart of craftsmanship and it isn't due to the randomness of beauty nor the mournful solitude of loneliness.

Regarding the experiences of youth, memory and nature, these things thread together several important factors of meaning found in Lin's creations. Of course, according to him, they are the fond memories from years of growing and therefore make up the earliest subject matter in his art. In early 1980, surrealism started to fade as a subject and the signs that revealed the transformation of his painting style—whether at the level of theme, grandeur, or perspective—his observations of Taiwan's natural scenery began to appear in large measures in his oil paintings.

In 1985, with the help of friends he entered Yu-shan National Park, waded into the Zhuoshui River and from his frame of view as an actual visitor he underwent a stunning and moving experience brought about from the imposing natural landscape. This guided him to return to the scenes of his motherland—with its myriad of natural changes—to work on new creative explorations. In 1986, he completed *Tribe at the Riverside*, *Zhuoshui River*, *Solitude*, and other

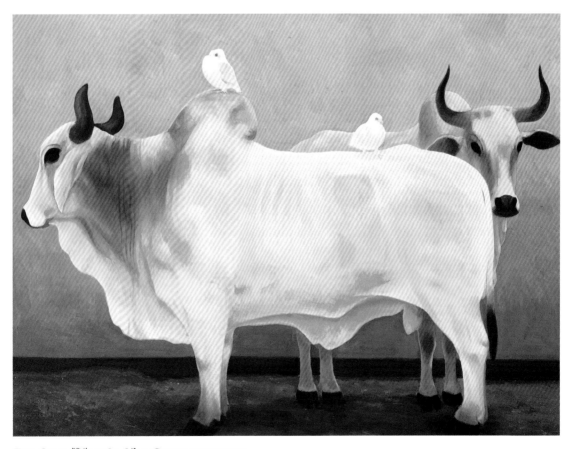

Two Oxen 雙牛 1982 Oil on Canvas 97×130.3cm

pieces with the Zhuoshui riverbank pebbles as the main characters. These works bring together the conditions of magical realism within realism and surrealism, revealing that even though Lin summons an imaginative native land through natural images, at the same time he attempts to summon a utopian world untainted by the dust and grime of reality.

In 1988, Lin, with plan in hand, visited Taiwan's northern coast, went deep into Yu-shan National Park once again, and even went into Taitung's Xiuguluan River basin to make a record and take pictures. The tour this time gave him a deep impression of the vitality contained in the land of Taiwan. Likewise, this sparked his change from contemplative scenes in the style of magical realism to realistic portrayals of the high mountains and wild streams of his native land. He replaced the melancholic and reserved static portrayals of the past with the vibrant and dynamic paintings of Taiwan's scenery. The Lin Hsin-Yueh of this time began to depict realism while standing squarely in a realistic world. He used brand new eyes to once again probe the meaning of "native soil." The abundant energy contained within natural landscape became the signifier of his exploration of where he belonged and the definition of Taiwan's vitality. Additionally, he created *Turtle Island*, *Northeast Coast*, *Zhuoshui River*, and other huge oil paintings.

Lin's creative turn echoed the Taiwan that had been changed by the wheel of time and it

White Horses in Dreams 夢境中的白馬 1986 Oil on Canvas 130×194cm

Alone in the Lake 湖中孤客　2015　Oil on Canvas　182×227cm

simultaneously possessed an inseparably chained relationship with his ideas regarding "concern for our native land" that started in 1970. In 1987, after the lifting of martial law, Taiwan went through large-scale, rapid political and social transformations. The nation and the subjective consciousness of Taiwan as an entity separate from China became the focus of cultural debates. Culture and society started to take native experience as being the path to rebuilding this subjective consciousness and the spiritual mind. In addition to the explorations of many artists putting the pieces together again and offering reinterpretations about the personal experience of growing up in Taiwan, the various cultural recollections from these life experiences and the contemporary societal phenomena of the era also became the accepted creative targets for those people identifying as artists. And Lin was undoubtedly an important pioneer here. Following the lifting of martial law, he used a figurative method to depict Taiwan's landscape so as to present concretely that which appeared to be disorder, but which in fact was a very active vitality.

Lin also used a new angle to demonstrate the spiritual properties of the motherland. He borrowed the scenery of a pure and endlessly surging waterfall in New Zealand to paint *Gushing*

Papaya Tree in the Sun 逆光色感律動中的木瓜樹 2015 Oil on Canvas 182.2×221.2cm

Waves (1994) and used the salmon of Canada's Adams River as the subject matter to render the stirring yet arduous road of *Returning Home*. This painting allegorizes the journey of the heart of those exiled dissenters who take the risk of returning to Taiwan to make a contribution. He shares a parable through this scenery and he evidently posits the hope that Taiwan can become a pure "land of dreams" that allows one's soul to comfortably return home.

Taiwan's nature and culture in Lin's works, without exception, are not painted based on what is actually witnessed with your eyes, but instead they are his selective receptions, duplications, and reproductions of the actual scene. He takes natural scenery as his subject matter, but doesn't merely render natural scenery. What is truly awe-inspiring in his art is the rich and varied culture and his passion for the motherland.

Following a shift in his frame of mind in 2000, Lin started to specifically create portraits of people, painting something he had rarely presented in the past. This kind of attention towards "people" seemed to be implying a return to the setting of real life from the realm of dreams. He used close relatives, friends, and students as the main characters and created *Tung Blossom*

Glory of the Giant Trees 台灣神木林的風雲歲月 2012 Oil on Canvas 334×654cm

Valley Recluse 幽谷居士 2012 Oil on Canvas 260×420cm

Season (2007) and other works. After 2000 these human figures inconspicuously became the most important vehicle for interpreting the elements of Taiwan life and the local circumstances of the people.

He also painted several works with the subject matter of fruits primary to Taiwan such as the wax apple, papaya, and others. After 2003 a series of works about papaya comprised his alternative interpretation of Taiwan's persistent yet ample vitality. But Lin's were not "beautiful" or "perfect" papayas, rather ones with dried dying leaves and young green branches were lain out together, the thriving and the decaying placed side by side in a primitive style. His enigmatic code for life resides in this unpolished positioning, a positioning containing both a persistent primitiveness and a lofty grace.

In addition to the three creative tracks of nature, people, and fruit trees, Lin once again returned to surrealism using a more expansive view to carry out inspection and reflection of his own memories and his country's history. *Specter in the Dead Forest* (2006) and *The Silent Heavens* (2007) both trigger memories of historical scars as if he is urging himself and reminding others to not forget the painful imprints on Taiwan's history. However, behind the heavy and unyielding images, he is also exhibiting the experience of seasoned maturity and confidence. The pursuit of "returning to one's native home" is still layered deep within his works, but the original conflict in the paintings has dissipated. Having passed through a realistic reflection and the consciousness of self-determination, Lin follows "the instinct of returning home," little by little overcoming layer after layer of dense fog, forging towards an undisturbed dwelling for the heart.

Along with changing his gaze and adjusting his field of view, Lin's artworks hastened towards stability and became more restrained internally, revealing a penetrating perception of life having undergone the pure experiences of living.

A kind of reconciliation and reverent consideration are exhibited in Lin's majestically structured panorama, *Formosan Landlocked Salmon: A World Legend Taking Place in Taiwan* (2011). Over a hundred Taiwanese salmon swim carefree in the gleaming crystalline water, the clear stream brimming with thousands of stones as they enjoy the sunlight's merciful touch and its life-giving gentle caress. In *Returning Home* there is a will and energy of fervent intensity for home and of striving to overcome adversity. In this picture, it transforms into the mood of falling leaves coming back to their roots never to wander again.

The longing to "return home," the place our heart seeks to inhabit, is what has motivated Lin's life code of unflagging creation. He was born with this code and it was activated through the growth of hardship, and these difficult experiences converge as a tenacious will of the spirit, leading him to advance along the road which seeks spiritual conversion. This turn for the better within his creative works proves the "instinct for returning home," showing us how the interaction between individual thinking and contemporary realism becomes the absolute kinetic energy of artistic creation.

Tung Blossom Season 桐花季 2007 Oil on Canvas 145.5×112cm

The Silent Heavens 寂靜的穹蒼 2007 Oil on Canvas 197×333.3cm

The understanding and interpretation of Taiwan's native enchantment as concealed in Lin's paintings cannot be realized by empirically pursuing his travel destinations or the appearance of the spatial geography, but rather they are realized by concentrating on the layers of meaning in the production and process of the work. Natural scenery is the place where his trail to develop an exposition on Taiwan's enchantment is revealed, but only by deeply understanding how he shuttles between the countless shifting variations and overlapping layers of realism and surrealism can you truly catch the most secluded, yet the most critically conscious and creative philosophies of his painting life.

His creativity is not entirely about putting a new form into the stylistic presentation of his paintings. Lin Hsin-Yueh's sensitivity and distinction are found in the subject material of local nature and culture. He tosses out an essay question for us about determining the main subject of his work: "Wherein lies the enchantment of Taiwan's local nature and culture?" Lin offers us no solution but rather an approach to the exploration and confrontation of his personal history.

Translated by Sterling SWALLOW 師德霖

* Excerpted from *Yishushoucang + Sheji*《藝術收藏 + 設計》(*ART COLLECTION + DESIGN*), February 2013, 28~45.

Lee Yih-Hong

Pioneer Ink Wash Painter
in Postwar Taiwan

臺灣戰後水墨的拓荒者　李義弘

WU Chitao 吳繼濤

Tiaoshi Coast No. 2 (Detail) 礁石海岸 II（局部）．2014．Ink and Color．142×77cm

李義弘 (1941-)

Lee Yih-Hong (also Li Yi-Hong)

Born in Tainan, Taiwan, Lee Yih-Hong graduated from the National Academy of Arts. He has long been committed to integrating traditional techniques and creating new ideas for ink-and-wash painting in Taiwan.

Lee Yih-Hong records nature through photography, painting, and calligraphy. He also introduced a new technique into the field of photography by combining photography with fresh ink, adding images with precise levels to make the work look peculiar and innovative. His paintings of rural southern Taiwan established his fame. In recent years, his landscape works have focused on fusing the mountains, light, clouds, etc., into a harmonious texture. His composition tends to be simple, and the images are more minimalistic. He is the winner of the Zhongshan Literature Award and Wu San-lien Arts Award.

Lee Yih-Hong was born in 1941 in southern Taiwan. He didn't receive much in the way of formal schooling, but since he was a rather weak and sickly boy from early on, frequent visits to the local Chinese pharmacy soon became a staple of his life. Watching the ancient doctor-cum-apothecary write out prescriptions with an old, dilapidated writing brush in a spidery hand (while feeling his patients' pulse with the other) was enough to wake the youngster's interest in calligraphy and drawing, and it was his budding zeal and passion for the arts that paved the way for his later career as a painter. After gaining acceptance into the National Academy of Arts (now National Taiwan University of Arts), he learned the ropes from widely respected teachers and artists such as Fu Juanfu 傅狷夫 and Gao Yifeng 高一峰 .

The winds of change and modernization were blowing through Taiwan's ink wash circles by the time Lee Yih-Hong graduated, and it was more or less by chance that he found a sympathetic teacher and mentor in Jiang Zhaoshen 江兆申 , at the time deputy director of the National Palace Museum in charge of the books and paintings department. Their affiliation and friendship would last for 27 years, from 1970 until Jiang's death, and the older man's influence, both in terms of ink wash skills and literati aesthetics, helped Lee to define his own creative position and artistic approach. Incorporating both tradition and innovation into his modus operandi, the young artist soon began to make photography an important element of his creative process, using it to sample useful themes and motifs for his

Coral Stones of Xiziwan 西子灣咾咕石　2017　Ink on Glossy Golden Paper　99.3×144.3cm

art. This is particularly obvious in his early work, and after ten years of honing his individual style he held his first solo exhibition at the Spring Gallery in Taipei, which made a big splash in the ink wash community. The following year Lee received further recognition in the form of the Sun Yat-sen Art and Literature Award, and in 1984 he was offered a position at the National Institute of the Arts (now Taipei National University of the Arts), where he taught painting until his retirement in 2007.

Traveler and Photographer

Local motifs have always been one of Lee's main sources of inspiration for his work. The sights, scenes, and landscapes of our island, in particular its natural scenery, are captured by the artist's brush with a style and authenticity that are rooted in a deep sense of aesthetic harmony. This was something he largely developed under the aegis of Jiang Zhaoshen, the abovementioned deputy director and one of the curators of the National Palace Museum, a man that aided Lee in making sense of the things he saw, heard, and experienced, and was a formative influence on his use of lines and color, as well as his succinct and focused style. The other crucial component in Lee's unique creative mélange is his professional-level skill with a camera, the fact that he made the viewfinder one of his chief tools. During the 1980s, works such as *Tainan Confucius Temple* with its poignant red walls and ancient trees, or *White Clouds in a Blue Sky* with its deliberately

Rocks in the Sun
帶著陽光的石頭
2015 Ink on Glossy
Golden Paper
189×96cm

concise chunks of color, were like a breath of fresh air, opening up new possibilities for a long-established art form.

In 1986, Lee Yih-Hong traveled to India and Nepal. Upon his return, he held an exhibition titled *Journeys in Northern India*, and works like *Ancient Mountain Town*, *Old Temple High in the Mountains*, *Bodhisattva*, and *Dal Lake* all speak of the artist's fascination with the Buddhist tradition, as well as showing the profound impact the foreign vistas had on his imagination. Here we find a focus and spirituality that transcends the limitations of conventional Chinese landscape painting. Two years later, he released a series of paintings titled *Song of Trees*. Some of these works have a stark, almost forbidding quality, such as *Old Buddy* and *Verdant Vibrancy*, while others, including *Field Tree*, are brimming with bucolic nostalgia. Another work from the same year, *Eerie Autumn Yard*, also displays the thematic originality and multi-layered textures that established Lee as one of the most important ink wash artists of his generation.

Since times immemorial, traveling and observing the world around have been mandatory

Tiaoshi Coast 跳石海岸 2013 Ink and Color, Canvas, Kyoto Mulberry Bark Paper 210×600cm

for visual artists wishing to find fresh ideas. By visiting different places, taking photos of his environment, and sketching from life, Lee Yih-Hong managed to gain a deeper understanding of the nuanced and intricate relationship between natural scenery and the mood of a painting, between reality and composition. In the prime of his life, Lee published *Nature and Painting*, in which he attempted to merge the media of photography and ink wash painting into a unified concept. The publication had a huge impact on students of drawing and sketching at the time, and it continues to influence the discourse on artistic representations of the world to this day. Meanwhile, Lee's travels to Europe, India, Nepal, South Africa, and China, among other places, further nourished and fertilized his imagination, enriching his mental vision and enhancing the breadth of his artistic scope, especially with regard to the sheer magnificence and beauty of the natural world. Around 2001, having reached the ripe age of 60, Lee began to communicate his travel experiences via a series of scroll paintings, such as *Realms and Rivers*, *Pines on Huangshan*, and *Yuliao Guandu*, guiding the audience's view from the near to the far, and offering oscillating perspectives of subtly entwined actuality and illusion, object and reflection. In this way, he updated

the conventional content and form of traditional ink wash painting, imbuing the genre with new meaning and complexity through innovative modes of expression. This period in the artist's life was marked by a growing focus on his living environment, something that went hand in hand with a decade-long period of introspection in Sanzhi, an area at the northwestern tip of Taiwan. His mature and increasingly sublime style is a reflection of his ever-deepening love for his native soil, nothing short of an attempt to capture the soul of the land.

Tiaoshi Coast No.2 跳石海岸 II 2014 Ink and Colors 140×77cm

Exploring Artistic Imagery

During this period, Lee started to deliberately emphasize local scenes and motifs. Aware of his growing attachment to the rugged northern coastline, he shifted his focus away from compositional refinement towards almost scrupulous attention to his actual surroundings. Five paintings with Balian Creek as their overarching theme also serve as a kind of testimonial about his experiences working with jiaobai bamboo paper, a special kind of rough-textured paper made in Puli's Guangxing Paper Mill. From 2002 onwards, Lee made ventifacts one of his main subject matter, employing a blend of black and color inks to depict the rugged coastline with its assorted windkanters and other types of interesting-looking terrain shaped by wind and water.

Tale of Stones No.3 石頭物語 III 2013 Ink on Paper 209.3×198.5cm

Letting the various tints and hues bleed into each other, and applying the traditional Chinese texturing technique called *cunfa* (the "wrinkle method" 皴法) the artist recreates the lines and silhouettes of rocks and sea in a fashion that is both realistic and impressionistic, underscoring his standing as a modern literati painter with a particularly deft and elegant style. Adding a new twist to the conventional *jimofa* (the "layer method" 積墨法), a technique that uses distinct shades of black and gray to convey nearness and distance in landscape paintings, Lee applied the same principle to colored ink for even more impressive and lifelike breadth and depth. As a whole, these compositions are held together by vigorous brushstrokes with a strong calligraphic quality. At 60, decades of practicing calligraphy had made Lee an expert at structuring his paintings' space

to perfection, while his sure, swift strokes render all vistas stunningly vivid, as can be witnessed in works such as *Linshanbi at Ebb Tide* or *Ventifacts at Shimen*. These paintings also laid the groundwork for later works, including for example the *Tiaoshi Coast* series. Lee Yih-Hong once said:

Our natural environment affords painters an endless amount of material that can inspire and provide them with nourishment for their creative minds. Take the huge boulders crashing from steep mountainsides, for example, only to crack up into smaller pieces that are slowly carried down rivers and creeks until they reach the plains. The flowing water shapes these rocks and stones into a myriad of forms, until their surfaces, ledges, and corners are often as smooth as glass, with no apparent lines, cracks, or other obvious traces of texture.

White Boulders of Liwu River 立霧溪的白石　2011　Ink and Color on Laizhou Bast Paper　103.5×103.5cm

Shimen Daylight 石門天光　2017　Ink on Laizhou Bast Paper　210×210cm

Lee elaborated in more detail when talking about the build and structure of rocks and boulders in the Balian Creek near Sanzhi:

When the creek's water levels are low, many rocks will be jutting out from the water and exposed to the sunlight, which reveals the mud and debris adhering to the boulders. . . . When the tide is going out, even the littoral rocks are glistening in grayish-white hues. Therefore, when painting seascapes, or more specifically coastal scenes, it is usually not necessary to use cunfa or other traditional techniques for depicting rough shapes and textures.

At this point in his career, Lee Yih-Hong was frequently traveling to Hualien, and on these trips he would take many photographs to serve as templates for paintings to be executed in fine

detail after his return. Particular favorites were scenes featuring the Liwu and Shakadang Rivers with their wealth of huge rocks and boulders strewn across riverbeds meandering through steep, majestic gorges. In many ways, Lee's output from this period is a thematic extension of his series of works picturing Taiwan's craggy northern shorelines with their assorted wind-and-water-faceted rocks. In works such as *White Boulders of Liwu River* and *Liwu River Gorge* the artist aims to capture the magnificent beauty of marble boulders with their veined and speckled texture, while *Sparkling Liwu River* and *Towering Cliffs by the Liwu River*, two oversize paintings, show the dramatic precipices and narrow ravines that make up the Taroko Gorge's most spectacular stretches, giving the viewer a vivid sense of the dazzling heights, striking depths, and at times almost overwhelming feeling of closeness and cool seclusion that are all part of the experience. The various inks are allowed to run and blend with each other to generate layers of sublime shades,

tints, and hues, all serving to create the almost three-dimensional quality and abstract aesthetic appeal that are two of the hallmarks of Lee's freehand imagery. In 2013, Lee painted a hexaptych titled *Tiaoshi Coast*, sort of a culmination of his artistic "craggy rock" journey that had taken him from sketching from life to more abstract modes of expression. The piece is teeming with the artist's passion for his subject matter, a fact that is visible in the delicately executed texture of the rocks, using traditional cunfa and chromatic shading for depth and a fascinating interplay of light and shadow, with the rocks and boulders appearing like contrasting reflections in an artistic photograph.

His bravura brushwork and consummate skill with lines and other calligraphic elements gave Lee the confidence to further expand his artistic scope in works such as *Acacia Grove* and *Cold Spring* with their succinct style and composition. In pieces like *Mount Jade Cypress* and

June Sunshine
六月豔陽 2010 Ink and Color on Kyoto Mulberry Bark Paper 46×93.2cm

Lotus Pond 荷塘 2014 Ink on Paper 67×33.5cm

Mount Jade Hemlock, basking in a kind of subdued golden glow, the astute observer may perceive the freshness of the artist's impressions from his ascent of Mount Jade, with cypresses vaguely visible in the thick mists, like coiled and twisted dragons perched ominously in front of a dark cave, and spots of bright verdancy in the distance showing here and there through the thick foliage of the immediate surroundings.

Form Born out of Travel and Play

A close look at Lee Yih-Hong's oeuvre reveals that "travel" and "play" are the basic concepts that inform his entire creative modus operandi. Without the inspiration derived from travel and photography, the artist might have found it very difficult to select his favorite motifs with such exquisite flair and intuition. "Travel" allowed the artist to enrich his imagination and fine-tune his sensitivity, while "play" was often the catalyst for new concepts, triggering a fermentation process that produced anything from whimsical ideas to output in different media, thus broadening Lee's range and reach. "The pursuit of an individual style is based on dissatisfaction with the stuff already in existence." For Lee, it is the lonely nights with no other sounds but the wind and rain outside, and the soft swishing of the brush across paper, when he has his best eureka moments, when his constant inner dialogue suddenly bears the most unexpected fruit. Inspirations born from such moments include a number of fairly abstract works that combine inkjet printing with ink and wash painting, such as *Huayan, Brilliant Days, The Joys*

Impulse 乘興 2009 Ink on Paper 34.2×34.5cm×2

of Shakadang River, Impulse, and *Lotus Pond*, but also works reminiscent of traditional *qinglü* landscape (青綠 landscape in blue and green) paintings such as *Clouds over Jishan Islet*, and even pictures of demon catcher Zhong Kui or little scroll paintings showing flowers or strangely shaped rocks. At the age of 70, Lee Yih-Hong seems to focus mainly on two types of paintings:

First, there are highly formalized compositions, such as polyptychs or pictures divided into squares of the exact same size. Very many of his works depicting rocks and reefs fall into this category, including *Tale of Stones, Era of Stones*, and *Tiaoshi Coast* series. There is clearly a connection to be drawn here with Lee's beloved pursuits of photography and design, as well as his dabblings with fashion photography and interest in popular icons over the years: all these have influenced his visual tastes and preferences, and contributed to his evolving artistic style. What early critics described as panoramic photography and divided composition are in fact creative methods that have gradually morphed into specific visual and aesthetic structures. In early works such as *Mountain Vistas* with its classical rendering of the Li River, or *Ebb and Flow Around the Fish Traps* with its waves beating on the rocky shore, we see a fine intermeshing of concrete and abstract compositional elements, arranged almost like pieces on a chessboard, but also much experimentation with brushwork, "dry strokes," lighter shades of ink, and running colors—all signs of things to come. By mixing up the formal and thematic sequential structure of traditional painting collections, Lee also manages to challenge our visual habits. He also loves to use the sharp contrast offered by the effective use of black and white, such as arranging dark rocks in white spaces, sprinkled across the composition like brilliant stars across the universe, widely scattered but ever so bright. Examples include *Tale of Stones No.3, Tale of Stones No.4*, and *Shimen at Low Tide*. Other pieces show dense clusters of shiny black gravel shimmering with faint reflections of light, such as *Era of Stones No.5* and *Shimen Daylight*.

Mount Jade Hemlock 玉山鐵杉 2012 Ink and Color on Kyoto Pear Bark Golden Paper 185×185cm

Then there is the *Golden Shores* series. These pictures are basically a variation on Lee's eternal motif of sea rocks, born out of his curiosity for new and changing vistas and driven by a range of creative approaches, from the collages that the artist first experimented with during his college years, or the splash color approach of his middle years, to the later incorporation of inkjet printing into his work. Since ink will not adhere to gold leaf, the artist used glue and acrylic mixed with mineral pigments, deftly applying them with vigorous brushstrokes to capture the shape and texture of reefs and sea rocks, as in *Washed by the Slow Tide* or *Rocks in the Sun*, with the shorelines stretching off into the distance. In *Crashing Breakers at Beiguan* we have waves splashing against rocks with an eruption of white spray, while *A Dialogue Between Coral Stones* and *Coral Stones of Xiziwan* focus on weirdly shaped individual rocks and cliffs. All in all, Lee Yih-Hong, always with his finger on the pulse of the times, never fails to surprise his audiences through constant innovation and the sheer diversity of his output.

Conclusion

In his book *Taiwan Fine Art Series 32: Lee Yih-Hong*, Hsiao Chong-ray 蕭瓊瑞 points out how Lee went through the whole gamut of ink wash development over the past century, from the Innovative School (or New Ink and Wash) via the New Literati School to the Modern School: "Taking the nativist approach as his starting point, Lee proceeded to master the subtleties of the literati tradition, and then amalgamated his emerging individual style with the best aspects of modern ink wash painting: experimentation with new media and compositional panache. It is fair to say that in both theory and practice, Lee represents the acme of contemporary ink and wash." Taking an even broader view, we can state that the modern manifestation of painting and calligraphy as exemplified by Pu Xinyu, Jiang Zhaoshen, and Lee Yih-Hong, represents the continuation of China's long-standing literati painting tradition in Taiwan, where it took root and brought forth new and beautiful blossoms. True, the literati school in its narrowly defined sense may have lost much of its immediate relevance in our day and age, yet even an artist like Lee Yih-Hong, who eventually strove to shake off the shackles of conventionalism, remains very much indebted to the principles of traditional landscape painting, which enabled him to shine even brighter as a star and pioneer of a new age, an era that continues to inject fresh meaning into time-honored aesthetic ideals.

Ventifacts at Shimen 石門風稜石 2009 Ink and Color on Kyoto Mulberry Bark Paper 187×96cm

Translated by David VAN DER PEET 范德培

Ho Huaishuo

Ho Huaishuo and the Artist's Affair with the Moon

流逝的月光
——永恆的美感

YEN Chuan-ying 顏娟英

Endless Flow 長河 1975 Ink and Color 58×92cm

何懷碩 (1941-)
Ho Huaishuo (also **He Huai-Shuo**)

Born in Guangdong, China, Ho Huaishuo studied at Hubei College. He came to Taiwan in 1962 and graduated from National Taiwan Normal University's Department of Fine Arts, and later obtained a Master of Arts from St. John's University in New York.

Ho Huaishuo is not only an important painter, but also a renowned art critic and prose writer. He has long been concerned with the modernization and future of Chinese painting, criticizing the cultural hegemony of Western modernism. Most of his paintings are ink-and-wash; they are dark and poignant but done with superb skill and never vulgar. Ho values brushwork and composition, and believes that uniqueness, cultural heritage, and reflection of the spirit of the era are the three essential elements for an artist. He himself is also a practitioner of his own philosophy.

The young drifter

Ho Huaishuo was born in 1941 in a small village in southern China. He finished primary and junior high School in his home town and knew at an early age that he was destined to pursue a creative career in literature or art. After graduating from junior high school, he traveled far from home and entered the senior high school affiliated to Hubei Art Academy in Wuchang. The training he received emphasized Western painting techniques in drawing, watercolor, and oil painting. He did not decide to focus on ink painting until shortly before he entered the university. Next to the Art Academy was Huazhong University; its library's holdings in literature and philosophy formed Ho's best companions. He pored through important literary classics from the *Book of Poetry* to Tang poetry. His habit of reading gave him the capacity to form his own judgement at an early age.

The time he attended high school and college in Hubei coincided with the 1957-1958 Anti-Rightist movement, in which intellectuals who were not "reformed" became targets for oppression. From 1958 to 1960, the Communist Party's "Great Leap Forward" caused such a large number of people to die of starvation or malnutrition that it stands as one of the greatest calamities in human history. Ho, whose build was slight to begin with, had to deal with a lot of spiritual pressure and do his reading surreptitiously to avoid discovery and criticism. Besides having to participate in forced labor projects, he lived always on the verge of starvation and sickness. In 1961, he was granted permission to visit his parents in Hong Kong, where he spent a year with his father before going to Taiwan as an overseas Chinese student.

During his time at Hubei Art Academy, Ho Huaishuo became familiar with the works of four contemporary ink painters who later had the greatest influence on him. They were Huang Binhong 黃賓虹, Lin Fengmian 林風眠, Fu Baoshi 傅抱石, and Li Keran 李可染. He claimed that when he was young he had already admired Huang Binhong for the tenacious strength of his brushwork and copied over a hundred of Huang's works. As for Lin Fengmian, who had studied in France and created oil paintings that adapted traditional Chinese artistic forms, Ho Huaishuo admired the pure simplicity of his subject-matter and his casual but accomplished style. He thought that Lin Fengmian represented the combination of Western creativity with Chinese ideas in a refined, purified painting vocabulary. On the other hand, the balance between the vast spiritual force and

Ancient Town 古城 1967 Ink and Color 71×98cm

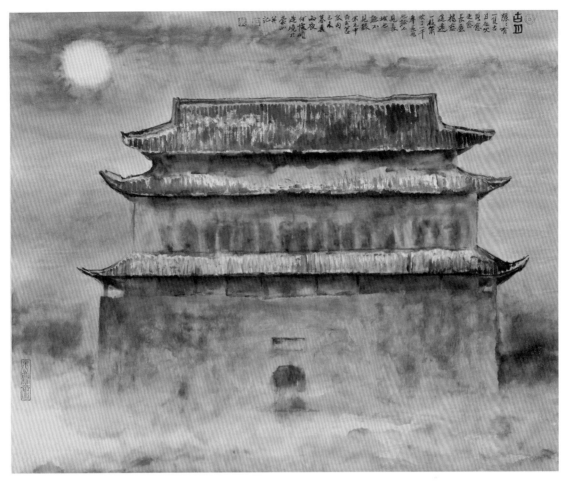

Ancient Moon 古月 1979 Ink and Color 67×81cm

lyricism in Fu Baoshi's paintings stimulated Ho the most that he later adopted the name Huaishuo ("embracing greatness") for himself.

In 1963, Ho Huaishuo was admitted as a third-year transfer student to the Department of Fine Art at National Taiwan Normal University, where he found the teaching too conservative. In the graduation exhibition of 1965, He received First Place of the Minister of Education Award. An American embassy official, Mr. Littel, made the acquaintance of Ho through this exhibition. Littel later invited Ho to hold an informal exhibition at the American embassy officials residential compound on Yangmingshan, and introduced friends to buy Ho's paintings. This not only helped to relieve Ho's dire economic situation but also increased his name recognition. In the fall of 1970, Ho held his first formal solo exhibition at the Sino-American Culture and Economic Association in Taipei, garnering many favorable reviews. The channel for exchange with the US eventually led to the opportunity for him to live in New York for four years (1974-1978).

Ho Huaishuo sees himself not only as an artist but also as an intellectual. While he advocates the incorporation of the strength of Western art, he also opposes the hegemonic

aspect of contemporary Western art, including modernism and postmodernism. He feels that it is his destiny to learn from Western civilization without forgetting the spirit of the Chinese people. He once said:

> I attach a lot of importance to the intellectual's moral stance. This stance does not refer to old notions, such as viewing self-sacrifice for the country as the complete attainment of benevolence. . . . Instead we have to strive constantly to inject new life into our culture. This spirit is not patriotism narrowly defined, but something possessed in common by people throughout the world.... Our local native culture should be on a par with the best in the world. This is our responsibility and honor.

Of course, realizing such aspirations and sense of responsibility in today's society is very difficult. However, Ho Huaishuo's predecessors in contemporary Chinese art, such as Xu Beihong 徐悲鴻 , Lin Fengmian, and Fu Baoshi, despite all their tragic experiences, are his models. Their example encourages him to continue his struggle.

Individual style and modernism

Ho Huaishuo thinks that artistic creativity arises from three sources. The first is the accomplishment of prior masters, i.e., tradition. Next is the phenomenal world--the universe, nature, human life, society. The third is one's own spirit. In *Discourse on Modern Chinese Painters--the Spirit of the Masters*, He cited eight Chinese painters who echo the crisis of Chinese culture and express an individual awakening or unique personal feeling.

Regarding the phenomenal world, Ho thinks that the most important task is reflecting the time one lives in. He has always held a strongly critical attitude toward society. The vicissitudes of nature and social life can only function as a negative mirror for his creativity. This idea is also conveyed when he writes of Fu Baoshi: "All of Fu Baoshi's best paintings well up from images within his heart, though the investigation of nature and the borrowed perspectives from people of the past cannot be absent." Thus, for Ho, the artist's sense of the times is ultimately linked to his own conceptual innovations and expressions of his own inner world.

After experiencing a drifting life as a young man, Ho's sense of the crises of our times and the precariousness of human life is cast back into his paintings with profound intensity. As this life no

In the Woods 林隱 1991 Ink and Color 68×103cm

longer has any beautiful dream or innocent expectation, there are only pain, fear and suffering in fantasy. The only way to begin healing is to return to the lonely world of one's dreams, because no matter how vacant or monstrous it is, it provides broader room for self-expression than the real world ever can.

But Ho Huaishuo still has limitless affection for the here and now. In his early period, Ho was clearly influenced by Fu Baoshi and Li Keran. These early paintings are not filled with tragedy or melancholy. In fact, many of them are rendered from a bird's-eye view and convey a sense

of blithe, floating ease. For instance, in *On a Lone Flight of 1971*, he uses an eagle spreading its wings high over a desert to guide the viewer's perspective. Among the limited number of objects a constant call-and-response is established. Although there is a sense of isolation, genuine loneliness is absent. A dead tree stands in the midst of a mostly featureless expanse and seems to wave in the breeze, beckoning toward the eagle.

Painting and literature

Ho is deeply aware of the close connection between Chinese painting and poetry. He thinks that painting has to rely on literature to fill out its spiritual content, because literature, especially poetry, is capable of the most profound, complete expression. Content-wise, painting and literature

Alley in the Rain 雨巷 1981 Ink and Color 66×66cm

both express the romance, subjective spirit, and humanist color of Chinese art as a whole. The refined simplicity of subject-matter in Ho's paintings is undoubtedly related to his experience in poetry, and through further exploration of the narrative aspect of painting he has modeled its identity with literature. Ho thinks that Chinese painting can express time's passage. For instance, in *Solitary Journey* of 1980, the expanse of land is flattened through the eagle's perspective, but a line of mountains suddenly rises through the mists, blocking our line of sight and the eagle's flight path. This kind of opposition and contention for preeminence among images is also seen in the parallelisms of Chinese poetry

Alley in the Rain is a celebrated work of the early 1980s that Ho is proud of. Although the composition is inspired by Li Keran, it is more detailed and powerful in its execution. The

Winter Light 冬日 1986 Ink and Color 67×67cm

attenuated 'S' formed by the rows of rain-drenched rooftops defines the path of a solitary traveler. The poetic inscription is taken from an emotion-filled line by the modern romantic poet Dai Wangshu: "Grasping an oil-paper umbrella, wandering alone down a wet and long, long lonely alley."

Accumulating and combining techniques

Ho Huaishuo consistently uses rice paper for his paintings and applies repeated washes for a layered effect. Before undertaking a painting, he will always do many studies, compare their strong and weak points, and refine the composition to unassailable perfection. He will not take up the brush for the final work until he is confident to do so. The process can take a long time, since he thinks that repeated revision in the drafting stage makes possible the creation of a multi-layered, cumulative effect in the final composition. This approach is very different from the traditional emphasis in Chinese painting on forming a whole composition "at one go" on the basis of an image formed in the heart, but is rather borrowed from Western notions of composition. This is a part of Ho's effort to change Chinese tradition.

The effect of long, complete concentration during the process of refinement is also evident in the free but pensive mood in his paintings. For instance, in *Passing Guests* (1983), dodder-like vines rise skyward, their blossoms appearing like so many butterflies. Around 1975, Ho had begun using river images to represent memory of the past, thus (by extension) of home. In this

painting, the river rushes up from the foreground as if it were standing vertically, and an old, decrepit footbridge arcs high above it. As in traditional Chinese poetry, where our lives are compared with floating duckweed and travelers passing by, this painting features no cozy dwellings where the human figures can find lodging. We should note that apart from the wooden bridge, rendered with an economy of means,

Rhythm of the Sea 海韻
2007 Ink and Color 97×94cm

Escape 逃逸 2010 Ink and Color 105×66cm

A Scene from Li Yu (*AD
937-978*) 李後主詞意 2006
Ink and Color 104×53cm

this painting already provides no narrative visual guide. Instead, the artist tilts the plane of the composition up in order to highlight the rhythm of the lines on the surface. The large masses of vines occupy the left and right, establishing a mutual attraction. The rocks in the stream, rendered with sparse, suggestive brushstrokes, seem to punctuate the composition's rhythm.

Ho Huaishuo's use of the method of splashing on paint with the brush reached its height in his 1988 work, *Eternal Rain*. The inscription is worth noting:

My use of this method to paint foliage and vines began from an inspiration while traveling in Europe in 1977, and my painting *Passing Guests*, done in the summer of 1983, was the most thoroughly drenched. In 1984 I had a solo show at the Hong Kong Art Center, and a guest remarked, "This is Jackson Pollock's (1912-1956) method modified for ink–extremely clever!" I felt as if I had suddenly awakened. But when I created this method, I was not thinking of Pollock at all.

Of course, Ho Huaishuo's wandering lines and splashed-on dots are not directly taken from the American abstract expressionist master Jackson Pollock, although the new generation of painters in Taiwan were familiar with Pollock's improvised, spontaneous methods since the 1960s.

In a preface Ho wrote for a solo exhibition in 1990, he indicated that his creative work had already been internalized, that it had become the expression of his personal, inner fantasies:

The larger part of my favorite subject matter is transcendent, what is suspended over "reality," phantom sensations in my mind. Some of these phantoms are images, evolved from certain indescribable "secrets" deep in my heart since childhood.... And the pursuit of knowledge, artistic training, absorption of Chinese and Western culture, world travel, and personal experiences over a number of decades have refined those images and guided them, so that in my exploration I arrive at and express the appropriate forms.

Visions and demons on moonlit nights

Ho Huaishuo is especially skilled at depicting contrasting light rays and imbuing them with feeling. In *Thinking of Distant Loved Ones Beneath the Same Moon* (1987), a solitary person is seated on a plank bridge with a thatch roof, looking much like one of the many rocks. The moon itself is somewhere over the painting--there is only the reflection of the moon's light on the water. The play of the light is such that the poet could just as well be seated under a spotlight. The rocks jutting from the water's surface are arranged in a sequential order from the lower left corner toward the horizon, as if to suggest the longed-for loved one. The scintillating effect of the reflected moonlight is captured by the fine, dense brushwork, yet the light remains something impalpable, like a fine wisp of smoke. Although the moon is eternal, it too can grow old. In *Ancient Moon* (1979), Ho inscribes a "new-style" poem by Yu Kwang-chung 余光中 evoking the landscape of the "old country":

Indistinct, an ancient moon lies in wait. The longer I go, the more the mirage recedes. A

flute has been playing a thousand years. I can't hear Chang'an, I can't hear the Great Wall.

In this painting, the old city gate tower represents the old capital of Changan, as well as Ho's feelings for old China. The red mirage is broken up in the mists, as if to suggest that Chinese traditions are about to crumble like that old city.

A contrasting, more positive image in traditional landscape paintings has been trees, since they were taken to represent male virility and vitality and the accumulation of time and wisdom. A thick tree trunk always gives people a sense of security and stability. *Winter Light*, painted in 1986, presents a scene with all the simplicity and force of a children's tale. The house seems to float between the gray sky and dry grassy plain like a big face, its black door a wry smile tilted toward

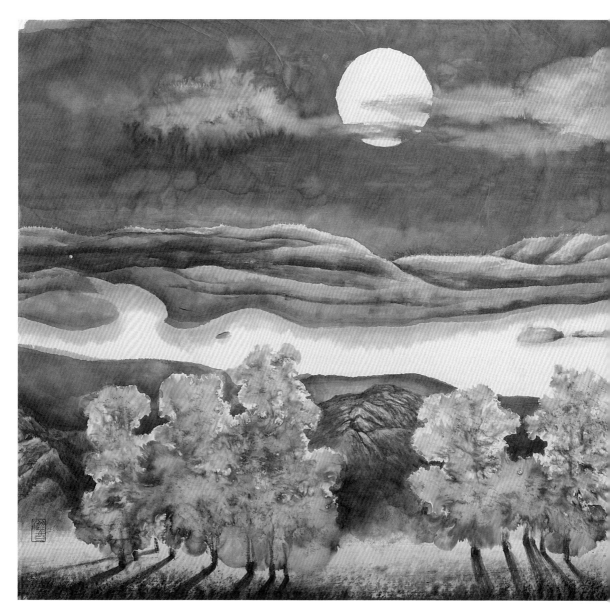

Poetic Moonlit Night 如詩的月夜 2010 Ink and Color 66×102cm

the right. The two trunks in the foreground form a giant arc off-centered toward the left. The asymmetrical arrangement creates an implicit tension.

The development of the anthropomorphized trunk motif in Ho's paintings seems to reach a climax with the two trunks, suggestive of a man and woman, in the right half of *Sea Passion* (1989). After this, Ho stopped using this motif for a while, shifting to develop the river motif. It is worth noting that the background of *Sea Passion* uses the same technique as that of the moon-reflecting sea in *Thinking of Distant Loved Ones Beneath the Same Moon*. Although the moon's image cannot be seen, the gentleness of its light is everywhere.

Motifs suggestive of struggle and desire were developing at the same time in Ho's oeuvre, as if they were really parts of the same idea. The motif of the destroyed forest, for instance, suggests repeated trials and suffering, until everything has been scorched away. The most perfect expression of the death of a forest (and all that implies) is found in *Elegy of the Yellow River* painted in 1989 after Ho had witnessed the Tiananmen Incident. The inscription reads: Elegy for the Yellow River.

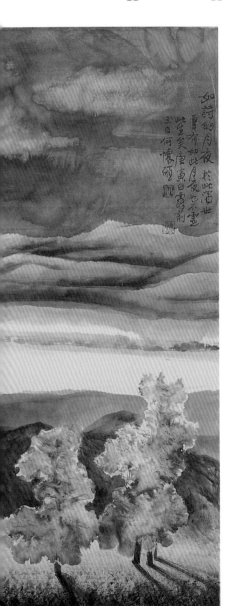

This painting is simultaneously an expression of Ho's fondness for Chinese history and his sadness and protest against the current Chinese political culture. The Yellow River in the background may represent the unbroken line of history, but the forest dominating the foreground of the composition is utterly blasted, as if struck by lightning and burned completely. He uses this painting to express his grief and anger for the dead. However, not all has been lost: hope for the return of life is revealed through the river, whose calm, gentle surface, bathed in moonlight, forms a sharp contrast to the monstrosity of the forest. The river and forest make a complementary Yin-Yang pair, adding another important symbolic dimension to the painting.

Mental scenes

The year 1993, when Ho Huaishuo made a trip to Russia, marked a new milestone in the development of his paintings. The poverty in Russia's society, juxtaposed with nostalgia for the past, was utterly at odds with what he had studied about Russian culture and language when he was young. After calmly listening to his recollections and sad songs, the image of a

scene without a past, present or future appeared in his mind. After he returned home, he created a painting entitled *The Scene of Mind: Incessant Clouds*.

The line of the horizon is pressed down to the lower one-fourth of this painting, and the viewer looks up to a partly cloud-covered gibbous moon in a starless sky. In the lower left is a simple yet vaguely familiar house, standing squarely on a grassy plain. In the phantasmagoric heavens, clots of black cloud emerge behind the moon, covering the sky. Only the area around the house is covered with faint moonlight.

In 1996, typhoon Herb brought disaster to the area around Taipei. That night, when the artist was listening to the howling wind, he painted *Eternal Moon Light*, which shows a pair of trees, representing a man and woman with their backs to the viewer, looking at the thin line of a stream in the distance. What is really eternal and unchanging? Perhaps it is the moon, the poet's constant companion. Even though the moon is presented as a vacant circle with indistinct edges, it still reveals the artist's unlimited affection. The wide, transparent trees, looking like puffs of cotton

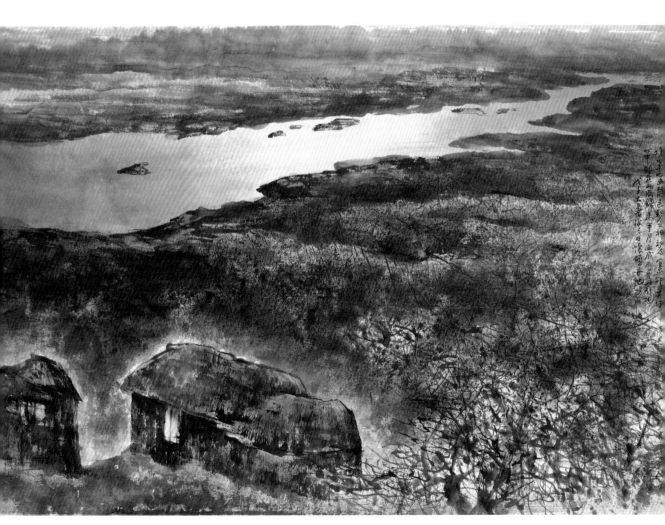

Moon River 月河　2008　Ink and Color　67×98cm

candy, are also an expression of his love for humanity. The sky is mostly clear, save for a luminous cloud that graces the "feminine" tree on the right.

Moon at the End of the Century, finished in 1995, suspends an intensely radiant silver moon over a Ziggurat-like apartment tower. Each of the souls residing there has a different face, a different set of memories; each has modified his space accordingly, creating a jumbled exterior reminiscent of many apartment buildings in Taiwan. Wisps of cloud float lightly outside the windows, and the top is so close to the moon that one could almost reach up and grasp it. The artist uses this image as a clear, moving expression of his sympathy and passion for humanity.

The drifting moon as a symbol of emptiness

After the 1989 painting *River of Lust*, the female image that had stood in the form of trees began to recline in the form of undulating rivers. The painting brings the viewer into its own complete, independent, closed world, unaffected by anything outside. It is a quiet inner journey, a meandering thought. The full, gentle image of the river simultaneously contains within it the notion of "life source" and something that constantly flows on, never to return. It is a dual image suggestive of both life and death.

Moon River I depicts a wide expanse of barren, desert-like land. A huge moon near the horizon shines over it all. A line of trees with skinny trunks stand in the foreground, recording the passage of time. The bright river looks like a reclining woman who stretches her arms lazily over her head while bathing herself in the cool moonlight. Across her attenuated body are streaks of mud and water. In the deserted territory of this painting, this long stream could stand for life's potential.

Thereafter, Ho began to explore the motif of returning to primordial landscapes. The journey is accomplished after purifying the thought in order to search for a place to consign one's spirit. *Wandering Clouds*, finished in 1998, embodies this idea. The canyon face is the wall that forms the object of the artist's meditation. Long clouds float in the pure air, suspended and still. Trees lined up in the foreground seem to link hands to guard the near ground, whose contours form a female body. Perhaps the space is a dried-up riverbed where seeds are scattered to await the re-awakening of the earth.

"Dreams are a higher truth than reality," concludes Ho. "Our physical selves, rooted in the real world, are not free--only the free spirit can undertake limitless quests. All transcendental pursuits occur through dream, and are the only things worth striving for in this life. . . . Perhaps one could call it "dream realism." I like to use constantly appearing visual images to create suggestive or symbolic expressions. This tendency is probably more readily apparent in my paintings over the past nearly ten years."

* From *The Chinese PEN* (Taiwan), (now *The Taipei Chinese PEN*), 108, Summer 1999, 48-80.

Lee Ku-Mo

Infinity in a Scroll—Lee Ku-Mo's Painting and Calligraphy

李轂摩的書畫世界

Shih-Ping TSAI 蔡詩萍

Clouds in the Countryside 一片淡墨兩三閒雲 2015 Ink on Paper 70×68cm

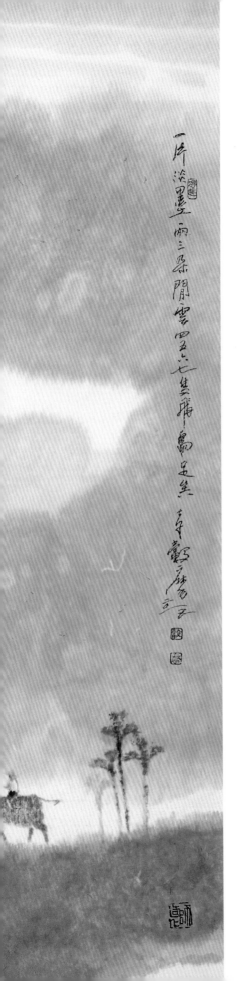

李轂摩 (1941-)
Lee Ku-Mo (also Li Gu-Mo)

Born to a farming family in Nantou County in Taiwan, Lee Ku-Mo is the model of self-taught success in ink-and-wash painting. His paintings show Taiwan's native customs and scenery, full of humanity and intimacy. When he was young, Lee did paint mounting and seal-cutting for a living. The treasures of the National Palace Museum, which had been moved to Taiwan with the Nationalist government, were temporarily housed in Taichung, a short distance away from Nantou. Young Lee Ku-Mo had ample opportunities to frequently visit and learned from the treasures. Later he converted to Buddhism and became a painter and calligrapher. Lee created a large number of works of rural scenery and childhood memory in which the viewer can sense his distinctive wisdom and humor.

Most critics have noticed in Lee Ku-Mo's paintings the artistic realm revealed in "Leisurely Watching Mt. Nan," his whimsical brush and ink sketches of Taiwanese rustic life, and his feeling for "happy-go-lucky to achieve one's goal." However, exactly what significance of such perception to paintings can hold in this modern world?

Has the grand tradition of Chinese painting, coined "the intrinsic fusion of poetry and painting" by the early Republican artist Feng Tzu-Kai 豐子愷 , which serves as the basis for the Chinese society to internalize its everyday life and life itself and to allow the natural union of man and universe, completely gave way to the new era? The renown Chinese-French painter Zao Wou-Ki 趙無極 again found freedom and security in the splashes of brush and ink painting many years after he had ceased taking up a brush.

Having admired his brush and ink work, his French poet and art critic Henri Michaux commented positively via a quote from Wang Wei 王維 , the Tang Dynasty poet painter, "There is infinity within a one-meter scroll wherein the form is transformed from the formless. And so we come to know that the essence of painting is the essence of poetry." Is this fusion of poetry and painting uttered by a Frenchman a coincidence? What kind of painting is it?

Indeed, the more we review the rebirth and succession of brush and ink painting in the face of radical changes, the more we appreciate the resilient life force of this medium. And, the more we realize we are being goaded by the industrialized, numericalized, quickening rhythm of life,

Song of the Farmers 田園之歌 2010 Ink and Color 106×103cm

the more we yearn for a certain handicraft-laden, simple, folksy lifestyle. In this kaleidoscope of existing conditions, the style of Lee Ku-Mo the Taiwanese brush and ink painter, stands out all the more in the artistic realm with its serenity, soothing effect, and carefree simplicity.

The most salient aspect of Lee Ku-Mo's brush and ink painting is his use of the medium to record the rustic life of Nantou where he lives. It embodies Taiwan's tropical climate: the fresh air in the high mountains, the floating mistiness, the fertile soil, the lush green grass, the rich foliage on majestic trees, the abundant fruits, the multitudinous groups of fowls and their like that constitute the typical motif of Taiwanese characteristics.

Chirping Birds in the Bamboo 風姿招展有知音 2013 Ink and Color 70×70cm

Frogs in the Well 井底之蛙
2010 Ink on Paper 103×50cm

The essence of brush and ink painting is best conveyed through natural landscape. It follows that landscape painting constitutes the backbone of brush and ink painting. However, owing to the incessant warfare and migration after the Tang and Sung dynasties, the configuration of mountain and water elements in landscape paintings changed with the times: it reflected the immediate surroundings of the painters. The most interesting difference can be seen in the dangerously precipitous cliffs and majestically piled-high-rocky mountains famously recorded by Fan Kuan 范寬 in his *Travelling among the Creeks and Mountains* 谿山行旅圖 and in the gentle hills softly emerging in the drizzling mist south of the Yangtze River as painted by Huang Gongwang 黃公望 in *Dwelling in the Fu Chun Mountains* 富春山居圖 . These landscape scenes were delineated by the painters as observed in varying situations and under different conditions. Yet, the painters of various eras were hardly confined by times and locales but depended on their personal attachment

A Happy Couple 唱隨諧樂 2013 Ink and Color 91×92cm

to the natural scenery, their fascination with the historical and literary association of mountain and water elements and their own interpretation of the awesomeness of each scene of nature.

However, apart from a small body of works which continue the ancients' preference for grandiose landscape scenes such as *Let Go Beyond the Universe, Clear Brook Passing through Green Hills, Love for Nature*, the preponderance of his landscapes are wholly Taiwanese in character. A contributing factor in this is Lee Ku-Mo's very own fortunate circumstances. He lives in Nantou County, Taiwan's blessed region of the best scenery with high mountains and crystal clear water. This offers him the best milieu not only to carry on the traditional landscape but also to pioneer a new path. For example, the majestic, soul-stirring *Unworldly Home* appears to be a typical literati landscape painting with its naturalistic scenes of familiar mountain ranges,

A Sweet Moment 溫馨　2017　Ink and Color　68.5×70cm

**Meeting Bosom
Friends across Time
and Space**
圓夢 穿越時空會知音
2013 Ink and Color
136×69cm

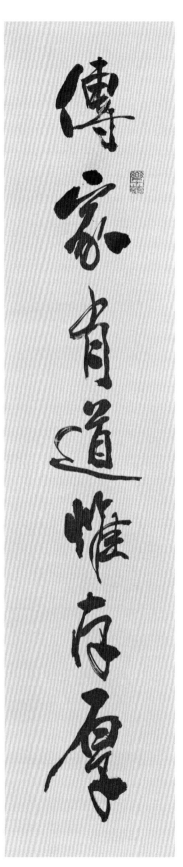

suspending cascades and floating mist. Yet, a detailed examination would show a hoe-carrying farmer walking his buffalo, a laborer shouldering common necessaries, the local barking dogs, the tiled cottages leaning on undulating hills and even the very few upright betel nut trees by the dwellings, all of them are the typical rustic scenes of central and southern Taiwan. It would be spot on to say that Lee Ku-Mo hails from the Chinese brush and ink lineage, but the fact that he has little trouble injecting an indigenous Taiwanese element in the veins of this thousand-year old landscape genre should not be ignored.

If brush and ink painting were the best time-honored vehicle for the literati to express their yearning, then for Lee Ku-Mo it would be his enticing light-hearted rustic life sketches. That, I think, is what he excels in, and, his most moving subject matter.

As one would expect, his *Spring Wind Blows*, *Misty Rain Floats*, *Fisherman's Song Sung*, *White Cranes Fly*

Calligraphy　書法對聯
2016　100×21cm ×2

exemplifies the Southern Chinese misty, drizzly vista. Yet, the prey-searching white herons darting over water, those perching on branches preening contentedly, rain-geared fisherman leisurely rowing his boat, the lingering lyrics of "so what of imperial power to me?" echoing in the sunset sky – don't all of these mirror Lee Ku-Mo's own journey in time and space? It represents lodging one's emotions in nature and expressing one's yearning through poetry and literature. The fact that Lee Ku-Mo arranged the reproduction of this painting as the first plate in his album entitled Impromptu most clearly declares his intention. "May the six domestic farm animals[1] prosper" is the customary well-wishing greeting in Chinese society. In an agricultural society this greeting is rooted in the dependence on livestock in making or supplementing a living, or in using some of these domestic animals for making the annual celebratory meal for the Spring Festival. Not all brush-and-ink literati painters would use the six domestic animals as motif. However, most painters from a farming community background, particularly those from poor families, are partial

1 cow, horse, sheep, pig, chicken and dog

Every Day a Good Day 日日是好日 2013 Ink and Color 97×108cm

to depicting these playmate companions of their childhood or these labor-mates who basically helped them to carry out their domestic chores. Lee Ku-Mo's treatment of poultry and these domestic animals in his paintings is extraordinary in his deep feeling for them: the imposing masculinity of the cockerel in Leisure Supreme, the great love of the mother pig looking tenderly at her litter of piglets in *Mother Pig Giving Birth to Piglets*, the happy goose spreading his wings to welcome the rain in *Sweet Rain After Long Drought*, the contentment of both the buffalo and his young handler in Nostalgia. These paintings of his impart a faint sense of nostalgia and considerable warmth to those who scrutinize and study them.

Keeping life simple to express one's yearning and maintaining serenity to achieve one's goal. It is easy enough to ape simplicity-keeping, but not quite so to express the intrinsic value of one's yearning. The ancients had long ago noticed that it was not uncommon for the literati to resort to shortcut by retreating to the mountains as hermits. So, apart from proving it with the passage of time, the way to express one's yearning requires one actually to transcend and ridicule worldliness. Lee Ku-Mo's works in this respect are considerable. Often the audience would get the point and would nurse a secret smile.

In *Like - Don't Demand* a black cat sits on a chair staring hard at the mouth-watering fish in a painting, seemingly drooling like the cat watching the mouse in a Disney cartoon movie. In *Safe at Home*, Lee Ku-Mo reinterpreted the saying of "the frog at the bottom of the well" by transforming a whole family of frogs as the symbol of the home-guarding, hard-working and ambition-free

You Harvest What You Plant 種瓜得瓜 2015 Ink and Color 72×150cm

Easy Floating 優哉游哉 2011 Ink and Color 106×103cm

simple folks. *The Superior Managing the Subordinate* presents an interesting explanation of the seasonal orderliness and the reverence to tradition in an agricultural society through the mouth of an old folk, a lovely pictorial enlivened by some twittering chicks surrounding some farm tools. In *Visiting the Plum Blossom for News* a rooster and a hen stroll under a sky of red plum blossoms like a pair of lovers engaging in loving exchanges. They are the most humanized pictorial description, livening up Lee Ku-Mo's longing for country living and for sincere, mutually trusting human relationship.

There is a genre in Lee Ku-Mo's brush and ink sketches which is also a quintessential product of the typical Chinese society. Lost for a descriptive name for it, I might as well borrow from the

Basket of Tangerines for New Year 年年大吉
大利
2012 Ink and Color
90×47cm

Tsai Ken Tan [2] 菜根譚 and call it "*The Motto of The Tsai Ken Tan Way of Life.*" Similar genre of works were still found after the Late Qing Dynasty. Feng Tzu-Kai, who used brush and ink comics to illustrate his criticism of the Chinese society of his time and to offer enlightening suggestion, was a worthy successor of this genre. Lee Ku-Mo's approach differs from that of Feng Tzu-Kai's quasi-current-affairs satire. The principal subject matter of Lee Ku-Mo's painting remains to be poultry and livestock found in everyday life, but he merely employs the domestic animals to convey a certain attitude to life, as in *Like – Don't Demand* mentioned above. And, in the extraordinarily refreshing *My Teacher the Hollow-Stem Bamboo* [3] where two little birds engage in a duet singing

2 a late 16th-century book of aphorism
3 Humility is associated with bamboo as its stem is hollow, the Chinese characters, 虛心 (hsuhsin) for which is phonetically the same as those for "humanity."

Lychee and Bamboo Leaf-wrapped Dumplings 勵志包中 2010 Ink and Color 68×68cm

praises of humility as symbolized by the bamboo, one of "The Four Gentlemen of the plant family."[4] In *Every Day a Good Day*, while a pair of chirping rooster and hen is illustrated through the concept of uniting calligraphy and painting, the subject matter alludes to the harmonious loving interaction of the two sexes in the humdrum of everyday life.

4 "The Four gentlemen of the plant family" is the theme of traditional Chinese culture, represented by the plum, orchid, bamboo, chrysanthemum to symbolize a person's noble moral character.

A Lofty View 登高博見　2013　Ink and Color　90×80.5cm

In Lee Ku-Mo's painting and calligraphy exhibition titled Impromptu, his brush and ink paintings certainly stood out, but his calligraphy showed none the less his spontaneous execution. ·

Evidently, Lee Ku-Mo's calligraphy, whether drawn in the seal script, the official script, the regular script or the cursive script, is almost devoid of the conventional forms of calligraphers in general. Always spontaneous, by using his own distinctive correspondence script Lee Ku-Mo eloquently duplicated the Buddhist sutras: *The Heart Sutra* and *The Chapter on the Universal Gate of Bodhisattva Avalokiteshvara of the Lotus Sutra*, superbly executed various couplets, and whimsically penned the *Calligraphy is painting, painting is calligraphy* series such as *The Higher the More Chilly and Free and Easy*. All of them show Lee Ku-Mo's love for calligraphy and his technical mastery from decades of practice. The calligraphy scholar Lin Lung-ta who teaches in National Taiwan University of Arts commented on Lee Ku-Mo's calligraphy by borrowing the line "How could no Dharma be when Dharma never existed?" from Huang Ting-chien 黃庭堅 , the famous poet-calligrapher-painter of the Northern Sung Dynasty who excelled in all three branches of the literati accomplishment. That line was excerpted from Huang's poem entitled *Postscript to the Verse Dedicated to the Seven Buddhas*: "The Dharma was no Dharma, but no Dharma is also Dharma. Now that being the case, how could no Dharma be when Dharma never existed?" That is absolutely appropriate in understanding Lee Ku-Mo's calligraphy. When we are curious about the exact source from which master calligrapher Lee Ku-Mo did draw, don't forget that it is precisely Lee Ku-Mo's contentment and spontaneity that allow him to enter the realm of freedom as summed up in "How could no Dharma be when Dharma never existed?"

As for Lee Ku-Mo's paintings, there is no cause for concern as to how tradition will pass on. In our review of contemporary brush and ink painting controversy, there is also no need to worry about how the genre might renew itself. The innovators will keep innovating while those who feel comfortable in the traditional will continue to maintain the contentment found. As I said before, "Lee Ku-Mo's contentment, his disinterest in the various arguments of recent times, his lodging his emotions in the trivial aspects of rustic life, and his clear vision of the continuation of brush and ink painting through the past thousand years, all of these imbue us the admirers of his paintings with a gentle sense of the beauty of living, and enable us to find in both his person and in his paintings and calligraphy a kind of serene acceptance of the rhythm of life.

In this context, Lee Ku-Mo is undoubtedly one of the successors of the grand tradition of the Chinese literati paintings. Before his times this tradition had gone through innumerable ups and downs, yet it is still alive. After his times, how could this tradition come to an end? If you do not believe it, then please keep watching his works on painting and calligraphy.

Translated by Linda WONG 黃瑩達

*Excerpted from *Guofu Jinianguan guankan* 《國父紀念館館刊》 (*Journal of National Dr. Sun Yat-sen Memorial Hall*), 37, March 2014, 23-33.

Tong Yang-Tze

The Calligraphy of Tong Yang-Tze

董陽孜的書法

compiled by Michelle Min-chia WU　吳敏嘉

董陽孜 (1942-)
Tong Yang-Tze (also Dong Yang-Zi)

Born in Shanghai, Tong Yang-Tze came to Taiwan when she was a child. An important female calligrapher, she is excellent at writing vigorous and unrestrained cursive-style calligraphic works in huge scales. The structure and layout of her brush works created a unique, contemporary interpretation of Chinese calligraphy.

Tong Yang-Tze graduated from National Taiwan Normal University's Department of Fine Arts and received a Master of Arts from the University of Massachusetts. She started from copying ancient stele rubbings, and now incorporates Western composition techniques in her work. She uses calligraphy lines as an important creative element to produce a modern graphic design appeal within the aesthetics of traditional calligraphy.

In recent years, Tong Yang-Tze has been promoting the art of calligraphy by incorporating calligraphy into contemporary life and visual arts. She has focused on cross-border artistic creation and highlights the contemporary nature of calligraphy through cooperation with innovators in different art forms such as painting, video, architecture, music and even fashion design.

Calligraphy is the oldest and most revered art form in the Chinese artistic tradition. During the past millennia, Chinese calligraphy has undergone countless evolutions. In ancient China, it was the medium for the gods. Words were inscribed with great care and diligence by diviners onto oracle bones. In the Chinese scholar-literati tradition, calligraphy was a very intimate part of life. Through calligraphy, scholars practiced discipline and cultivated their personal characters. The calligraphic styles of great masters were emulated and copied, ad passed down from generation to generation.

Today the brush is no longer used as an instrument of every day writing, and intellectuals no longer write decent calligraphy. Some say that calligraphy exists today only under two conditions. One, to record the sayings of ancient sages to be hung on the walls for moral encouragement; two, to be displayed on the walls of living rooms to give them a cultured air.

Has calligraphy become a thing of the past, an object of antiquity that belongs to museums? No. Here in Taiwan, a woman calligrapher, Tong Yang-Tze has given new expression to this ancient art by creating works of calligraphy defined by both its artistic expression and its calligraphic art. Her work is bold, innovative, and full of energy. It is traditional yet modern, disciplined yet free, planned yet spontaneous, lofty yet mundane.

Tong Yang-Tze is probably the best known calligrapher in Taiwan. In the eyes of her admirers, her calligraphy is contemporary Chinese calligraphy. In the eyes of others, her calligraphy resembles abstract art. Should we consider her works calligraphy or painting? It is a very difficult question to answer. One thing is certain though, and that is, regardless of how her

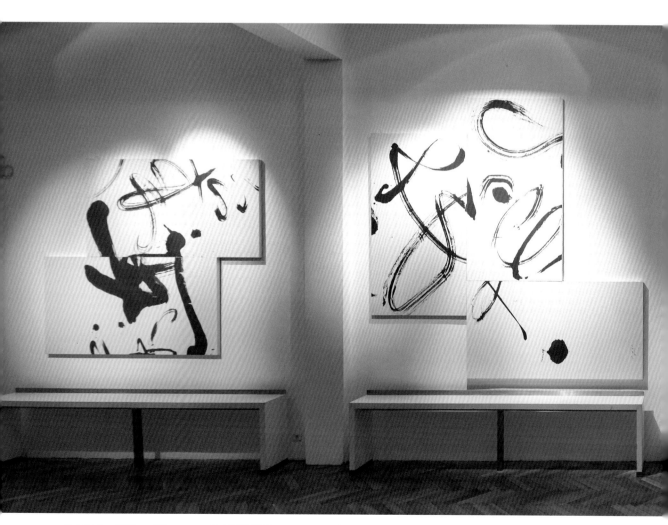

Exhibition *"Silent Movement"* 無聲的樂章 2016 Center for Fine Arts, Brussels

work is defined, her calligraphy impresses and moves the beholders. Han Pao-teh 漢寶德 , a well-known architect and scholar, remarked, "When I first saw the large strokes of Tong Yang-Tze's calligraphy, I felt the energy of one who, after downing huge quantities of wine, gives rein to a mighty steed and rides like the wind into the desert plains!" In describing the stylistic image of Tong's calligraphy, Tai Ching-nung 臺靜農 , the renowned Chinese scholars, said, "The brush she wields has the essential strength of a crossbeam. Her vigor shatters regularity; her inkwash and splayed tip techniques complement each other. Is it calligraphy or is it painting? Fused, it defies separation." Joan Stanley-Baker, art critic, commented, "Tong's calligraphy are not meant for a timid heart. They demand the heroic breath and breadth of a giant. They are hoary voices shouting to the gods and there we stand, mesmerized, as we watch the powerful ritual dance, with forms moving in and dispersing, thickening and thinning, where dots can be like hammer blows and the ink can drown oceans."

Let us examine Tong's achievement to date. She began practicing that art as a child, studying

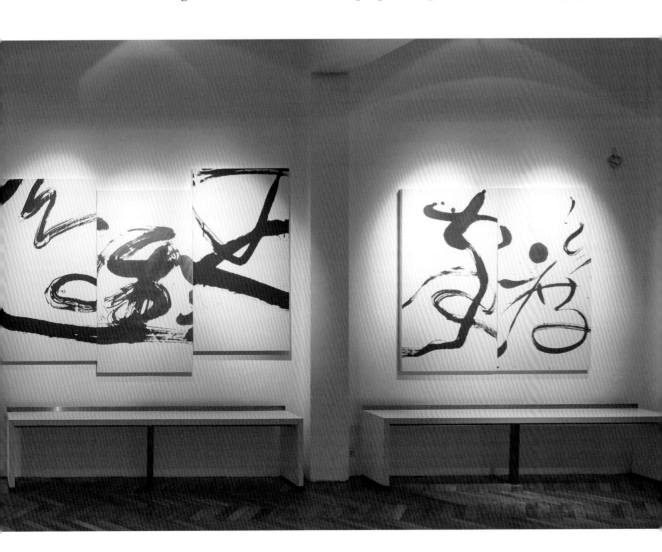

the calligraphy of the Tang dynasty master Yen Chen-ching 顏真卿 . Her father made her write out two hundred large-sized characters each day. This made her quite an accomplished prodigy in calligraphy. When she entered the Department of Fine Arts at National Taiwan Normal University, she continued to pursue her interest in calligraphy, while exposed to the concepts and techniques of contemporary art. At that time, the contemporary art movement was raging like wildfire in Taiwan, and may have given her, then a student, a sense of restlessness. It was the central concern of each aspiring art student to discover that critical juncture between tradition and individualism. She went on to study art in the United States at the University of Massachusetts. There, she majored in traditional oil painting and ceramics. Facing America's variegated world of art and living in the huge, whirlpool-like timeframe of New York, she became confused, and discovered that the only way of responding to all the stimuli was to pick up her old, familiar calligraphy brush again.

In New York, she found her way back to calligraphy, and examined the currents of contemporary abstractionism. She gradually discovered herself in brush and ink, and eventually, from pictorial structures, she discovered modernism. Tong exhibited her work in the U.S. and Taipei throughout the 1970s, receiving wide acclaim and encouragement. In the 1980s, she became the toast of Taipei after her solo exhibition at Taipei's Spring Gallery, showing to the public her huge characters dripping with ink in abstract constructions which emerged from her thoroughly regulated Yen Chen-ching style training. She became without question the representative of contemporary calligraphy.

In the 1980s, the most notable trait of her work was the design of the total composition. She had left the regulations of traditional calligraphy, crossing over to the conventions of painting. She would arrange several characters of different sizes in space, and make the important characters especially large, tantalizing the visual sense of the beholders. At that time, however, her character configurations were still largely traditional, and could be easily deciphered and appreciated.

Towards the 1990s, Tong's art moved to new realms. Her uses of various character configurations departed further away from tradition, and in the opinion of many art critics, her calligraphy evolved into a form more like painting. Characters had become difficult to decipher, and it was difficult for one to tell how many characters there were in any given piece. The characters had lost their traditional composition, for Tong had gathered and loosened the grouping of the characters in such a way as to form one entire and wholly integrated block. So deeply are the characters inter-related that it is sometimes difficult even to identify each as individual word right away. Her innovation included brushing bold strokes across screen panels. Sometimes one central character can cover three panels, while the remaining characters must fit within the space of less than two panels. Sometimes she would deconstruct a character and reconstruct it, spreading it all over the painting surface. Yet, her characters are characters, and brush and ink remain brush and ink, and she in no way diminishes the spirit of calligraphy. She has introduced the parched, dry-brush, the "flying-white" or *feibai* 飛白 technique, into her work. This is a brush technique full of

movement and power, rarely seen in the works of Yen Chen-ching. With the newly invented ink-brush flavor, plus the deconstructed configuration, her characters dance like ghosts upon the scrolls, revealing an abstract, mysterious living air. Viewers find themselves mesmerized by the flying dots and strokes in the ritual dance of her brush. Then they read the label under each work

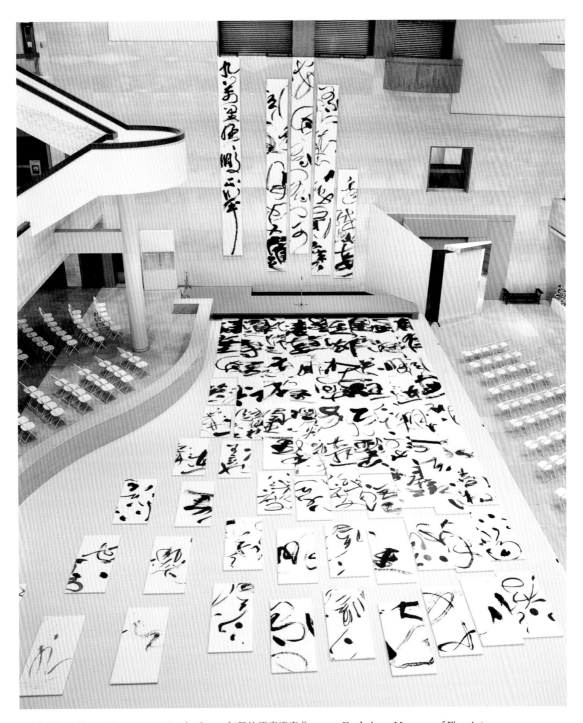

Exhibition *Silent Movement Variations* 無聲的樂章變奏曲 2012 Kaohsiung Museum of Fine Arts

and come to appreciate each work twice: once as painting, once as calligraphy.

Tong takes great pains in the selection of the characters and phrases that she interprets through her calligraphy. She states, "Because of its very long history, it is extremely difficult for artists of later generations to try innovations in the art of Chinese calligraphy. The only element in this art is characters, but these are at the same time symbols of specific things and notions. Although calligraphy is not a matter of 'duplicating' the meanings, it does serve the function of imbuing the written words with structure and style.　For this reason, I devote a great deal of time and attention to the choice of characters and phrases. Those with beautiful and profound associations often inspire thought, and the means for creative expression." She further explains, "Standardized character-shapes are but the raw material. My passion and purpose are to create unique constructions using subjective interpretations of the script to bring out various levels of meaning and flavors."

Apart from the selection of characters, Tong has also injected a great deal of design elements into her calligraphy. Her works are the result of immense planning. Every piece is reviewed in her mind for a long time.　And once she lifts her brush, she finishes the whole piece very swiftly. She rarely succeeds on the first try, and often goes through eight to ten practice runs before she is satisfied. From this it is clear that she has gone very far beyond tradition. We know that traditionally, famous calligraphers usually have the entire composition ready in their minds before

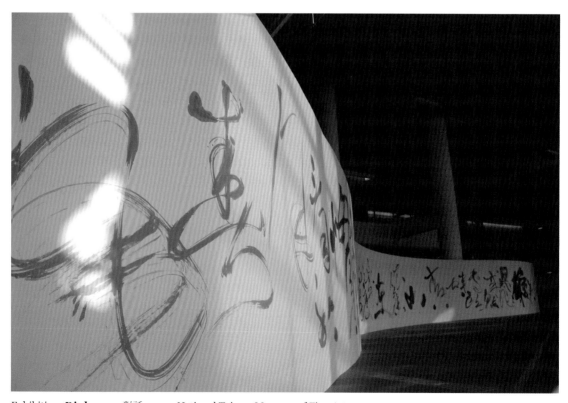

Exhibition *Dialogues* 對話 2009 National Taiwan Museum of Fine Arts

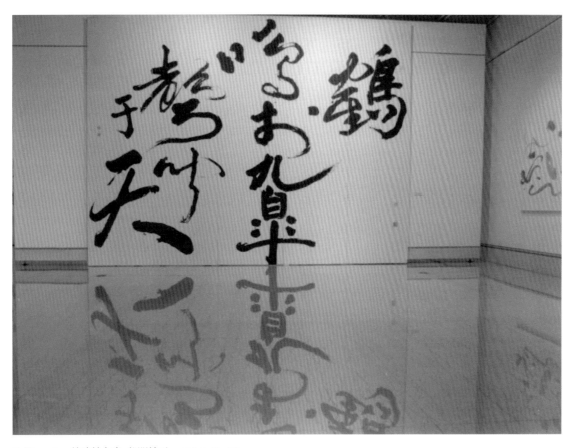

Calligraphy 鶴鳴於九皋 聲聞於天 1998 358×485cm

writing the first character and are able to complete the whole work at one sitting. Therefore the brushwork left by the masters are not always even in quality. But the Chinese rarely fault them for this, because calligraphy was viewed as a tool of communication, and not an art requiring painful planning. Since everything followed a priori dicta there was in fact no room for much planning. In this respect, Tong has broken away from tradition. Her work is not born in the traditional scholar's study, but in a professional painting studio. The dimensions she selects for her work are large enough to serve as a centerpiece on the living room wall of a middle-class family, and the texts she chooses inspire profound reflection and satisfy the spiritual needs of the new-age intellectual. Her brush traces are lively and unfettered. Those who understand, appreciate the implications of her calligraphy; those who do not understand, appreciate her composition. That is why Tong's calligraphy is so popular in Taiwan.

Though she practices China's most ancient art, Tong has managed to keep pace with the times. Her reputation is already well established. Looking back on several decades of calligraphy, Tong, like a lone warrior, has filled the blank page of contemporary Chinese calligraphy. We can be sure that Tong Yang-Tze's work will continue to surprise and inspire us.

* From *The Chinese PEN* (Taiwan), (now *The Taipei Chinese PEN*), 105, Autumn 1998, 34-45.

Tong Yang-Tze: Choosing a Different Path

董陽孜總是選擇不一樣的路

Cora WANG 王力行

Tong Yang-Tze

After graduating from National Taiwan Normal University's Department of Fine Arts, Tong Yang-Tze went on to pursue a master's degree from the University of Massachusetts. During her time in the United States, she also worked as a designer in New York. After returning to Taiwan, Tong did not take up a teaching position, nor did she join the lecture circuit. Instead, she chose a different path—one rarely traveled by others—and has continued on her own way to this very day.

Her innovative power in the field of calligraphy is derived from two main sources: her talent, which she cultivated since she was a young girl and expanded into other fine art genres as an adult, and her bold character, which allows her to constantly challenge the status quo and make

amazing artistic breakthroughs. Instead of following conventional ideas about Chinese characters fitting perfectly into the squares of practice grid paper, she almost "paints" her characters, using an artist's eye to fashion her own unique style. No wonder fellow calligrapher Tai Ching-nung has nothing but praise for her work, "Vigorous brushstrokes full of verve and momentum, perfectly balanced strength and delicacy, plus outstanding compositional skills combine to create a fascinating interplay of black and white, of lines and space. Painting and calligraphy organically merge into one: this is where Tong's greatest and most sublime artistic achievement lies."

Tong's first big breakthrough was to think big, and to write big characters into big spaces. Examples for this approach include the 358x485cm piece *Cranes Call from the Nine Marshbanks*, and *Their Cries Are Heard in Heaven* (gracing the main hall of Tainan National University of the Arts) and the 57m extravaganza *The Rolling Waters of the Yangtze River Keep Flowing Towards the East, Their Spray Washing Away the Tears of Heroes*, as well as her work for the National Theater and Taipei Main Station.

Writing big characters is much harder than you might think. When I visited the studio at her home, she told me that she always wears her most comfortable clothes for this purpose, and puts a small towel around her neck. Then she picks up a writing brush as big as a broom and starts—the point is to finish each character in one fluid motion, and before long she finds herself sweating profusely. The count of characters she's thrown out because she wasn't satisfied with the result is

Sao 2016 No.4 騷 2016 之四 2016

certainly just as a big as the number of sweat beads her efforts have produced.

One time, I asked her why she was doing this to herself. Her answer was, "I'm getting on in years, there are only a few years left in which I can still write big characters like this!"

Doing Calligraphy with Architects and Designers

In recent years, her major breakthrough has been to discover cross-border creativity. She found eight architects willing to play a game of "space and calligraphy" with her, and the results of their cooperation were published in a book titled *At Ease with Characters*. In another crossover collaboration, she worked with designer Chen Juei-hsien 陳瑞憲 to make a famous bit of classic imagery come to life: that of Wang Xizhi 王羲之, widely regarded as the greatest calligrapher of all time, "sitting by a pond practicing calligraphy, so that all the pond's water served as his ink." Taking their inspiration from this, the two of them designed a big "ink pond," allowing adults and children to have fun writing Chinese characters together.

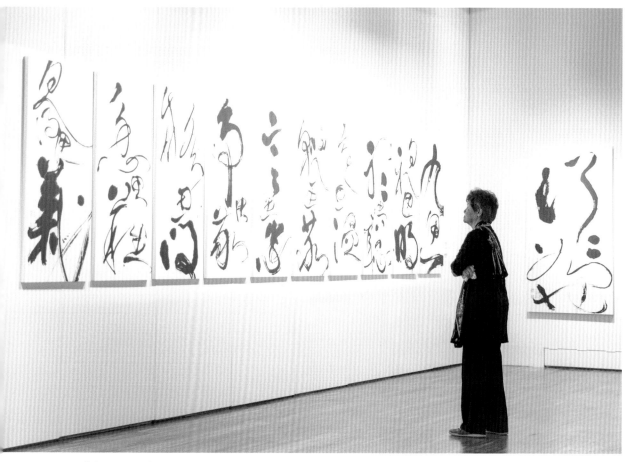

Exhibition *Confucius Analects* 子曰 2016

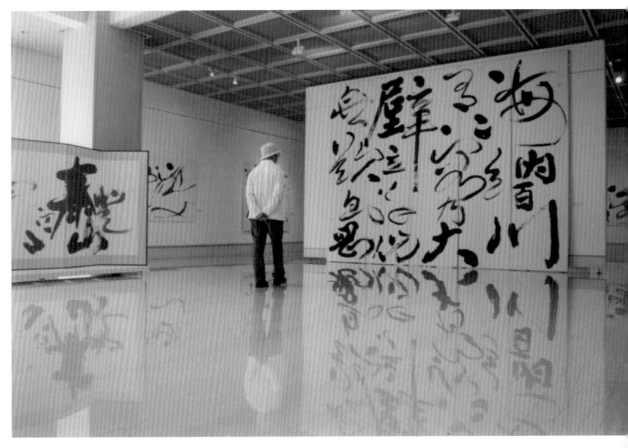

Calligraphy 海納百川 有容乃大 壁立千仞 無欲則剛 1998 358×485cm

She also won over singer Ashin 阿信 from the popular band Mayday and architect Yao Renlu 姚仁祿 for two crossover performances featuring 100 mutilated Chinese characters. The two pieces were titled *Silent Movement* and *Sonorous Calligraphy*.

Tong Yang-Tze is always eager to try something new, and she never seems to do the same thing twice. One time she invited me to see a performance of her latest work, titled *Sao*, at the National Theater's Experimental Theater, a production that combined calligraphy, choreography, and jazz music in a very successful attempt to express the beauty of calligraphic lines and brushstrokes through the elegant and dynamic movements of the dancers.

More recently, Tong has been working on a new project involving the character *cheng* 誠, carrying meanings such as "honest" and "sincere." The innovative kick this time around is to display a Chinese character in three-dimensional space, but content-wise the focus is on honesty throughout society: a call on leaders and followers, politicians and the general populace alike, to make an effort at creating a better place for everybody.

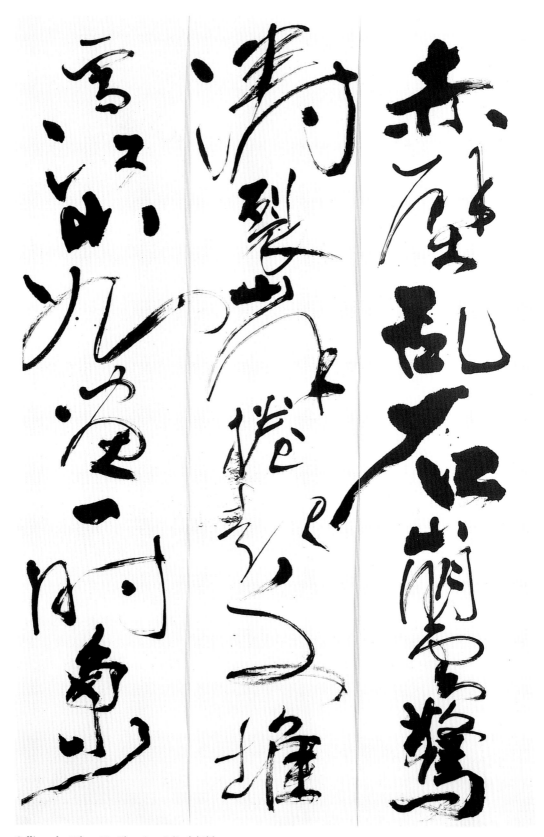

Calligraphy **Nian Nu Jiao** (partial) 念奴嬌 2002 247×792cm

大江東去浪淘盡

千古風流人物故壘西

邊人道是三國周郎

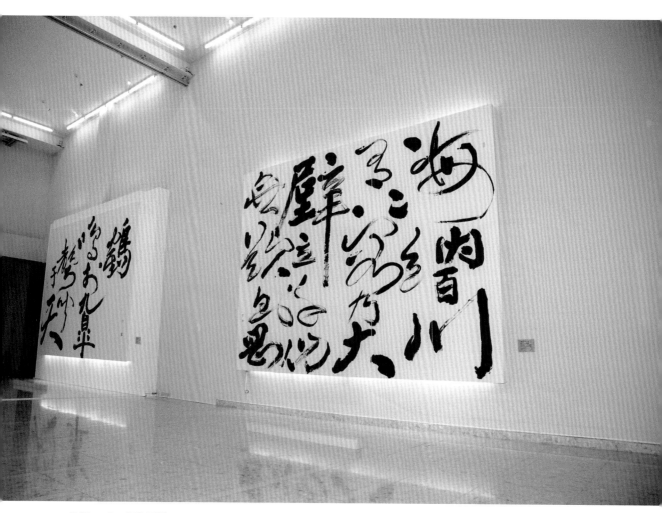

Calligraphy 海納百川

The basic concept for this project has its germ in the political and social unrest that shook Taiwan in 2008. In order to reflect the need for dramatic change, Tong went from conventional two-dimensional calligraphy to a 3D approach, using bizarrely shaped branches and pieces of wood for her purpose. It took the artist four years to find the right specimens of wood and a suitable exhibition venue, because she did it all herself—necessarily so, since she has no assistant or any other staff, no agent or office who could help her with these things. So she'd be writing calligraphy in her home, and during breaks from her creative work she'd be making phone calls to arrange everything. All from her home. That's why she likes to jokingly refer to herself as a "housewife."

Cheng, made from beautiful pieces of strangely shaped wood, has already been shown at ten different venues all over Taiwan, and I was fortunate enough to visit several of these exhibitions. Once, in a high-speed rail carriage on our way back from Taichung to Taipei, I told Tong, "You must write a book about all this, you know!"

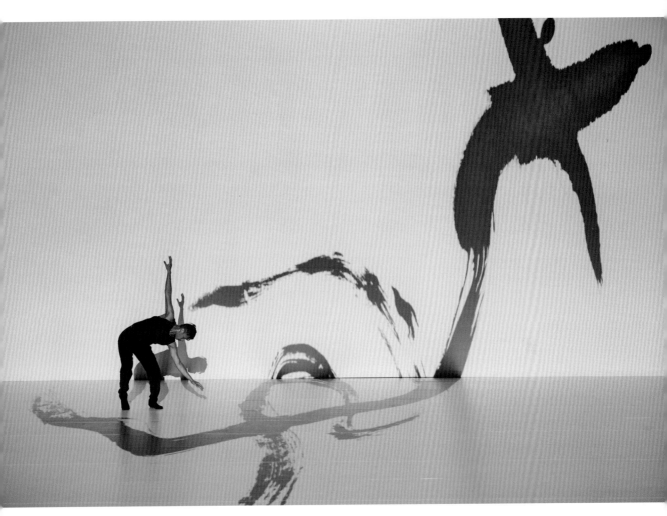

Sao 2016 No.1 騷 2016 之一 2016

That book now has a title: *Cheng—Tong Yang-Tze's Moving Sculptures.* It is a lasting record of the artist's journey, promoting the idea of sincerity by showing how earnest and sincere Tong is about calligraphy in all its forms and manifestations.

Translated by David VAN DER PEET 范德培

* From *Yuanjian*《遠見》(*Global Views Monthly*), 344, February 2015.

A-Sun Wu

Primitive Charm in the Art of A-Sun Wu

阿三的蠻荒魅惑

Carlos G. TEE 鄭永康

Sang Sang & Nani (Detail) 2007 & 2012 Wood Board 183×183cm

吳炫三 (1942-)
A-Sun Wu (also Wu Xuan-San)

Born in Yilan, Taiwan, A-Sun Wu is a well-known painter, sculptor, and collector of primitive art. He is known for the bursting vitality of artistic interpretation of primitive art. He graduated from National Taiwan Normal University's Department of Fine Arts and studied in Spain and the United States. In the 1970s, he travelled to Africa, Latin America, the Arctic, and Oceania to visit the aboriginal tribes and to experience their lives first-hand. Following this, his style changed and he produced works with vivid colors and intense brushstrokes.

Later, Wu continued to travel assiduously all over the world. His works have also been exhibited in many countries. He won the Wu San-lien Arts Award, the National Award of Art, and the Ordre des Arts et des Lettres.

A-Sun Wu traveled to five continents in search of artistic inspiration. There he found the primitive beauty of nature and the human soul.

To the outsider, his works appear as though they were created by an ethnic African artist. But beneath the veneer of such primitive, often haunting, expressions is a complex motley of inspirations and origins that cross the boundaries of cultures and ways of life. Today, A-Sun Wu draws artistic inspiration from childhood memories of bucolic life in his native Yilan, as well as the things he saw and observed in his many travels: the symbolic totem of the Mayan ruins, the lush vegetation of African savannas, or even the stark contrast between strong sunlight and the shadows it casts. It is this curiosity, at once artistic and humanistic, that has

become the driving force behind three decades of tireless travels, art creation and study.

In 1970, shortly after graduating from the Department of Fine Arts at National Taiwan Normal University, A-Sun Wu traveled to Spain. There he spent three years learning Western painting at the Royal Academy of Art. During this period, he learned the use of ink to depict sense of dash and vigor. Spain attracted him for its simple and homey surroundings that quaintly reminded him of his birthplace. Many years later, he recalled that what he could associate with Spain were nature and people. His paintings of this period were thus a harmonious blending of these two.

Convinced that painting is a lifelong pursuit and that an artist must face constant pressure in order to develop a unique style, Wu again left Taiwan in 1974 for New York. He found the city completely different from what he had seen before and the stark contrast strengthened his character. This period in the evolution of his painting career is characterized by realistic works often depicting the fast pace of life in the Big Apple with a vivid palette. It was during this four-year period when his skills as an artist matured.

After a brief stay in Japan, A-Sun Wu decided to return to Spain, from where he took many

Asmat Family 阿斯曼家庭 2005 Acrylic on Canvas 238×369 cm

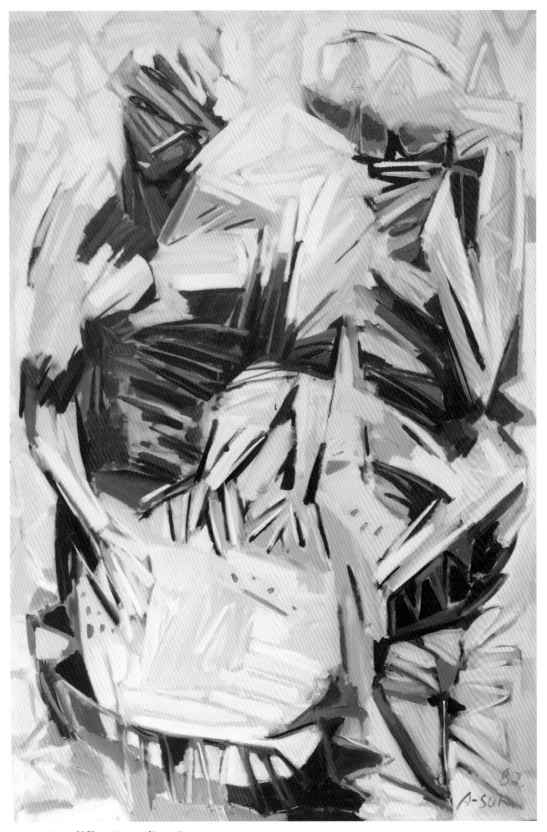

Drum Beat 鼓聲 1982 Acrylic on Canvas 130×194cm

trips to the African Continent. The African sojourns that started in the summer of 1979 proved to be deeply influential, for they changed the very way he conceived art as it is and the style of his creative expressions. As he recalled many years later, his African trips made him learn more things from human beings and nature than from all the art history books and museums he had read and seen.

Africa intrigued him in many ways. He loved the vast expanse of the continental heartland and found artistic inspiration in its simple people, as well as the diversity of the life forms it hosted. Even the shadow cast by the strong African sun gave him ideas on painting expressions. Africa was the wellspring of his keen sense of primitive beauty, something that was to leave an indelible mark on his artistic persona.

His works during this period thus project a strong primitive appeal. Taking inspiration from the resilient stubbornness for life of the African peoples, he developed rough brush stroke to create works that reminded one of the vigorous lines of tribal sculpture. In the second phase of his Africana trips, lasting from 1982 to 1983, his paintings showed even more changes. He adopted

East African Chief 東非酋長 1987 Acrylic on Canvas 130×194cm

South Pacific Legend 南太平洋傳說 1988 Acrylic on Canvas 162×130cm

bolder lines and incorporated more dash and rhythm into his works. It was during much of this period when he decided to adopt primitive simplicity as the lifetime theme of his art. The impact of Africa on him cannot find better description than in his own words: "This African trip changed the structure of my painting, especially in my lines. I indulged myself in a dynamic, vibrant, dazzling presentation and freed them on my canvas. It's like extemporization and release of obsessed hysteria beyond the control of consciousness."

For A-Sun Wu, artistic creation is always a process, never a finale. This and the fact that he loved traveling made him embark on another trip, this time to Central and South America. There he was awed by the highly developed cultures reflected by the ruins of the Maya and the Inca, especially their ancient totems, architecture, pottery and textiles. During this period in the development of his career, he depicted the scenery, life and customs in the tribal villages scattered along the banks of the Amazon and in the Andes. Form the Samba dance of the natives, he learned to portray dynamism and verve for life. Different from the previous stages, the works of this period are bursting with vibrant colors and rapid lines that aptly capture the rhythmic passion of the

Samba dancers. As a result, his style received an added dimension: a more direct sense of vitality and rhythm.

His exposure to Africa made him become even more fascinated with ethnic culture. From 1987 to 1995, A-Sun Wu visited islands in the South Pacific in search of more inspiration. Awed by the monoliths of the South Pacific, he once again felt that burning passion for things primitive. This inspiration resulted in a series of works that personified rocks and stones. With a keen sense of imagination, he also completed a series of paintings centering on the legends and folklore of the islands. He later visited New Guinea to study the Paleolithic culture of the Asman tribe, resulting in works that are typified by the use of three dominant colors: black, red and white. His artistic expressions, combined with the eye-catching interplay of these colors, added more ethnic impact to his works of this period.

Between 1992 and 1993, A-Sun Wu painted several works featuring the human face to depict the wide spectrum of human emotions. Describing this series of works which showed haunting, primitive appeal, he said that he had merely drawn landscapes on faces. He has always been

Beaded Hair Lady 珠髮女郎 1990 Acrylic on Canvas 182×227.5cm

fascinated by the effect of strong sunlight on things. For his next series of works, he adopted neon colors to depict glaring sunlight and used cyclic rhythm in his lay-outs to infuse a sense of motion in his subjects.

In 1995, he again traveled to New Guinea to observe the Asman tribe. Dipping into Asman tribal woodcarving art, he created works using the colors red, black and white and employed lay-out that are crisp and simple. A-Sun Wu paints in a way that art critics would rather call interpretation than mere expression. He shapes his paintings through a direct contact with his subjects and paints while watching, instead of watching before painting. This method perhaps explains why his works project a directness that can only be found in primitive art or children's drawings. He tries to express the feeling of something with color and shapes bearing no direct resemblance to the real thing. When one looks at his paintings, it is easy to see that his contours disappear and the rhythmical presentation of the subject's details is magnified. It is this latter feature that makes people associate his work with abstract painting.

Wu often emphasizes that there is no fixed angle or direction to view his paintings, especially

Irian Jaya Family 伊利安家庭 2006 Acrylic on Canvas 200×250cm

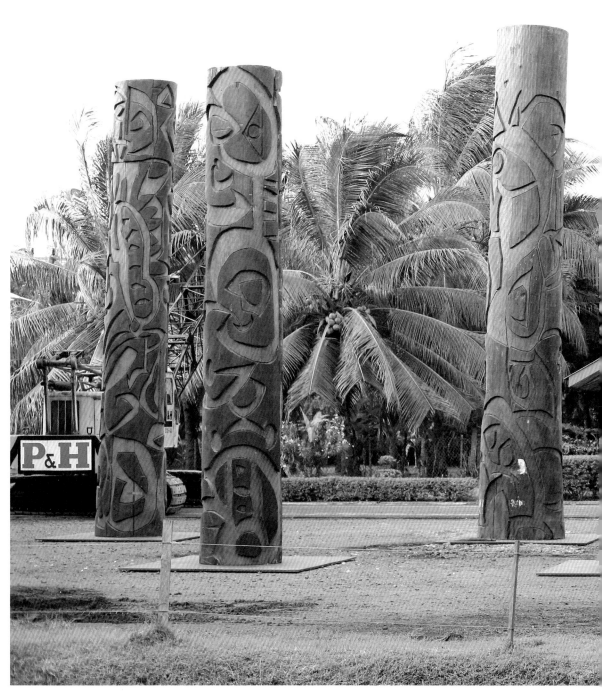

We are Family : A Metropolis Jungle 我們都是一家人：都市叢林　2008　Wood Carving

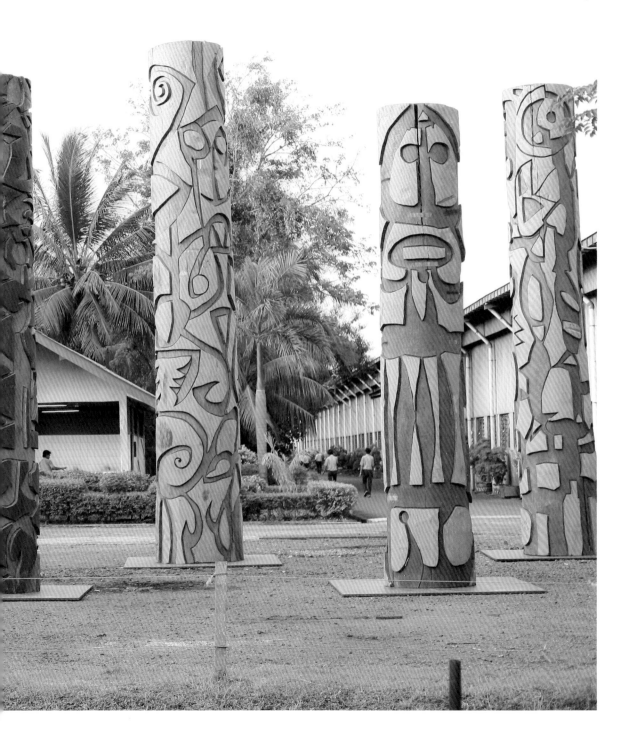

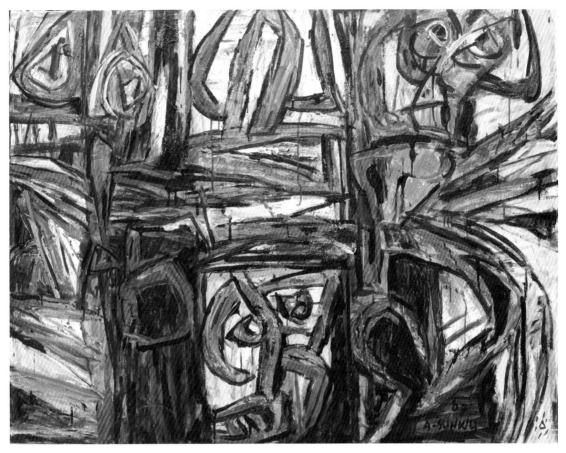

A Girl Wearing a Skirt 穿裙子的女孩 2007 Acrylic on Canvas 146×112cm

his more recent works. He thus sometimes signs the same work twice, one on top and one at the bottom, such that it is possible to hang his work upside down. When asked to explain his lay-outs, A-Sun Wu merely said that "by withdrawing the dimensional concepts, we can redefine mankind's role and position in the universe."

Despite the strongly African charm of his works, A-Sun Wu's real primitive attributes are in Taiwan. This can be seen in the dominant colors that he used. Red, white and black are typical of the arts and crafts of the Yami people living in Taiwan's Lanyu (Orchid Island). These colors are replete with symbolism. Red represents blood, life, energy and joy. White symbolizes peace, while black stands for tolerance, primitivism and essence. For him, these colors are rooted in the core of humanity and in our most convoluted and complex inner selves.

Later in his career, Wu found a new genre in pottery whose inspiration came from memories of his childhood days in rural Yilan. He remembered having been surrounded by large earthenware jars filled with preserved vegetables and food, and being asked by his grandmother to step on salted turnips inside a jar prior to drying in the sun. In search of the right clay material to use, he went to Spain, France, Japan and many places in Taiwan. He found it in the South Pacific. It was

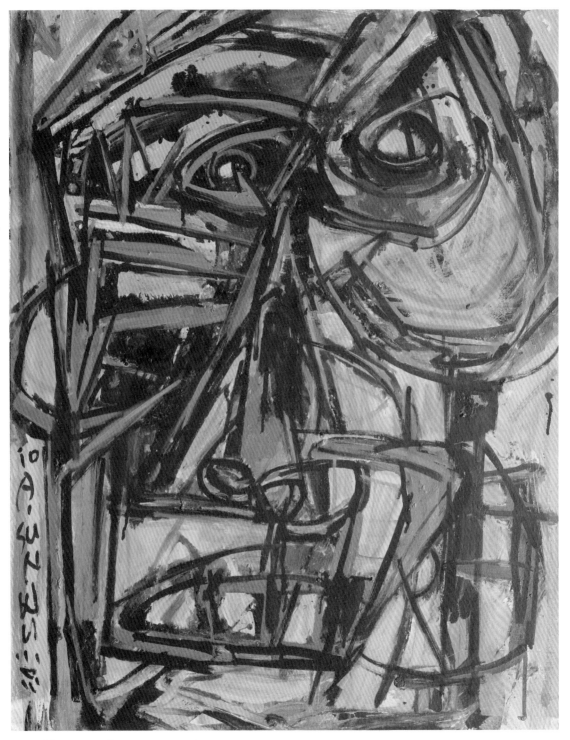

Hope 盼 2010 Acrylic on Canvas 73×61cm

My Sister and I Playing at Grandma's Home 我和姊姊一起在外婆家玩　2008　Acrylic on Canvas　112×435cm

Statue and Totem 雕像與圖騰　2006　Old Board　206×17×104cm

Vitality of the Jungle 叢林的生命力 2012 Acrylic on Canvas 162×194cm

clay material that he fired with a characteristic burnt smell reminding him of over-roasted sweet potatoes, a snack he enjoyed as a kid while grazing the family cow in the fields.

A-Sun Wu's efforts have been well rewarded. His works now form part of the collection of important museums and art collectors around the world. He received various awards including the Paris International Young Artist Award, the Ministry of Education Special Culture Prize and the Wu San-lien Arts and Literature Award, among others.

Speaking after one of his trips to Africa, A-Sun Wu said: "Even today there are a number of friends who still fail to understand why I made the trip to Africa. Yet this journey of my life, which I made at a great cost, in terms of finance and health, has turned out to be more meaningful and fruitful, in my mind, than my trips to the United States and Europe."

Indeed, the molding spirit of Africa, that dark and enigmatic continent, has created A-Sun Wu and has shaped his artistic career. He was right when his instinct told him to "listen to the voices of the dark" as Victor Hugo put it one-and-a-half centuries earlier.

* From *The Chinese PEN* (Taiwan), (now *The Taipei Chinese PEN*), 107 (Spring 1999) 40-51.

Syue Ping-Nan

Master of Calligraphy and Seal Making

薛平南：書印雙雋

TSAI Ming-tsan 蔡明讚

Seals carved by Syue Ping-Nan 薛平南篆刻
作品
From *Xue Ping Nan Zhuanke Ji*《薛平南
篆刻集》[Syue Ping-Nan Seal Carvings
Collection]. Taipei: Topline Study Treasures
Co., 2011.

薛平南 (1945-)

Syue Ping-Nan (also Xue Ping-Nan)

Born in Kaohsiung, Taiwan, Syue Ping-Nan graduated from Taipei Municipal Teachers College and later from the National Academy of Arts. He is good at both seal carving and calligraphy, combining the traditional with innovation.

Syue Ping-Nan's calligraphy achievement was the result of intensive study of different styles of ancient Chinese calligraphers. He learned both the *Bei* (engraved stone tablet calligraphy) and *Tie* (master works printed on paper) of Chinese calligraphy, and has won the Zhongxin Literary Award, the National Award of Arts, and the Zhong Shan Literature Award. In recent years Syue Ping-Nan has hosted television programs and recorded CD-ROMs on the art of calligraphy and seal cutting in Taiwan.

In the winter of 2003, Chinese Television System (CTS) of Taiwan produced the program *Calligraphy Lessons—Writing and Appreciating Calligraphy*. The program's focus was on instructing the audience in the writing techniques (through demonstrations from the master) and the principles of aesthetic appreciation, starting with the basic concepts and progressing via introduction of the five principal calligraphic styles: standard, running, grass (or cursive), official and seal. Because of their rich and highly instructive content, as well as the vivid presentation, a thousand copies were sold on DVD less than half a year after the program was broadcasted, causing quite a stir in calligraphy circles. The tutor starring in the program was the widely acknowledged calligraphy and seal master, Professor Syue Ping-Nan.

Syue Ping-Nan was born in Kaohsiung in southern Taiwan in 1945. He graduated from the PE Department of Taipei Municipal Teachers College and the Department of Craft Design at Taiwan Arts College. For his creative work in calligraphy and seal, he has received

Calligraphy in Seal-script Style　篆書六屏條　寒玉堂聯文　2014　136×34cm×6 (Collection of Taiwan Soka Association)

various prestigious awards, and has taught at a number of colleges and universities in Taiwan. He is widely recognized as an eminent authority and artist in the field of calligraphy and seals.

Syue Ping-Nan began the serious pursuit of calligraphy at the age of twenty, studying at the "Hsin Taiping Shih" under the tutelage of Li Pu-tung 李普同 . At thirty, he became the disciple of Prof. Wang Chuang-wei 王壯為 who initiated him into the art of seal carving. When he was 34, he resigned from all his teaching posts to focus all his energy on calligraphy and seals. Today, he looks back on past years of creative work, teaching, making friends, promoting calligraphy and seal, exhibitions, travels, collecting curios, studying and other refined pastimes, a remarkable career characterized by his indefatigable quest for excellence and outstanding achievements. These came as a result of small steps and gradual growth, a deliberate and well-measured cultivation only possible through perseverance and practice. Syue's calm nature, studious disposition and open-minded, generous personality are legendary and much admired.

As an indication of his aesthetic orientation and preferred calligraphic tradition, Syue has a personal seal engraved with the characters *you pai* 右派 , which denote the school of calligraphy rooted in the standard grass or cursive hand of Yu You-ren 于右任 and the natural and vigorous *Beibei* (northern stele 北碑) style. But the truth is that Syue Ping-Nan acquired a high level of proficiency in all calligraphic styles by famous calligraphers, be it the seal script, the official (clerical) style, grass hand, running script or standard (regular) style. His standard hand is based very much on the compact and regular scripts of Ouyang Xun 歐陽詢 and Chu Suiliang 褚遂良 , while his Beibei hand follows the models of Zheng Wengong and Cui Jingyong, marked by a refreshing simplicity and liveliness. When writing in the official style, Syue tends to emulate the solid and dignified patterns of *liqi* 禮器 and the East Han *Yiying* 乙瑛 Stele, while his seal style calligraphy, inspired and of graceful fluidity, is clearly influenced by Deng Shiru 鄧石如 and Wu Rangzhi's 吳讓 之 small seal, as well as Wu Changshuo's 吳昌碩 Shigu Wen 石鼓文 inscriptions on drum-shaped stone blocks from the Warring States Period, 475-221 B.C.). Finally, Syue's running and grass ("cursive") hands, although not quite at the center of his focus, can yet be described as his most distinctive scripts in many ways: basing his style firmly on Yu You-ren's standard grass hand, Syue has clearly internalized the paramount tenet "employ the running style where appropriate, and glide into cursive writing where inevitable." Renouncing the southern style (*Nantie* 南帖) of the renowned "Two Wangs" (Wang Xizhi 王羲之 and his son, Wang Xianzhi 王獻之) with its strong emphasis on smooth lines and supple elegance, Syue rather adopts a more rugged and forceful approach, going somewhat against the mainstream of running and cursive hand calligraphy since the establishment of the Republic of China in 1911. It is almost as if Syue was eager to achieve a conspicuous blend of the more impetuous *Beibei* and the subtler *Nantie* schools, and since his specific style employs less continuous lines and more unbroken curves, it has a more solid and robust quality, surprising the eye with unexpected twists and determined strokes. The overall effect is intriguing, and very distinct from the tempered firmness that distinguishes the "hard yet soft" lines of the standard style or the gentle curves of the seal script. Put in other terms, most

Calligraphy in Cursive-script Style 行草四屏條 忠介誠篤 及時行孝 翔泳歸仁 敬天愛人 2014
136×34cm×4 (Collection of Taiwan Soka Association)

calligraphers are apt to highlight the powerful lines, full of "bone and muscle," in the writing of Tang (Dynasty) standard style or *Beibei* (northern stele) script, and to accentuate the softness and elegance of the strokes when producing pieces of free-flowing running or grass hand in the tradition of the Two Wangs and the later Ming and Qing dynasties. Not so Syue, who essentially uses the seal style to write *Beibei* calligraphy and manages to express the restrained force of "steel packed in cotton" in seal, standard, official and stele (monumental) pieces. Turning to running and cursive work, on the other hand, Syue's art bears the above-mentioned but frequently overlooked characteristics of fewer continuous lines and more twisted or broken strokes. These unique attributes are largely due to the fact that Syue's brushstrokes are firmly grounded in the standard grass hand, giving his writing a well-rounded and vigorous yet also rugged appearance. Considering this aspect, we find that he has already transcended the limitations of his Master Yu You-ren's oeuvre—wielding the brush with the firm hand typical of the regular seal and northern stele styles, he yet gives sufficient rein to the original and idiosyncratic elements of the standard

cursive script to come up with his own rather unconventional brand of the *You Pai* style.

If we are to identify Syue's most mature and compelling style, our choice has to be his seal script. Here his talent finds its fullest expression in a graceful, well-polished hand, which is the result of combining elements from both the great and the small seal styles: the rhythmic beauty of Li Si 李斯 and Li Yangbing's 李陽冰 small seals are amalgamated with the poised charm of Deng Shiru and Wu Rangzhi, and further tempered with the plainer, less adorned yet powerful strokes of ancient bronze inscriptions 金文 or Wu Changshuo's stone-drum carvings. In form and structure, Syue's calligraphy thus successfully merges the best qualities of both seal styles, achieving a vivid expressiveness and visual appeal that never deteriorate into ostentation, but maintain a balanced harmony and serenity. Surveying the great masters of the seal style since the beginning of its heyday during the Qing Dynasty, it becomes clear that what is usually called an artist's distinctive strength is in fact often his overindulgence in one single aspect of the style. This could, for example, be said of Deng Wanbai 鄧完白 (or Deng Shiru) and Wu Rangzhi's tendency towards extreme aesthetic refinement, of Zhao Zhiqian 趙之謙 and Xu Sangeng's 徐三庚 peculiar charm and preference for original, unorthodox designs, or of He Yuansou 何蝯叟 (or He Shaoji 何

Seal Carvings 篆刻 得真如 含章可貞 涵之如海

Seal Carvings
誠意　我愛吾廬　福海壽山

紹基) and Huang Binhong's stark simplicity. As for Wu Changshuo, his strokes sometimes tend to display an excessive fierceness, while Qi Baishi 齊白石 occasionally has a propensity to err on the side of willfulness. By contrast, Syue, applying smooth strokes with a steady hand, uses just the right amount of meticulousness and restraint without sacrificing creativity, which is why we may well call him the proponent of a moderate school of modern seal calligraphy. Examining how he developed his particular style, it becomes evident that Syue's secret lies with the old formula "cultivating calligraphy via seals, and vice versa." In the thirty years he spent in perfecting his seal-making skills, Syue produced between four and five thousand seal sketches: imperial seals in the Qin and Han Dynasty styles, Yuan Dynasty stamps and Qing Dynasty seals in Anhui and Zhejiang styles, topped off by a variety of works in ancient calligraphic styles (including characters that were abandoned or modified in the Qin Dynasty's script reform). Syue's comprehensive knowledge of the various schools and styles allows him to roam freely back and forth between the closely intertwined arts of seal and calligraphy, but he always writes up a design on paper before he proceeds to the cutting part. In doing so, he pays painstaking attention to the finest details of composition and structure, and in the completed works we may appreciate the craftsmanship and mature aesthetic sense that went into the embellishing and polishing of every single piece. Zhao Huishu 趙撝叔 (or Zhao Zhiqian) once said, "For seal carving, one follows established practice, for everything outside of it, one uses one's skill. But keep in mind that true skill comes only with good

231

Calligraphy in Clerical-script
Style　古隸四屏　菜根譚五則
2008　135×34cm×4
(Collection of Taiwan Soka
Association)

菜根譚五則

寵辱不驚　閒看庭前花開花落　去留無意　漫隨天外雲卷雲舒（其一）

氣象要高曠　而不可疏狂　心思要縝密　而不可瑣屑　趣味要沖淡　而不可偏枯　操守要嚴明　而不可激烈（其二）

階下幾點飛翠落紅　收入來無非詩料　窗前一片浮青映白　悟入處盡是禪機（其三）

心無物欲　即是秋空霽海　坐有琴書　便成石室丹丘（其四）

心地無風濤　隨在皆青山綠樹　性天有化育　觸處都魚躍鳶飛（其五）

practice!" Good practice can produce skillfulness, and skillfulness will allow a calligrapher to wield the brush-pen with great ease and inspiration, and free from any constraints. Cases in point are Wu Dacheng of the late Qing Dynasty, who made copies of the *Confucian Analects* 論語 and the *Classic of Filial Piety* 孝經 in the style of ancient bronze inscriptions, employing it even for epistles or letters, and Wu Changshih, who wrote collections of poems and couplets in the stone-drum style. Both artists opened up new vistas for the art of calligraphy—and so has Syue, who amply displays his experience and genuine skill in his seal style renderings of Tang Dynasty poems, which strike a delicate balance between solid craftsmanship and a natural and unrestrained elegance. In recent years, a strong wind of "experimentalism" has been blowing through calligraphic circles. Many artists are now vying to outdo each other in "deconstructing Chinese characters" and "letting the ink flow freely" to impress with some kind of dazzling results, but what they really achieve are often carelessly executed specimens, put together in a slapdash fashion and without much aesthetic appeal. Syue has not been affected by these modern trends, but continues to follow traditional artistic practice and principles to craft large screen works with monumental seal style characters that truly impress with their momentum and impetus. Even when produced in a swift

Calligraphy in Stone-inscription Style　北碑四屏條　敦師悅禮　孝悌端雅　據德依仁　篤信樂道　2008　136×34cm×4
(Collection of Taiwan Soka Association)

and seemingly casual manner, these pieces manage to capture the imagination with their splendid beauty.

Syue Ping-Nan learned the ropes of seal carving from Wang Chuang-wei, mostly according to the Anhui style of Wu Rangzhi. As Wu Fouweng put it, "I have always held that instead of emulating Deng Wanbai, it is much more profitable to follow the example of "Master Rang" (Wu Rangzhi)." His stance can probably be explained by the fact that while Deng, "Wanbai the Recluse," excelled in every style and initiated a great revival of classical calligraphy (which resulted in the establishment of an eminent school by his followers), Wu Rangzhi expanded on Deng's style, which he much admired, to create something new and original. Gao Yehou 高野侯 , an accomplished seal engraver, painter and scholar from the Republican Period, had the following to say about Wu: "When carving seals, Wu wields the knife like a brush-pen, applying the tip of the blade with supreme subtlety and skill, particularly where lines connect and in places where strokes twist, turn or curve. In seal-style calligraphy, Wu's talent shows in well-rounded yet dynamic strokes that epitomize the best of Wanbai's art. Even so, Wu falls rather short of Wanbai in terms of forceful vigor and grandiosity, largely because Wanbai has a preference for even, completely balanced strokes, while Rangzhi is at his best when going for the unconventional and out-of-the-ordinary." In Syue's seals, the same dynamic elegance and effortless fluidity are apparent that also mark Wu Rangzhi's expert use of both carving knife and brush-pen. At the same time, Syue imbues his work with the bold magnificence of Wu Changshuo's stone-drum-inscription style, thus resolving the shortcomings of the Anhui schools. Renowned Master Ye Ming 葉銘 of Hangzhou's Xiling Seal Society 西泠印社 declared, "To become well-versed in the art of seal carving, it is absolutely mandatory to be able to go beyond the usual limitations and conventions. Those who are satisfied to stay within the traditional boundaries of the art will be content to follow the patterns and shapes of the Qin and Han seal styles, doing everything strictly by the book, and copying every stroke and every character from existing examples. Those, however, who are willing to look for inspiration outside of seal carving proper may sample all the fine arts at liberty to select their finest features and essential traits, to combine and connect these features to create something fresh and novel, and in doing so sublimely transform the entire genre. He who can accomplish all these things has truly reached the highest level of seal carving, and will achieve a beauty and aesthetic pleasure beyond words." Syue Ping-nan's seal oeuvre, while firmly rooted in the orthodox Qin, Han, Yuan Dynasty styles, also continues the Two Wangs' tradition of "viewing calligraphy and seal as one," an integrated and harmonious whole where one may detect traces of engraved inscriptions in written characters, and the smoothness of the brush-pen emerges in the carved seal. Last but not least, painstaking composition, minute attention to details and careful execution are the paramount creative principles that give Syue's finished seals their compact and ingenious quality.

Over the past twenty years, many widely favored, high-quality seal materials have become readily available, including pagodite 壽山石 , but also others such as rose quartz, Qingtian stone

Calligraphy in Seal-script Style 篆書六屏條 擬中山王器銘 2014 136×23cm×6

青田石 and Balin stone 巴林石 , all coming in a variety of textures and colors. This has created favorable conditions for seal carving artists, as has the publication and reissue in recent years of numerous seal print collections sampling specimens throughout the Chinese Dynasties. These compilations are now easily accessible to contemporary artists, who also tend to exchange ideas and appreciate each other's work, all of which is making it so much easier for them to look for "outside inspiration." Syue's work is characterized by two distinguishing features. To begin with, he will "select the stone to fit the design," which means that he first comes up with the theme or content, and makes a calligraphic sketch, before he starts to look for a stone of a suitable material that has the right size and texture to fit the proposed design. Secondly, Syue prefers

oval-shaped Yinshou seals 引首章, because their more irregular shape allows for more diverse compositions and structural variety than square or rectangular seals, making them ideal for the Anhui Zhuwen style. (Yinshou seals, which can be rectangular or oval/round-shaped, are used usually at the head of a piece of calligraphy, or in the top right quarter of paintings, mostly to balance the composition.) It is often said that "as the knife cuts, the artist's emotional energy is carved into the seal stone." If you choose a stone of superior quality that is smooth and pleasant in appearance, apply your knife with brisk, competent efficiency and arrange the spaces in an appropriate manner, then your seal will naturally and easily surpass other pieces and stand out even among the best specimens. But let us not forget that when you have completed the seal's *mian* or "face" 面 (the main part) to your full satisfaction, there is still the margin script 邊款 that also requires your undivided attention. Aesthetically it is very disappointing when the perfect luster, superior material and exquisite carving of a seal are not matched by an equally well-executed margin design. As a rule, Syue Ping-Nan does the signatures on his seal margins in the standard style of the Jin and Tang Dynasties, wielding the knife like the brush and placing the characters with infallible accuracy. With Syue, the margins generally show the same delicate and thought-out structure as the seal proper, which explains why many connoisseurs and collectors show a particular affinity and predilection for his seals. Syue Ping-Nan told me how Wang Chuang-wei once carved a seal carrying the inscription "Calligraphic expression changes and matures with the years." This could very well serve as a description of how Syue has currently entered into a new phase of his artistic career. In the past, he used to focus entirely on the pursuit of perfection in seal carving and ideal proportions in seal-style calligraphy. Predictably, this sometimes led to a certain amount of over-sophistication at the cost of spontaneity. Yet today, Syue is more inclined to exercise restraint and "let good be good enough." He may even leave a few imperfections and traces of the cutting process to add a touch of naturalness. He himself calls this "mixing conscious effort with intuitive spontaneity, or striving for the best in one's work but also knowing when to stop and let go." This is the highest plane of artistic achievement, when talent and skill have metamorphosed into pure artistic genius, which

Calligraphy in Cursive-
script Style　行草中堂
白居易和元積放言
2014　136×68cm

賜君一法決狐疑　不用鑽龜

祝蓍試玉要燒三日滿辨材

須待七年周公恐懼流言日

玉莽謹蕪未篡時向使當初

方便死一生真偽復誰知

公秉山和元積言放言　甲午羿春薩君爾政七十

is then further cultivated until one may attain the level of divine intuition. This stage can only be reached gradually after many years of constant and devoted practice. You could also say that a piece of calligraphy touched by divine intuition is a direct reflection of the artist's lifelong pursuit of mastership, and its final culmination in a state of unconstrained, free-flowing creativity. Having said that, we can still identify some clear-cut individual traits of Syue's style: he basically combines exceptional vigor and verve with a carefree and elegant ease, embracing both the solid and powerful magnificence of the You Pai School's Beibei (northern stele) tradition and the dynamic elegance and genuine smoothness of the two Wangs. Thus he achieves a unique and refined style without ever compromising his own aesthetic principles.

In China, poetry, calligraphy, painting and seals are considered to be the main genres of artistic expression for intellectuals and scholars, and as such they may be pursued independently or, more often, practiced as complementary arts. During the Tang Dynasty, poetry, calligraphy and painting were first called "the three peerless arts," a classification that lasted until the middle of the Qing Dynasty, when seal engraving became so popular and widespread that it was given equal status, and henceforth poetry, calligraphy, painting and seal were known as "the four peerless arts." Even before that, right up to the beginning of the Qing Dynasty, proficiency in all the three peerless arts was regarded as the mark of an accomplished scholar, as it indicated the highest achievement both in terms of character cultivation (developing one's talent and wisdom) and academic success (study and erudition). Of the men of letters who have devoted themselves to the four peerless arts, some have excelled in both poetry and calligraphy, such as Liu Shian and He Zizhen; others produced outstanding works in calligraphy and painting, such as Gong Banqian or Huang Yingpiao. Then there were those who are remembered for their excellent calligraphy and seals, among them Deng Wanbai and Wu Rangzhi. Those who managed to shine in poetry, calligraphy and painting include Zheng Banqiao 鄭板橋 and Jin Dongxin 金冬心 , while Zhao Zhiqian and Zhao Shuru 趙叔孺 stood out in the three categories of calligraphy, painting and seals. Finally, Wu Fouweng and Qi Baishi were able to create remarkable works in all four peerless arts. The role of intellectuals and scholars has undergone great changes in modern times, and art has become a specialized profession like many others in our industrial society. Under these circumstances, one may, according to one's talents and inclinations, select just one of the four "peerless arts" and concentrate on perfecting one's professional skills in that field—and this can be quite enough to build an entire career on. In this new environment, where earning a living is just as important as devotion to the fine arts, Syue not only developed his own distinctive calligraphic and seal style, but emerged as one of the major artists in those fields with an impressive oeuvre to his name, one that is valued and appreciated by his contemporaries.

Translated by David VAN DER PEET 范德培

* From Syue Ping-Nan's 薛平南 *Shu-yin chiao-hui*《書印交輝》[The double pleasure of calligraphy and seal]. Taipei: National Sun Yat-sen Memorial Hall, 2004.

Shi Song

Buddhist Artist Shi Song

修行人的藝術實踐—
大樹之歌・畫說佛傳

YEN Chuan-ying 顏娟英

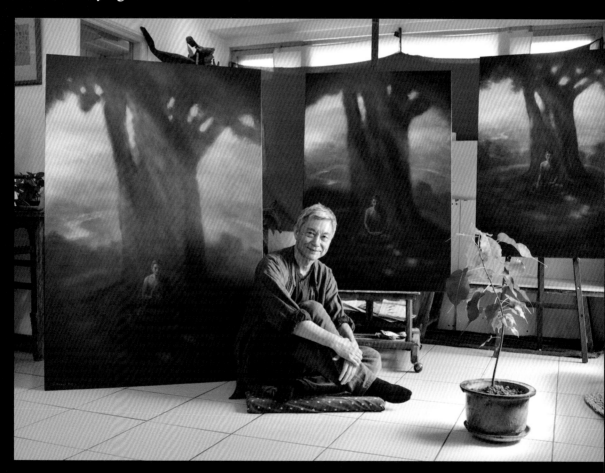

Shi Song 奚淞　(Photo by Hsu Yu Kai 許育愷 , courtesy of Shi Song)

奚淞 (1947-)

Shi Song (also Xi Song)

Born in Shanghai, China, Shi Song and his family came to Taiwan in 1949 with the Nationalist government. After graduating from the National Academy of Arts, He went to France to study painting. He is now one of the few Taiwanese artists to apply Western techniques to Oriental Buddhist paintings.

Shi Song is also an accomplished author. His works include essays, novels, literary works combined with paintings. His exploration of Buddhism turns artistic creation into a form of meditation and his literary works an in-depth exploration of life.

Shi Song is renowned for his series of line-drawing Bodhisattva images and still-life paintings. He also pictures the life story of Buddha on canvas.

Besides being a painter and writer, Shi Song is also an expert calligrapher as well as woodblock artist.

Art practice is the practice of spiritual cultivation through artistic creation. Spiritual cultivation is an essential daily commitment that may include walking meditation, sitting quietly, copying the sutras, or, with great concentration and an attitude of reverence for the Buddha, painting a flower in a dish of water or an image of Guanyin, or continuing to conceptualize how to express the mental state of Buddhist cultivation as well as observing daily one's own Buddha nature mature through art. Shi Song is a rare example of a Buddhist practitioner-cum-artist.

In traditional Buddhist painting, expression in paint and Buddhist sutras are mutually complementary and supportive. Thus, it can be described as "telling the life of the Buddha in pictures," or the sutras transformed into visual images. This kind of pictorial expression possesses a strongly literary, narrative quality, and revolves around the story's main character, highlighting the merits of the Buddha's work. It could be likened to a comic strip, presenting a series of climactic events. Yet the story's setting, such as the rocks and trees, are not the main point of expression. Shi Song's painting series *Song of the Great Tree* conveys the story of the Buddha with realistic, natural scenery, using the eternal vitality of a tree as an ode to the life of the Buddha. The broad, serene emerald-green forest symbolizes the rain of the Dharma nourishing the earth. It represents the Buddha's equanimity and compassion, and at

the same time brings everyday spiritual cultivation back to the simplicity of earth, water, fire and wind— all the fundamental causal relations of material phenomenon seeking out the harmony of the four great elements, the never-ending care of the earth.

The Buddha in Shi Song's eyes is not the stereotypical image— ancient, faraway, mysterious, unfathomable. Quite the opposite: The Buddha is dynamic and understanding. He travels in spiritual cultivation throughout his life, living as an example for the people of the world, through gentle words and deeds, speaking the Dharma far and wide to all who are fated to hear. To seek out and observe the places where the Buddha once walked, the artist traveled several times to India and Nepal, where the Buddha lived and attained enlightenment, as well as to Burma and Thailand, where primitive Buddhism is still commonly practiced, to personally encounter the myriad changes that the Dharma reveals. Therefore, the scenery in Shi Song's paintings of the life of the Buddha includes the primitive forests of South Asia and Southeast Asia, saturated with sunlight and youthful vitality, yet it also blends in the banks of the Xindian River, where the artist often walks meditatively in everyday life, and the moist, shifting, warm, graceful hills nearby. The earth has nurtured the myriad creatures, ceaselessly in motion. Humanity relies on it for survival, just like the Buddha's teachings, boundless and ever-present in the world, consoling the human heart. Shi Song has said that he hopes, through his heart and eyes and hands, to convey in his art what he repeatedly experienced: "using my feet to measure the earth that the Buddha walked, using my eyes to see the scenery the Buddha saw" (*Scenery*). His artistic creation is in fact spiritual cultivation, using his heart to cling close to the immeasurable heart of the Buddha. This heart is broad and unbounded, gentle and all-encompassing. It is transparent as empty space, yet able to shine on all living creatures, illuminating the whole world.

Spiritual cultivation has no borders or limitations. Shi Song's stories of the Buddha's life have no theatrical climaxes or narrative distraction; rather, they depict the moment right before, or the process through which, cultivation ushers in a new state of mind. In *Mother Maya Travels to Lumbini*, the artist says:

> *Great with child, Maya the mother of the Buddha rides an elephant to the*
> *gardens of Lumbini. The wild lotus pond, penetrated by light from the heavens*
> *and surrounded by the shade of the forest, is like a channel through which*
> *the new life moves toward the world.*

In the lower left corner of the painting, the mother of the Buddha, riding an elephant, and her retinue—all intricately depicted—emerge from under a giant tree that encircles them. The peaceful, bright lotus pond in the center seems to symbolize the uterus nurturing the new life, drawing the viewer's line of sight into the deep reaches of the forest, attesting along with Maya to the birth of the Buddha. In this large painting, the artist's careful, delicate brushwork reflects a soft substantiveness accumulated after repeated observation over a long period of time. Moreover, the exceptionally expansive spatial framework, reminiscent of architecture, gives the viewer the three-

Old Vase 古瓶 1999 Oil on Canvas 100×80cm
From Shi Song 奚淞 , *Guangyin shitie*《光陰十帖》[Ten still-life paintings depicting time]. Taipei: Lion Art Publishing, 2011, 15.

Osmanthus 桂花 2003 Oil on Canvas 65 ×91cm
From Shi Song 奚淞 , *Guangyin shitie*《光陰十帖》[Ten still-life paintings depicting time]. Taipei: Lion Art Publishing, 2011, 75.

Basil 九層塔　2003　Oil on Canvas　72.5 ×100cm
From Shi Song 奚淞 , *Guangyin shitie*《光陰十帖》[Ten still-life paintings depicting time]. Taipei: Lion Art Publishing, 2011, 61.

Jasmine 茉莉 2003 Oil on Canvas 72.5 ×100cm
From Shi Song 奚淞 , *Guangyin shitie*《光陰十帖》 [Ten still-life paintings depicting time]. Taipei: Lion Art Publishing,
2011, 23.

New Year's Orchid 報歲蘭 2003 Oil on Canvas 65 ×91cm
From Shi Song 奚淞 , *Guangyin shitie*《光陰十帖》[Ten still-life paintings depicting time]. Taipei: Lion Art Publishing,
2011, 17.

Guanyin Bodhisattva 白描觀音菩薩 Ink on Paper. From Shi Song 奚淞, *Sanshisan tang zhaji*《三十三堂札記》[33 notes and Guanyin Bodhisattvas]. Taipei: Lion Art Publishing, 1991, 151.

dimensional illusion of being present in the scene. This expression of space and time unconsciously draws the viewer in to see through the artist's eyes, personally sensing the tranquility, joy and reverence of Buddhist practice.

The artist, continuously engaging in spiritual cultivation, observes the minute changes transpiring within the flow of time, fathoming the heart of the Buddha in each motion and pulsation. In contrast to the realistic rendering of *Mother Maya Travels to Lumbini*, the next picture, *The Great Renunciation*, employs soft blue hues to express a moment of lingering sorrow and incomparable calm. The artist deeply senses the compassion of Prince Siddhartha, who early on "felt with sensitive nerves the impermanence and suffering of humanity and resolved to pursue the path of understanding." Fleeing his palace filled with desire and allure in the middle of the night, the prince arrives at the bank of the river at dawn, "shearing his own hair, shedding his royal robes and ornaments, and handing them to his servant" to carry back to the king's palace. From here he passes beyond the sadness and pain of the mundane world, and takes the solitary, eternal path of spiritual cultivation. The setting of this picture is the Xindian River near his Taipei home, where the artist strolls by himself every daybreak, in a forest of aAcacias. In the chilly morning fog, there seems to be a vague yet familiar shadow—a thin young man sitting with legs crossed,

A Blind Man 盲者 Woodblock Engraving

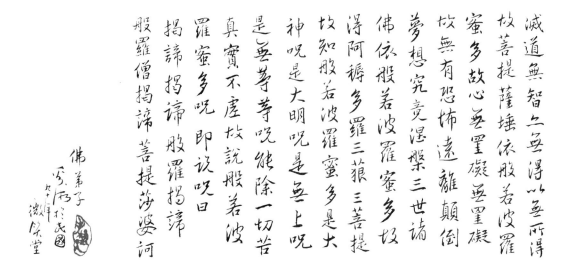

The Sacred Order/The Heart Sutra 聖教序／心經. From Shi Song 奚淞, *Xin yu shou: xie xinjing, hua guanyin* 《心與手：寫心經‧畫觀音》[The heart and the hand: transcribing the sutra, portraying Guanyin]. Taipei: Lion Art Publishing, 2001, 46-49.

lifting up his long hair and a sharp sword, quietly uttering an oath in his heart. As the sun pierces the blue clouds, the golden acacia forest and the surface of the water fill the viewer with lofty praise and limitless expectation.

　　Early Buddhist classics such as the Agama Sutra depict the Buddha from the time he left home until he became enlightened and developed a simple, spare life among a group of monks. The Buddha and his disciples developed a relationship of mutual reliance with lay believers both male and female who continued to live at home, a mutual relationship of benevolent teaching and sincere support that was particularly true and moving. The two paintings *An Offering of Grass* and *Gaining Enlightenment* subtly convey that, even at the most crucial moments, the Buddha did not forget the fundamental intentions of all living beings. Prince Siddhartha found an enormous, century-old pippala tree and, while sitting erect beneath it, he was about to engage in the ultimate, perfect meditation. A humble shepherd was out cutting hay and happened to pass by, and thinking to offer support to this dignified ascetic, he donated with his own two hands the only things he had—eight bundles of hay. Siddhartha gladly accepted this offering, and used it to build his "Diamond Throne" that "the eight winds cannot blow over." The man meditating and the man making the offer gazed on each other with feelings as close as father and son. The most trifling gift became an insuperable work of virtue. After a night of quiet meditation, Siddhartha "finally saw his true nature with a clear mind, and gained unsurpassed enlightenment." A Buddha was born.

　　Gaining Enlightenment depicts the most crucial moment in the life of the Buddha, and what has always been the ultimate wish of the many generations of those who have engaged in spiritual cultivation. That moment when the Buddha, after fearlessly braving the tests of Mara,

般若波羅蜜多心経

觀自在菩薩行深般若
波羅蜜多時照見五蘊
皆空度一切苦厄舍利子
色不異空空不異色色即
是空空即是色受想行
識亦復如是舍利子是諸
法空相不生不滅不垢不净
不增不減是故空中無色無
受想行識無眼耳鼻舌
身意無色聲香味觸法
無眼界乃至無意識界無
無明亦無無明盡乃至無
老死亦無老死盡無苦集

gains true enlightenment, has long been the common subject matter of Buddhist art, be it the Gupta-era sculptures of Sarnath or the Ajanta caves in India, or the Dunhuang caves in China. This scene has also appeared and reappeared at different stages in Shi Song's works. He has not portrayed Siddhartha as gaunt as a skeleton pursuing extreme austerity without success, nor has he depicted the feminine temptations of Mara. His picture shows sunlight saturating the deep forest and a river. The meditating Buddha resolutely sits, radiating a warm light, achieving a complete, precious Dharma in this world. In the center of the picture, the ancient pippala tree, like the life of the universe, protects the Buddha's honored place among humankind, and completes the web of causal relationships that led this tree to become the sacred Bodhi tree. Clear water flows by, and transparent air circulates around the meditating Buddha, quiet and calm. The benighted vexations of the world have vanished. The flora all around, the myriad creatures of the earth, all celebrate, bearing witness to the unsurpassed wisdom like a ripe, fragrant fruit. In this portrayal of the Buddha's process of enlightenment, the artist displays the deep experience of a devoted practitioner.

The First Teaching is the first step in the Buddha's life among his followers. Among the birds and blossoms of the forest, the earth is golden as the Pure Land itself. It is here that the Buddha teaches the Dharma to five ascetics. Each of these five earliest disciples has a different bearing and a different level of native intelligence. Each has been studying for a different length of time. Yet the Buddha is not even slightly concerned. From beginning to end he steadfastly explains the Dharma with boundless patience and equanimity. The Buddha teaches his disciples, constantly encouraging them, and the disciples listen with open minds, reflecting deeply. On the long, slow

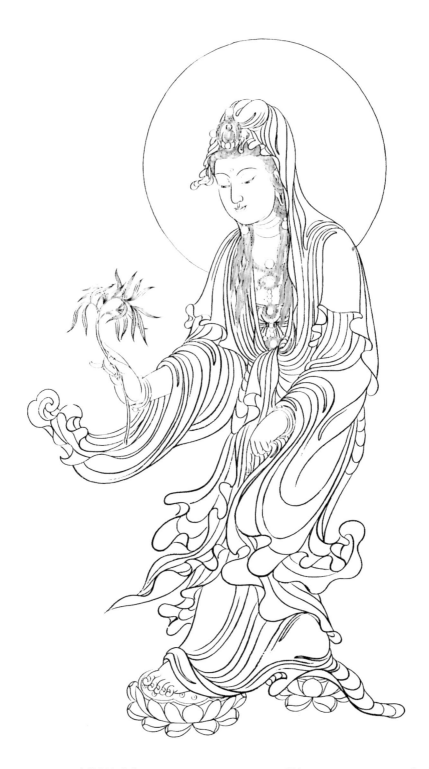

Guanyin Bodhisattva 白描觀音菩薩　Ink on Paper.　From Shi Song 奚淞 , *Sanshisan tang zhaji*《三十三堂札記》[33 notes and Guanyin Bodhisattvas].　Taipei: Lion Art Publishing, 1991, 69.

The Mangy Mutt 癩皮狗 Woodblock Engraving

road of spiritual cultivation, teacher and student remain faithful, like a form and its shadow. This is one of the artist's favorite subjects.

The Edge of the World is a supernatural yet brief story. Perhaps it was the first attempt at this series of the life of the Buddha. The painting is reminiscent of a 17th-century European religious painting. The postures of the two figures seem to foreshadow an astonishing miracle. In the depths of the night, as the moon falls in the west, leaving a residual glow, under a big tree that is shadowy and serene, suddenly Rohitassa, a radiant spirit with an exquisite face, approaches the Buddha with his great wisdom. Rohitassa kneels before the Buddha and asks him with sincerity: "Is it possible to reach the far end of the world, where one will never die?" Rohitassa says that in a previous life he had traveled the world, vainly seeking supernatural power. With a placid smile, the Buddha informs him that all such efforts are futile. Only by sincerely forsaking the self and learning the way of Buddhism, comprehending the Five Skandhas and following the Noble Eightfold Path—rightness of view, intention, speech, action, livelihood, effort, mindfulness and concentration—will you then fully comprehend that everything in this world is empty. This is the true understanding through which one may escape the troubles of this world and achieve nirvana. Upon hearing the Buddha's noble words, the goodhearted and intelligent Rohitassa is happy and filled with empathetic joy, and he reverently worships the Buddha. Then, like a shooting star, he disappears. The Buddha stands and expounds the Dharma, like a compassionate mother. Behind him, a road meanders toward the horizon, where the dawn is about to break.

Divination 問卜　Woodblock Engraving

The Buddha instructs his students every day, living a plain and simple life of spiritual cultivation. In this, there is nearly no narrative plot. What the artist has portrayed is the sincere mutual treatment of teacher and adherent, instructing and learning, coalescing in lofty sentiment. In *Anapana I* the Buddha travels into town early one morning with his student and only son Rahula, to beg for alms. On the road, the Buddha suddenly turns and says: "Be aware—everything is change and impermanence." The sensitive Rahula is immediately stunned. The only thing he fears is missing the opportunity to comprehend. He gives up the daily routine of begging for food, turns around and goes back to the garden, sitting beneath a tree and quietly contemplating the Buddha's teaching. In the picture, in the midst of a tropical jungle, the teacher and student look at each other at close range. They differ little in height, and the atmosphere is a little solemn. Under their uniformly red monk's robes, the bodies of the two men are as sturdy and solid as bronze statues, yet at the same time they have a realistic feeling, as if they might move at any moment. The Buddha's back is facing the viewer, his right hand slightly raised in instruction. The young monk is facing the Buddha, pressing his hands together. Day after day, the practitioners follow in Buddha's steps, traveling the road to Buddhahood, slowly emerging from the dark shade of the trees,

baptized by the first light of day, embarking on a form of learning filled with joy and challenge. In the painting *Early Morning Mendicants*, an old monk leads a younger one in the act of peripatetic purification. Their figures are strikingly similar to those of the Buddha and Rahula in *Anapana I*. The road of cultivation stretches out before them. Though it is long and meandering, they follow the way of their predecessor with footsteps resolute and steady. The morning light quavers amongst the tree leaves. The world seems to be filled with yellow butterflies, silently praising all those who in times past have pursued spiritual cultivation. We also seem to have witnessed the artist quietly follow in their footsteps. Shi Song has said: "We who live more than 2500 years after the Buddha passed away can still personally experience the Dharma that gives our spirits peace and happiness, as clear and bright as the light of dawn every day."

After spending many years producing *Song of the Great Tree*, a series of paintings in a classical style, Shi Song attempted a new interpretation with a more streamlined approach to the subject matter—in series of four or five paintings. Like spring, summer, autumn and winter, they shift in time within nature, in coordination with the four sacred events in the life of the Buddha: his birth, enlightenment, teaching, and ultimate attainment of nirvana. Over many years, Shi Song has engaged in painting as a meditative endeavor, and has practiced walking meditation in the hills and woods, constantly absorbed in the Dharma, dwelling in the Dharma whether in motion or at rest. In his *Life of the Buddha—Ashoka, Bodhi, Sal*, he employed the names of the three different trees present at the Buddha's birth, enlightenment and entry into nirvana, in remembrance of the Buddha's life of cultivation. These three paintings seem to be a return to the original Indian tradition of Buddhist art—the Buddha himself is not pictured, but only a symbolic object—the tree of meditation. Amidst the blue and green hues of "Ashoka," clouds overflow from the mountaintops onto a path beside a pond. The "Bodhi Tree" is a jade-green umbrella, valiantly safeguarding the world. The "Sal Tree" appears at sunset, blacks and reds illuminating each other. With a simple, gentle impressionist style, the artist invites us to enter the paintings, to meditate under the tree of Buddhism, or walk in circles around it, or recline or rest, joining with the artist in experiencing the gladness of the Dharma.

Not only is Shi Song both a Buddhist practitioner and an artist, he is also a superlative explicator in the written word. To put it more precisely, whether it be in paintings or in words, he enthusiastically exemplifies the practice of imitating the Buddha, and this is sincerely touching.

Translated by Brent HEINRICH 韓伯龍

* This essay was originally published in English as "A Buddhist Practicitioner's Art Practice—Song of the Great Tree" in *Xin yu shou sanbuqu—Shi Song huazhan* 《心與手三部曲—奚淞畫展》 (*Heart and Hand—The Paintings of Shi Song*). Taipei: Taipei Fine Arts Museum, 2011, 18-27. We hereby express our gratitude to the author for granting permission to republish the text. The paintings of the Guanyin Bodhisattva are from Shi Song 奚淞, *Sanshisan tang zhaji* 《三十三堂札記》 [33 notes and Guanyin Bodhisattvas]. Taipei: Lion Art Publishing, 1991. The still-life paintings are from Shi Song 奚淞, *Guangyin shitie* 《光陰十帖》 [Ten still-life paintings depicting time]. Taipei: Lion Art Publishing, 2011.

Yuan Chin-Taa

Yuan Chin-Taa's Art of Boundary Crossing

袁金塔的越界飄移與定錨

CHUANG Kun-liang 莊坤良

Hearts United under the Same Moon 千里共蟬娟 2010 Mixed Media on Paper 90×106cm

袁金塔 (1949-)
Yuan Chin-Taa (also Yuan Jin-Ta)

Born in Changhua, Yuan Chin-Taa is a contemporary Taiwanese artist with a strong creative force, a large number of works, and a unique style. Yuan graduated from the Department of Fine Arts of National Taiwan Normal University, where he later taught. He is one of the most innovative artists in Taiwan, and he uses a variety of mediums.

Through inks, acrylics, paper, pottery clay, photocopying, collage, traditional carving, and other mediums and methods, Yuan Chin-Taa is skilled at portraying changes in society, progress and various chaotic phenomena that have shaped Taiwan, creating a distinctive pop art style. In 2017 the Chan Liu Art Group established an art museum dedicated to Yuan. It is the first time an enterprise in Taiwan has established an art gallery for a living artist.

Yuan Chin-Taa is a *puer aeternus* of art. Art is his style of play, and the creative process that produces his art periodically plays out as a new artistic style that always gets attention, gets people talking. He claims his creative process is as delightful and spontaneous as a child's game, and that the ludic spirit he brings to his work is intensely liberating. Creating new forms of art liberates him from existing value systems, but not from society: his work has guided him to the most serious concern for Taiwan society and everyone in it. As Robert Frost put it, "Poetry begins in delight and ends in wisdom." That's the artistic path Yuan has taken.

Yuan has found numerous artistic playgrounds, places in the sun for his art, which can be discussed in terms of form and content. Formally, he sets out to cross boundaries, to appropriate different forms or media of artistic

expression: from European oil to Chinese ink-wash, from photocopying and laser printing to video reproduction; he works with acrylic, paper, clay, and experiments with sculpture and bricolage— you name it, he has played his way to a good feel for it. By crossing boundaries, he realizes his artistic ambitions, carried onwards by his inexhaustible creative inspirations. In Imaginary Homelands, Salman Rushdie wrote that cultural hybridization is the source of newness in the world. No wonder Rushdie prized cultural border crossing and the conceptual blending it brings. Yuan's art blends the domestic and the international, the local and the global, the traditional and the modern. In his border crossing imagination, Yuan embraces mongrels and hybrids and bears witness to novelty.

Content-wise, Yuan's artistic compositions are profoundly contemplative. He has discarded the stylized depiction, alienated from life, of traditional Chinese literati painting, and decided to seek material in the quotidian, in his authentic responses to society as it exists in the here and now. He is concerned with contemporary trends, and expresses his concerns artistically in works of great resonance. His artistic creations display a powerful modernity. From his early nostalgic agrarian realism of the 1970s to his reactions to dramatic social and political changes of the 1980s,

Busy 忙迫 1988 Ink on Paper 138×178cm

The Judge 判官 1993 Ceramics 40×43cm

from his discussions of eros and gender in the 1990s to his more recent enthusiasm for environmental protection and sustainability, he always expresses his views with a twist of his own trademark black humor. He always gets a laugh, but everyone laughs bitterly, with tears in their eyes, with disquiet in their hearts. His art comes from the reverberations of life in its daily and decennary rhythms. His creations shake off the shackles of exterior visuality to investigate the intrinsic truths of human existence.

But the form and content of his artistic commitment are inseparable. As William Butler Yeats put it, the dancer is the dance. Yuan's approach to the antithesis of form and content is dialectical: sometimes form leads the way, at other times content, but no matter what guides him, Yuan is always spontaneous, turning somersaults in art, the hand following the heart.

He has been classified as an ink wash painter, but he is hardly traditional. He seeks novelty and change, by no means complacent in his current achievement. In refusing to affirm himself he creates a new self. He has not confined himself to ink wash painting, but has dabbled in ceramics, installation art, and lately even paper art.

One of the four great inventions of Chinese civilization, paper has been used to create written and graphic art for a long time. Paper is a medium for writing and a manifestation of culture, used to transmit knowledge and record human civilization. But to Yuan, paper is not just a multifunctional medium but also a place for him to create a self-sufficient artistic space.

He handmakes his own paper in limited runs. Blending tea leaves and flower petals into the pulp, he creates petaline tea-scented folios. Such an intensive

Encroaching 蠶食 2003 Ink and Mixed Media 42×51cm

approach to paper-making is a gesture of respect for Tsai Lun 蔡倫 , the inventor of paper, and it is also a refusal, both of the mass production of paper and of the mass reproduction of art. In "The Work of Art in the Age of Mechanical Reproduction," Walter Benjamin lamented that the work of art, which once carried the aura of authenticity, was losing its shine at a time when it could be replicated *ad infinitim*. In his opposition to mass production and reproduction in industrial civilization, he tries to reawaken the humanistic concern that hibernates within each viewer with the soft texture of his handmade paper. As a return to simplicity, his paper creations prompt critical reflections on our contemporary way of life.

For his latest show, he has bound sheets of his paper into volumes that reinterpret three Chinese classics: *The Classic of Mountains and Seas* 山海經 , *The Book of Songs* 詩經 , and *The Classic of Tea* 茶經 . His reinterpretations of these flowerings of traditional Chinese civilization are appropriately modern.

The Classic of Mountains and Seas was traditionally unillustrated, but in Yuan's imagination all the ghosts and beasts referred to in the text are realized in fantastical ink wash illustrations. These illustrations give the work a fresh modern face and reduce the distance between the ancient tome and the contemporary reader.

Poetry in the Chinese tradition, which began with *The Book of Songs*, has always conveyed authentic emotions; in Yuan's artistic adaptation, this classic has a decidedly contemporary

New Interpretation of the Classic of Tea 茶經新解 2014 Ink, Paper, Mixed Media 900×900×120cm

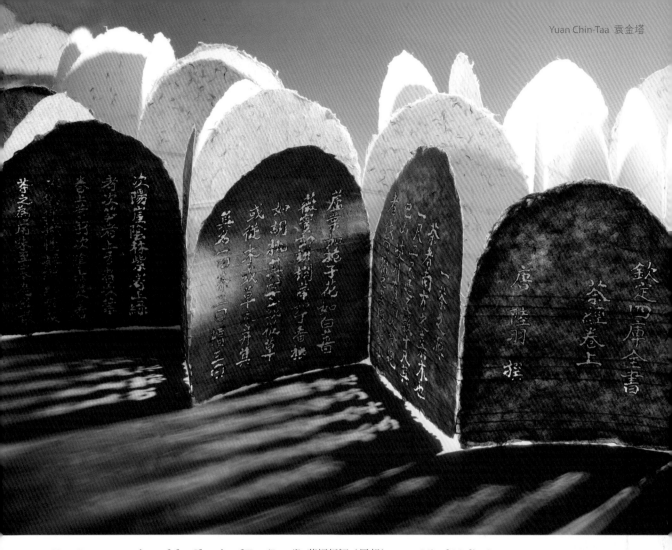

New Interpretation of the Classic of Tea (Detail) 茶經新解（局部） 2011 Mixed Media 840×29×100cm

feel. He paints pictures of fish as a running commentary on the love poems, comparing the way man takes pleasure in woman to the way a fish finds joy in water. By painting lips blood-red, he communicates the allure of love's temptation. With two fish kissing he symbolizes the pleasures of the flesh and comments on the worldly material desires that people today indulge in with abandon. His illustrations are a modern erotic reimagination of *The Book of Songs* that probes basic human desires, taking off the moral masks that the poems were made to wear by traditional Confucian critics. For the viewer, Yuan's work is a totally new visual thrill, a thought-provoking shock to the system.

Lu Yu's 陸羽 *The Classic of Tea*, the only such classic in the world, covers the planting, harvesting, processing, roasting, potting, cupping, tasting, and drinking of tea. It even includes stories that illustrate the cultural significance of tea. It shows that for Chinese people, tea is a way of life.

After making his handmade paper, scented with leaves and decorated with petals, Yuan then takes characters from the classic and scatters them onto each sheet. In this way, he decomposes the text, deconstructing its linearity. Instead of reading one character after another, the viewer takes his or her time, gaze wandering around the page. These random, open, instant, and discrete events of reading and gazing make for an interesting reimagination of the classic and allow for novel readings. In reimagining the classic, Yuan has set out from ancient Chinese civilization and found a route to the contemporary world. But in setting out from Chinese civilization, he has not forgotten the Taiwaneseness of his cultural identity. For he is Taiwanese, born and bred. To express his concern for Taiwanese culture, he makes a point of carving the characters for Dongding Oolong, Wenshan Baozhong, and Oriental Beauty – all important local varieties of tea – with the burning tip of an incense stick in his version of *The Classic of Tea*.

In creating his interpretations of the three classics, Yuan leaps into the fray of the politics of

New Classic of Mountains and Seas 新山海經 2011 Mixed Media 400×29×60cm

representation. Yuan imitates a traditional edition of each text while subverting it. By subversive imitation he repeats with a difference, and the difference is his subjective personal interpretation of the text. This difference is powerfully creative and imaginative, creating new possibilities of artistic experience.

Besides these three classics, Yuan has also created several big books, which continue the explorations he inaugurated in his "ceramic book series." Yuan has shown that books can be much more than reading media. They can also be stylish designs, playful articulations of line in two dimensions or in three, paintings or sculptures. The kind of book Yuan has made, which both is and isn't a book, recalls René Magritte's "Ceci n'est past une pipe." The Derridean *différance* of image and text, where signifiers give fluid pursuit to signifieds without ever quite reaching them, opens up a paradoxical third space that inspires the free imagination of the viewer and enriches the inexhaustible meaning of the work itself.

Painted Cats 粉貓　2002　Ink and Color　87×100cm

Frogs 蛙族 2008 Ink and Mixed Media 103×89cm

Happy Reunion 團圓 2015 Ink and Mixed Media 40×50cm

Yuan continues to push the boundaries of the book in his recent paper art. He blends not only tea leaves and petals but also characters into the pulp, which he then pours into fired ceramic molds to form thick paper sheets shaped like so many different teapots. These sheets are assembled into paper bricks, which he ink-washes and arranges haphazardly. Indentations in the bricks are places to put teapots, sunflower seeds and the outlined characters for "Taiwan tealeaves." With lighting, a pattern of hollow and whole appears, a fantastic relief effect that alters with the position of the viewer. It is so compelling, conveying a thousand different moods.

Red Frogs 紅蛙 2005 Ceramics 38×52cm

Life Pokers (13 pieces) 人生賭局（一組十三個） 2003 Ceramics
33×37×54cm (large) 28×35×46cm (medium) 22×24×39cm (small)

All about Tea 茶事　2014　Mixed Media　1300×225×80cm

Yuan's paper art displays what Roland Barthes would have termed the textuality of his oeuvre. Barthes distinguishes the work from the text. The work is a completed "being," while the text is an evolving "becoming." The former is a closed semiotic system, the latter a multi-dimensional open space in which signifiers from different cultures meet. The text involves the reader's consciousness in the process of signification, so that the reader participates in the interpretation of the text, creates it even. This Barthian theory of reading can be applied to the appreciation of art. When the viewer regards art, he or she enters the signification of the artwork-as-text, and engages with the artist/the text itself in a conscious exchange, a communicative negotiation. The viewer actively participates in the performance of the work, and is the coproducer of its meaning. The viewer is not by any means the passive recipient of meaning. The observer's task is not in reproducing the historical meaning of the artwork but rather in giving the work a new significance based on his knowledge, experience, and cultivation. In the process, new identities and values may be created. Appreciating Yuan's exhibit is the practice of this kind of theory, because it involves emotional expression and intellectual confrontation. The main point is not in the appreciation of his artistic creation but in the discovery (or invention) of one's self.

Artistic creation is an inner compulsion. It is an irresistible creative urge that draws an artist to self-development. Yuan's highest artistic concern is to devote himself completely to artistic creation. He sets out from Chinese ink wash, but he has broken out of the traditional frame of the form to explore new potential. In addition to his own artistic development, he has an intense sense of his mission in relation to tradition, which he both inherits and innovates. In his boundary-crossing imagination he blends the eastern and western spirits, setting out from the Taiwanese culture that has nurtured him to experiment in different media and expressive modes, thereby developing a distinctly Taiwanese ink wash painting.

In his latest paper art show, Yuan once again shows that he is seeking a place in history as a serious artist.

Translated by Darryl STERK 石岱崙

* From *Jinyishu*《今藝術》(*ARTCO*), 254, November 2013.

Meiing Hsu

Life as a Fugue:
The Art of Meiing Hsu

徐玫瑩的賦格人生

CHEN Man-hua 陳曼華

Bibliotheca VI 書事 VI 1999-2000 Copper, patina 5×37×4.5cm

徐玫瑩 (1957-)
Meiing Hsu (also Xu Mei-Ying)

Born in Taipei, Taiwan, Meiing Hsu graduated from the Department of Foreign Languages and Literature at Tunghai University. She earned a Master of Fine Arts degree from the University of Iowa. She is a metal artist and educator. In 1997, Tainan National University of the Arts established Taiwan's first craft research institute, to which Meiing Hsu is a major contributor.

Over the years, Meiing Hsu has devoted herself to the development of Taiwan's metalworking education while producing works of her own, including types of vessels, ornaments and sculptures. The main art forms Meiing Hsu devoted herself to include metal surface treatment, enamel, engraving, and casting. In recent years, she has focused on metal casting techniques. Many of her works are collections of plant stems, fruits or seeds, shaped into objects that show the combination of humanity and nature.

"If one may compare the visual arts with musical forms, I think that the baroque genres of canon and fugue as perfected by Johann Sebastian Bach probably come closest to my idea of beauty in creative works. A canon is a contrapuntal composition in which different imitative voices repeat an initial melody after a given duration, while a fugue—also contrapuntal—consists of a short melody or phrase that is introduced by one part and then successively taken up by others, further

developed by interweaving the various parts. Both genres involve intricate structures and forms of repetition, imitation, counterpoint, layers, tiers, and interlacements. Brimming with strict scientific logic and rationality, they yet allow for a free, spontaneous expression of mood and emotion."

—Meiing Hsu, *Reading Metal*

Early in the morning, between 4 and 5 a.m., when most people are still fast asleep, Meiing Hsu treads the many little paths that are crisscrossing the campus with a quick, light step, enjoying the cool air under a starry sky, soon to be taken over by the scorching sun of southern Taiwan. This has been her morning ritual for many years now.

After about half an hour, she returns home and turns on the Internet radio. This time of day is ideal for some classical music, maybe something from the Baroque period. Very possibly, she'll be listening to one of her all time favorites: Bach.

The breakfast table is usually set with mantou, or steamed rolls, and coffee—a nice combination of Eastern and Western cuisine—plus some fruit bought at a nearby farmer's.

Biblio-abruption III 斷層 III 2002 Copper, laser print transfer, patina 100×33×8cm

Bibliotheca V 書事 V 1999-2000 Copper, patina 24×25×18cm

Afterwards, she'll sit facing the little backyard garden, enjoying a hot cup of tea.

Or she may be writing a few paragraphs, or reading a few pages in a book. This is her alone time, the part of the day when she can do whatever she likes without being disturbed by others.

Eventually, she'll enter her studio, which is also her classroom, and begin the most active part of the day, working alternately as a creative artist and a teacher, two facets of her existence that are intertwined like the thematic variations of a fugue. This will keep her busy until after sundown.

Finding Pockets of Time for Creative Work

Hsu says, "Ideally, I'd wish to be a bit more of a creative artist than anything else."

However, reality paints rather a different picture.

As a university professor, Hsu obviously has to devote much of her time to teaching and administrative duties. At the same time, she is in charge of a metalworking studio, where among other things she has to handle the fundraising activities that make it possible to invite international artists for lectures and master classes. All these things take up much of her everyday time.

Even so, Hsu has never been willing to give up her career as a creative artist. As a result, she knows no holidays or vacations, because every off day or morning without classes, and even entire weekends, as well as summer and winter vacations, she spends in her studio working with blocks, strips, and sheets of metal to follow her one true vocation as a maker of art.

So she uses almost every available pocket of time to proceed on the hard road towards creative achievement, a road on which repeated frustration is the secret ingredient for pleasure and happiness.

Biblio-leafage III 葉書 III 2002 Copper, laser print transfer, patina 21×66×10cm

Stylistically, most of her works show a simple, clean and slender elegance. Her early *Reading Metal* series features copper leaves embellished with chemical coloring and arranged into cascading, multi-tiered layers reminiscent of the pages of a flick book being flipped before the observer's eye. Put together with great precision, these elaborate sculptures with their exquisite lines reveal the artist's meticulous craftsmanship and control of her medium.

Hsu's style underwent some subtle changes when she first encountered the metal casting of plants and flowers.

That year, the green bamboo in her neighbor's garden blossomed, a phenomenon Hsu had never witnessed or even imagined before. She had heard people say that when bamboos blossom,

Biblioleaf I 冊葉 I Copper , laser print transfer, patina 27×20.5cm (each)

Hidden Words: Objects from Heaven 藏字：天物 2005~2007 Copper, gold leaf, laser print transfer 33cm in diameter

the grove is about to die out. So she decided to pick some of the flowering bamboo twigs and cast them in bronze to create a lasting record of the rare bamboo blossoms. During the casting process, however, the flowers were damaged or broken, so that the shape of the final work was by no means the same as that of the original blossom. Perfectionist that she is, Hsu tried to produce more faithful images by repeated remolding and recasting. She discovered that using wax molds allowed her to create completely faithful reproductions of the flowers—yet she also found that it was in fact more interesting to use the blossoms themselves as molding material, because it rendered the casting process pleasantly unpredictable. She liked the more organic process driven by the soft, capillary structure of the flowers, and after some consideration chose to enjoy the surprising,

Pinustilia 松槿 2012 Cast bronze, stainless steel wire 8×6.5×6cm

ever-varying shapes and forms of the blossoming and wilting flowers, and accept the volatile and capricious results as a metaphor of life itself.

By making replicas of real objects, Hsu learned a wonderful lesson, which was to accept the final results of the creative process regardless of how much they did or did not conform to her original expectations, and to see "flaws" as attractive variations, the very core of a work's charm even, in the same way that idiosyncrasies make life more interesting. The result of this revelation was a series of works, including *Pinustilia, Swietenia, Ficus,* and *Thunderhibis,* all of them artistic studies on the theme of *Panta rhei.*

However, these "flaws" go very much against the grain of traditional metal craft.

Conventional metalsmithing is built on the principles of finely honed skills and immaculate precision, and these are exactly the things that Hsu imparts to her students: consummate technique comes before everything else. Take welding, for example—it is essential to clean away the solder and produce clean surfaces. Another basic skill students need to master is to saw metal sheets to size with one clean cut, rather than relying on additional filing to straighten out crooked lines. These and other fundamental skills and techniques are not only crucial for achieving

Counterpoint 對位 2012 Cast bronze, wood, mineral pigment, shell powder 205×35×7cm

proficiency in metalsmithing, they are also at the heart of what makes metal crafts such a special and unique form of artistic expression. But Hsu also felt that contemporary metalsmithing, especially as a genre of the visual arts, should probably go beyond such narrowly prescribed boundaries, thus pushing into new aesthetic territory. With regard to welding—coming back to one of our examples above—this could mean to tolerate rough surfaces by deliberately not cleaning away any debris, thereby elevating the conscious abandonment of specific skills to a novel creative concept. One artist who employs this approach to open up new possibilities is the well-known US metalsmith William Harper, who discovered the fresh kind of allure emanating from enamels that had been worked to something less than perfection. From then on, he intentionally created objects that would be considered "ugly" or "grimy" by conventional standards, and this soon became one of the hallmarks of his individual style.

The Spirituality of Metalsmithing

One of Hsu's works is titled *Counterpoint*, which consists of conifer cones, cast in metal and dyed indigo, that are fixed to the top of boxes made of gold leaf-covered wood. The boxes are all

Counterpoint (detail) 對位（局部）

of the same height and depth, but show variation in breadth, in the same way that the notes of a musical piece will differ in length. For Hsu, the boxes with their strict geometrical shapes form a lively contrast with the organic appeal of the indigo cones, making the pieces come alive through the juxtaposition of rational and emotional aspects. They also offer an oblique narrative of the artist's inner sensibilities.

Counterpoint. Just as in Bach's fugues, variations on a theme are interwoven and developed to form a complex pattern. Looking back on how she first became involved with metalsmithing, Hsu may well feel that it happened as if in juxtaposition to her father's life and profession.

As a child, she would often see her father, then a mining and metallurgical engineer, drawing up blueprints and graphics, a sight that left a deep impression on her young mind. After graduating from university, Hsu went to the United States for further studies, at first planning to enroll in a design-related department. But she soon noticed that among the elective courses with a creative focus, metalsmithing appeared to offer the most variety in terms of equipment, tools, and techniques, while also allowing for fairly free combinations with other genres and media, such as painting, prints, photography, sculpting, ceramics, and various fibers and textiles. She had found her calling: metal crafts, loaded with challenges and possibilities like few other art forms. Interestingly, her father later switched to doing molding and casting, developing such expertise

Departure I 離巢之一 2012-2013 Cast bronze, wood, spray paint, shell powder 68×64×6cm

that he even went abroad as a technical consultant. It was around the same time that Hsu Meiing began to start experimenting with the casting of real objects, and so she suddenly found herself in a situation where she could ask her father for practical advice—their lives and careers gradually coming full circle, from her early childhood memories to their overlapping pursuit of similar skills against different backgrounds.

Fugue. Hsu wants to become even more of a creative artist, but intertwined with the artistic theme is the more practical tune of being a teacher.

Returning home from her studies in the States in the late 1990s, Hsu soon found work at the Tainan National University of the Arts (back then Tainan National College of the Arts), where she became a pioneer of metal crafts in Taiwan. Teaching at the Metalsmithing Department of the

Leaf Book I 箔書之一 2005 Copper, gold leaf, pvc coated copper wire, oxidized
30×30×12cm

Variation of Nest: Green 巢變：綠 2009 Copper, enamel, mineral pigment, gold plated 16×16×8cm

Graduate Institute of Applied Arts from 1997 onwards, she almost single-handedly brought things up to par, overcoming countless difficulties in establishing an excellently organized department with a well-rounded curriculum and professional facilities and equipment. To the great benefit of her students, she was also able to keep her finger on the pulse of international developments in metal crafts and arts, and foster regular exchange with universities abroad. Along the way, she experimented with a number of different approaches, such as listing seminal works of ancient Chinese crafts and technology (specifically, *Kao Gong Ji* 考工記 , or "Book of Diverse Crafts," from the Period of the Warring States, and *Tiangong Kaiwu* 天工開物 , or "The Exploitation of the Works of Nature," an encyclopedia compiled in the late Ming Dynasty) as compulsory reading for her "Contemporary Trends in Metalsmithing" class in an attempt to give a Western-dominated field an Eastern, more "native" touch. Every year, Hsu invites metalsmithing artists from other countries to come to Taiwan for a few days and teach master classes or hold workshops, thereby giving students a chance to improve their skills and receive inspiration from mature craftsmen and artists. Furthermore, her metal crafts studio offers aspiring young artists an opportunity to develop their creative instincts in a suitable environment.

And before she knew it, two busy decades had gone by. Today, her life still revolves around metalsmithing, and its importance and meaning have only deepened over the years.

Hidden Book: Sutra 藏書：顯轉識論 2005 - 2007
Paper, stainless steel mesh, aluminum leaf, laser print transfer, plastic cord 50×30×4cm

Hidden Words: Homage to S 藏字：致故友 2006
Paper, copper, gold leaf, laser print, plastic cord 40×30×6cm Calligraphy by Shi Song 奚淞

Metalsmithing relies to a very high degree on actual handiwork, which may make it seem somewhat out of place in today's world with its ever-faster technological innovations, and its emphasis on efficiency and economic viability. But in a way, these critical challenges only further underline what is so special and important about metal crafts and arts—as Hsu puts it, doing something with your own hands is beneficial in many ways, both to the professional craftsman and the dabbling amateur, because on a purely physiological level it promotes eye/brain-hand coordination, while at the same time generating deep joy and satisfaction on the spiritual plane. "Take time-consuming techniques such as raising, chasing (embossing) and repoussé," she says. "Why would anyone want to spend hours upon hours, day after day, on something where progress can be excruciatingly slow? But we enjoy doing it, we never tire of these repetitive processes, because in some mysterious way they seem to soothe our souls and help us grow. These are the core values of all art and craft."

For Hsu, the crucial thing in all creative activity is an ongoing learning process that teaches you how to best interact with your medium, whatever that may be. Of course you will make mistakes along the way, but these will help you to learn and improve your approach. As you progress, you gradually refine your methods and get ever closer to the goals you have set yourself. Yes, it can be frustrating when you go down a wrong path, but what you do is harness your

Fugue-Island 複格－島嶼 2016 Cast bronze, wood, shell powder paint 400×70×7cm

Fugue-Island (detail) 複格－島嶼（局部）

patience and overcome all obstacles, even and particularly those of your own making, because you know that ultimately this will make you a better artist. To become a decent metalsmith, let alone a true artist in this medium, one has to master many different tools and techniques. It is a long and complicated journey that requires constant practice, but it is also a voyage filled with surprises and unexpected setbacks that frequently test the practitioner's problem-solving skills. And isn't problem-solving what much of our lives are all about? Isn't it one of the most basic things we all need to learn: to meet challenges and overcome difficulties, thereby building self-confidence and personal identity? For Hsu, these are the biggest gifts that metal crafts have given her.

The wonder and beauty of visual art lie in its ability, via the material form of a work as shaped by the hands of the artist, and as seen through the eyes of the observer, to reach directly into the depths of our very souls. And no one is touched more deeply than the artist herself.

Translated by David VAN DER PEET 范德培

* From *The Taipei Chinese PEN,* 181, Summer 2017, 80-106.

Tu Wei Cheng

A Poem of Our Time: Tu Wei Cheng's Art

時代之詩：涂維政的藝術創作

SHEN Bo Cheng 沈伯丞

Bu Num Civilization Site in Tachi, Tainan City　卜湳文明遺跡大崎遺址作品　2003

涂維政 (1969-)
Tu Wei Cheng (also Tu Wei-Zheng)

Born in Kaohsiung, Taiwan, Tu Wei Cheng graduated from the Tainan National University of the Arts. He has won awards such as the Taipei Art Awards and the Jury's Special Prize of the Taishin Arts Award. His important works include *The Bu Num Civilization*, *The Emperor's Treasure Chest of the City* and *The Ancient Art Hall Auction* series. In 2017, a special exhibition, Collecting Europe, was staged at the Victoria and Albert Museum in London, and Tu was the only Taiwanese artist invited.

Tu Wei Cheng has always single-handedly managed his artistic production, curating and marketing his own exhibition. His work is large and complex in structure. He makes keen observations regarding the development of civilization, inheritance of cultural artifacts, and temporal orientation and visual presentation of traditional and contemporary art.

In the future, what will we be like as penned by archaeologists and historians? How will the history of our time be portrayed? And how will later generations treat us and this era?

In Tu Wei Cheng's art works, the "present" turns into an "imaginary past," where the artist plays the role of an archaeologist or that of a historian creatively revealing interesting, even humorous images of our society and contemporaries. Through the artist's forged wreckages and ruins, Tu leads the viewers to experience astonishing, fantasized, and even mysterious pulsation. Similar to the way many people feel vis-à-vis genuine archaeological sites or historical museums, these forged wreckages, just like the ancient cultural relics of any period in the past, connect the

spectators with the distant time and space. They are items of memory helping the spectators to assemble the shards of memory bit by bit. All of them, whether those broken, scattered pottery jars and shards of the *Bu Nam Civilization* or the antique optical installation of the *Optical Trick* (2011), are romantic fantasies of our time. It is precisely the romantic imagery of these creation that enables us to linger in our poetic fantasy, thereby arousing the viewers' longing to reconstruct the lost scenarios of their lives. In so doing it once again recreates the fullness of life as well as the memory of the era the viewers live in.

As opposed to orthodox scientific archaeology, Tu's works endow gravity on the memory of "the contemporary" in a romantic way. Like reading a poem, the desire to read on is triggered by the pleasure of sensation rather than by the rewards of knowledge. Tu's exhibits are more like the poetry of an era than the study of an area of knowledge. They intend to offer viewers the experience of game-playing rather than edification. Through learning about archaeology and history and their application, the "ancient objects" of Tu's handmade works are like symbols of memory encompassing us and our times.

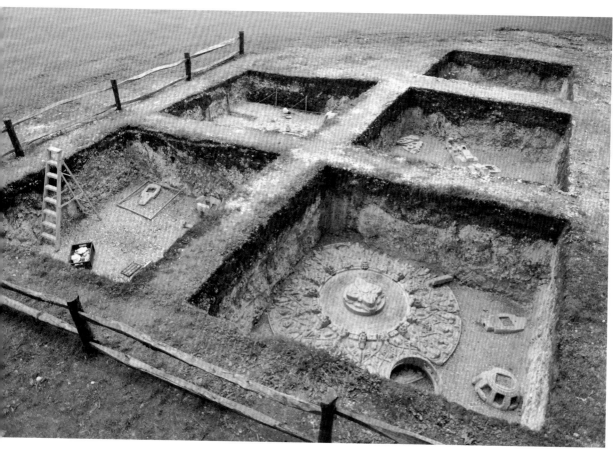

Tu Wei Cheng was invited by the Cass Sculpture Foundation to exhibit in the UK, 2016.
涂維政 2016 年獲邀英國卡斯雕塑基金會委託設置典藏展出

1 The Retrograde Xenoarchaeology

Looking back at Tu's creative journey, the *Bu Nam Civilization Site Special Exhibition* 卜湳 文明遺跡特展 of 2003 was definitely the most significant and most outstanding landmark of his career. In this renowned exhibition held in the Museum of Contemporary Art in Taipei, he started his personal creative journey by re-defining and shaping time and human memory. The exhibition differs from the usual "xenoarchaeology" seen on television and movies. Tu presented the hypothetical "remains of the past" as the legacy and evidence of alien life and culture from outer space, thereby postulating an incredible "past" and "history," as if the Mayan or ancient Egyptian civilization was constructed on planet earth by space aliens.

Unlike the genre of xenoarchaeology, Tu's *Bu Nam Civilization* offers the viewers a "past" that has never existed. He manufactured the objects that are often found on actual excavation sites or among the displayed items in the National History Museum. They impressed the viewers as familiar cultural relics, such as ancient sculptural forms, cenotaph, bas-relief and excavated pottery urns. Yet, upon close examination of the details of the displayed items, the viewers would in a flash realize that both the design and the themes of these objects were all drawn from our contemporary daily life. Like a craftsman or artist from the distant past, Tu used his hands to depict the interactive relationship between modern people and their electronic necessaries of life. He thus created an impossible past through injecting contemporary scenes into an ancient art form. If orthodox xenoarchaeology concerns itself with creating a myth of a "highly civilized" ancient past based on actual finds and speculates a remote extraterrestrial civilization, then Tu's *Bu Nam Civilization Site Special Exhibition* would be deemed a revised version of xenoarchaeology in the opposite direction that turns the time axis of the here and now thoroughly upside down so that "today" becomes "the past." Moreover, orthodox xenoarchaeology always invokes a set of familiar archaeological symbols to imply a hidden advanced civilization. Tu, on the contrary, fashioned high-tech icons in his objects through ancient craftsmanship to bury the contemporary civilization in an impossible past. If traditional xenoarchaeology can be considered a contemporary mythical interpretation of the past, then Tu's exhibition would be tantamount to an ancient mythical interpretation of the present. Both these forms are the modern myths of our times. Together they expose the fascination of contemporary men to manipulate the past, history and memory for none other than the pleasure of immersing in the imagination of the exotic.

Unlike those creators heading towards high-tech installations and digital effect, Tu seems to stand against the tide. His works are characteristically hand-made. Yet, in the technological icons and images he introduced in the exhibit, the viewer senses a latent message that the artist has, indeed, acceded to the viewpoint of the electronic age. Meanwhile, the use of traditional production method to depict motifs of the technological age places Tu's works simultaneously in the opposite poles of new art and traditional craft. It is precisely this handmade characteristic that allows the artist's works to escape the mainstream technology and digital approach of contemporary art. Here

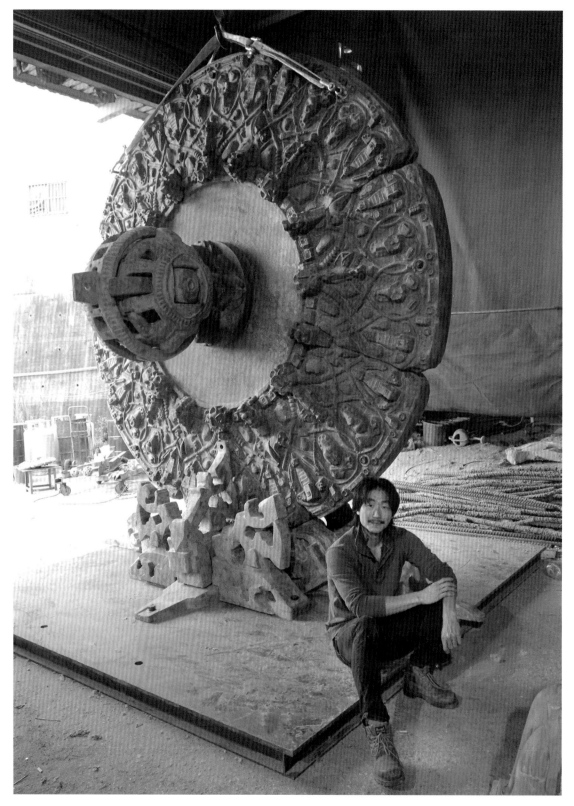

Tu Wei Cheng was invited by the Cass Sculpture Foundation to exhibit his *Wheel of Fleeing Souls* in the UK, 2016.
涂維政 2016 年獲邀英國卡斯雕塑基金會展出銅雕《魂遁之輪》

spawns his unique individualistic vocabulary and distinctiveness. The artistic distinctiveness of the *Bu Nam* exhibition lies in its combining technological ingenuity and old-fashioned craftsmanship, effectively transcending itself into the fabric of contemporary myth.

2 Inquiry into Unascertainable Truth and Epistemology

Since the *Bu Nam Civilization Site Special Exhibition*, the first important landmark in Tu's career as an artist, Tu has been contemplating the relationship between the historical truth and its interpretation. At the same time, he has also begun to pay attention to contemporary civilization. The issue that Tu focuses on is precisely what we call "the system of knowledge in the cultural circle." With two different exhibitions, the *Ancient Art Hall Auction* 古藝堂拍賣會 and the *M.O.C.A. Permanent Collection Exhibition* 當‧代‧藝‧術‧館常設典藏展 , Tu attempts to expose the issue of genuineness of antique objects and the acquisition guidelines of museums, which is essentially based on an unascertainable historical interpretation and a fetishistic obsession of objects.

On the other hand, these two exhibitions also attempt to bring into focus the museum's method of "aura production," which formulates the "past" and at the same time constructs the "future." Yet the artist's real concern is the episteme and the consciousness that provide the mechanism for the "here and now" to shape the "past" and the "future." Thus the two exhibitions

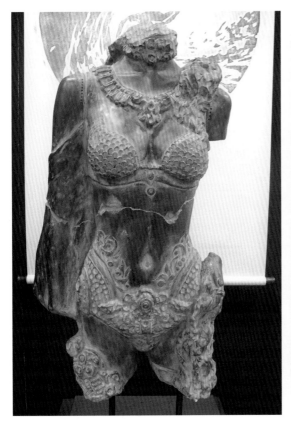 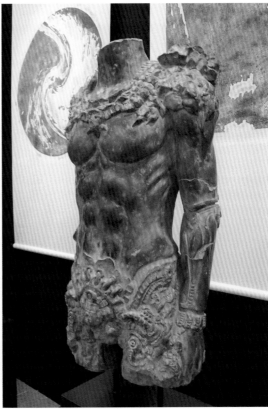

Water God 水神 Artificial Stone ***Mountain God*** 山神 Artificial Stone

and their artistic objects explore singularly the issue of the "here and now." In other words, the so-called "past" and "future" exist only in the scientific and fictitious construct of the "contemporary." This is exactly the starting point of the artist's inquiry. Is this the real truth, or merely an imaginary construct?

In the *Ancient Art Hall Auction exhibit* (Huashan Creative Park, Taipei,2004), Tu focused on the authentication of antique objects. Here Tu delved into the issue of our belief in history. As the artist put it, "Why is it that historical artifacts, whether genuine or fake, invariably rise in value in the face of human modesty? Why do they become objects of cultural tourism and of consumerism as well as entertainment? Do they represent the cultural pride of a particular locale, or an obsession with certain objects or fetishism, or the deification of historical fragments, or transforming history into art? Are we so suspicious of and dissatisfied with the contemporary cultural utopia that we are unwilling to risk believing in the modern world that is anything but absolute?"

Here one can see that Tu's view on history parallels Michel Foucault's. Both refuse to believe in the so-called authoritative interpretation of history or scientific narration of history. On the contrary, the real "truth" bypasses the intricate system of knowledge and authority as mentioned. Moreover, Foucault emphasizes that a person can resist and challenge the established system of knowledge via artistic creation and physical participation. Foucault's viewpoint further

Stele No. BM0802 BM0802 號石—搜櫥掛　2008 Artificial Stone　170×170×15 cm

enables us to understand Tu as a contemporary artist: his resistance to hi-tech manipulation and his preference for handmade crafts through intense physical labor. It is precisely with such participation and artistic creation that Tu is able to seriously challenge the consciousness behind the reception of antique objects and the traditional epistemology that continues to shape such consciousness.

In his exhibition *M.O.C.A. Permanent Collection Exhibition* (MOCA, Taipei, 2005), Tu diverted people's gaze from the antique objects and the past to contemporary art. In that

Stele No. BM0702 BM0702 石 2007 Artificial Stone 25×25×6 cm

exhibition, the artist fabricated a permanent collection of works and falsely claimed that it was from the MOCA (which in fact only displays but does not collect any art works). This exhibition revealed the artist's personal view of the approach of museums. In fact, it presented a far more provocative issue. According to Tu, "the motivation of this virtual museum collection is to parallelly present and question the following non-dualistic relationships: creation/curatorship/art museum acquisition system/viewing, as well as the following ties brought about by the displayed objects: old/new, tradition/contemporary, creation/curatorship, personal/systems, art/market."

Through the virtual "replica" of art works, this exhibition also challenges the viewers to reconsider the relationship between "ready-made goods," "re-presentation," "appropriation," "juxtaposition," "referral" and "creativity." As Tu says, "to create a controversy over an art work's collectability is an effective way to raise the question about 'the collection standards of contemporary art'." If the *Ancient Art Hall Auction* challenges the episteme of antique objects, then the *M.O.C.A. Permanent Collection Exhibition* throws into question the entire system of contemporary art museums. The exhibition underpins the fact that the only truth in the art world originates not from any objective or scientific standards. Rather, it is simply a mechanism of power.

Perhaps we can take these two critical, inquisitive exhibitions as artistic versions of Michel Foucault's *Les Mot et les choses: une archeologie des sciences humaines*. As Tu unmasks the intrinsic constituents of so-called art history and museology for the viewers, he not only leads them

Stele No. BM 0801-Star of Fleeing Souls BM0801 號石－魂遁之星　2008　Artificial Stone　R-208×15cm

to rethink the real issues of "history" or "epistemology," but also invites them to re-examine the so-called function of art and the role of the artist. His intended answer without doubt is that, like philosophy and the philosopher, art and the artist should continually inquire into and challenge the authority and the orthodox perception of our world.

3 Medium, Message, and the Beginning of Modernity

In his 2010 exhibition *Double Blindness* curated by Chin Yajun 秦雅君 of Eslite Gallery, Tu produced his first installation piece made of four bronze braille plates and four sets of mechanical musical boxes, entitled the *Quartet: Salute to Matteo Ricci and Shen Bo Cheng*. This exhibition represents not only Tu's tribute to Matteo Ricci and Shen Bo Cheng but also to two other philosophers. The raised dots on the bronze plate convert reading into touching, thereby turning visible message into haptic perception. By doing so the artist transforms the Canadian philosopher Herbert Marshall McLuhan's famous expression "the medium is the message/massage" into a tangible experience.

At the same time, the haptic message is transformed through the music boxes into aural music, thereby transposing the historical narrative into nostalgic songs of the past. Such

changeover reminds us of the origin of Western history, where the blind poet Homer recited *The Iliad* and *The Odyssey*. If history were the lyrics of songs or the rhythm in music or the uneven braille dots, then learning about history would go beyond simple reading and should embody hearing and touching. Moreover, given the two different senses of hearing and touching, the process of learning about history would then become all the more a topic of physical perception. The multiple sensory process would then once again defy the established structure of epistemology.

As a retro mechanical device, the music box witnessed the history of the introduction of modern culture to China for the first time by Jesuits Matteo Ricci and Johann Adam Schall von Bell. In the 17th century, the West and the East began to interact and influence each other through globalized trade, and the concept of Western art was ushered to the East. Tu's *Quartet: Salute to Matteo Ricci and Shen Bo Cheng* 四重奏：向利馬竇與沈伯丞致敬 salutes the scholar Matteo Ricci, who imported Western learning into China in early modern times, and the contemporary Taiwanese artist Shen Bo Cheng. The sound of music from the musical box created a poetic dialogue between the past and the present and between the West and the East.

4 Retro-style Visual Technology and Its Deep-Rooted Contemporaneity

If *Quartet: Salute to Matteo Ricci and Shen Bo Cheng* can be seen as an attempt to challenge the established structure of history and art, then the exhibition *Optical Trick* 視覺戲

Stele No. BM66-Gate of the Fleeing Souls (details) BM66 石牆—魂遁之門（局部）

Stele No. BM 0801-Star of Fleeing Souls BM0801 號石－魂遁之星　2008　Artificial Stone　R-208×15cm

法 may be considered Tu's bold challenge to the overall structure of art and the framework of its knowledge. As the artist says, "I explore the possibility of 'ultimate differentiation' through accumulating blunders made up of 'falsified events or history.' Words are first transformed into pictures, which in turn are made into melodious music. It seemed that a piece of memory is recalled and imagination is expanded through the sound of the music boxes and the chiming of the grandfather clock." What is clear is that, in his creative career that spans nearly a full decade, Tu has continually confronted the rigid established system with his imagination and his creation since his 2003 exhibition. This resilient attitude also bolster Tu's desire to search for pristine originality in his personal artistic creation.

Comparing with his earlier attempts, Tu went much further in *Optical Trick* to explore the

relationship between visual culture and modern technology. His reproduction of the 19th century optical instruments and the treasure cabinet of the Qing emperor offer the viewers a dazzling experience. For example, the large work *Treasure Chest* 多寶閣 placed at the entrance of the exhibition was remade from wooden furniture of an archaic style. This piece of work houses the contribution of eight artists and curators of the VT Art Salon in eight separate containers. The texture of the aged wood and the classical style of the *Treasure Chest* lure the viewers' imagination back to a certain ambience of old. This piece of forged antique instantly transforms itself into collective memory of the VT members, momentarily invoking the viewers' diverse memory of VT as well. *Treasure Chest* thus becomes a monument of the VT Art Salon, signaling the collective memory and history of the viewers and of the members who organize the space of the exhibition.

Yet, the purpose of making *Treasure Chest* is not merely to erect a monument of collective memory. Tu's real purpose is to rebuild the history of the birth of a museum through showing the traditional Chinese method of collecting and keeping treasures as displayed in *Treasure Chest*. The treasure cabinets of China are like the cabinets of curiosities of the royal families in the West, which is typically used to safe keep the king's collections. If the cabinets of curiosities started the eventual establishment of museums in the West, then the Chinese treasure chests would mark the starting point of museums in China. Similar to *Treasure Chest* was *Image Bank* 影像銀行, through which Tu aims to reconstruct the origin of the modern library in the East. The overall

Image Bank 影像銀行尋寶遊戲 2010 Taipei

The Emperor's Treasure Chest No.1 多寶閣一壹 2011

The Emperor's Treasure Chest No.4 多寶閣一肆 2012

design of *Image Bank* is inspired by the medicine cabinet of the traditional Chinese pharmacy. Its myriad drawers, arranged by the names and classes of medicine, store different medicine and medicinal formulae. It is easy to take advantage of the remarkable analogy between the Chinese medicine cabinet and the modern library in terms of the system of managing raw materials and knowledge. Through this two large scale objects, Tu repositions the modern system of exhibition and archive management and classification on the Oriental tradition.

Additionally, Tu also repositions our modern times on the recreated early modern age in his works. Apart from the two large pieces of work mentioned above, Tu also produces other pieces in his exhibit such the stereoscope, the Daguerre camera, etc. Meanwhile, he keeps making new music boxes whose braille dots can mimic the function of Morse codes. It is these works of lenses that reminds us of Jonathan Crary's *Techniques of the Observer: On Vision and Modernity in the 19th Century* and cautions us that our contemporary society is nothing more than a spectacle. Through each of these creations, the artist relocates our ongoing present to a point extremely close to an imaginary past. However, even though it is a past adjoining the present, it nevertheless arouses our nostalgia. If times vanishes faster than ever in the deluge of excessive information, then forgetting would be much easier than remembering.

It seems that the here and now is more enduring and meaningful amidst the gadgets of retro fad technology in *Optical Trick*. The present has been given additional value that allows it to be cherished and not easily forgotten. It will not just slide quietly into oblivion.

5 Museology a la performance

Besides challenging the power structure of history and epistemology, and apart from opposing the prevailing social establishment with his conduct, Tu carefully planned his 2010 Shanghai Rockbund Art Museum exhibit *Image-Sound-Museum* and his own *Optical Trick* exhibit to invite the viewers to participate in the exhibition on an experimental basis as well as to further scrutinize the concept of museology. In so doing he turned the museums into a venue wherein the viewers played major roles. This differs from the typical exhibitions in which viewers appreciate the design and the creation of the artists and the curators, or engage in some interactive works. Tu, on the other hand, invites viewers to put the finishing touches to his unfinished project, or to join the artist to finish the project together. For example, *Image Bank* works like Flicker or YouTube, allowing viewers to store and share their own images with others through the image bank. Through this group project, the work also becomes the collective memory of all its participants. As the project was designed as an urban game of treasure hunt, all participants must first become volunteer city rovers. This kicks off a chain reaction in the city, attracting more citizens to get involved and eventually creating a dramatic effect. The dramatic effect is as vivid as a performance poem composed of the separate murmurs of each participant, popping up at different corners of the city.

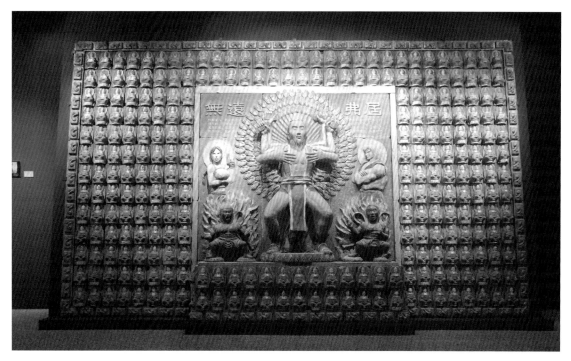

Confucius Dancing Mambo-Omnipresent 夫子跳曼波─《無遠弗屆》　2010

Through other projects like *Image Bank,* Tu pays homage to the famous concept of *homo ludens* (Man the Player) of Johan Huizinga. To Huizinga, play is the primary element in human culture and art. The Image Bank project echoes such a concept to become the origin of a new museology. This new museology concerns itself with the collective memory and its meaningful activities, rather than with the symbols and objects of power structure. In other words, the *Image Bank* project is a poem played by the city residents.

6 A Poem of Our Time

Tu, as an inventor, is devoted to carving out an imagined reality amid an ambience of reminiscence. At the cross junction of the present and the past, he sets up utopia after utopia, inaccessible kingdoms that can only be contemplated from a distance. These utopias mix the real with the fictional, and they are all filled with spellbinding romance. Those who walk into Tu's exhibition experience a nostalgia evoked by his works. It is precisely this nostalgia of the present that enables our days to be more poetic and more beautiful. And so the artist's exhibitions morph into poems of our time, leaving the viewers whispering without words.

Translated by Linda WONG 黃瑩達

* From *Yishujia*《藝術家》(*Artist*), 446, July 2012.

Notes on Authors and Translators

CHEN Man-hua 陳曼華 earned her Ph.D. in Social Research and Culture Studies from National Chiao Tung University in Hsinchu City, Taiwan. She is currently Assistant Researcher at the Department of Historical Compilation and Research of Academia Historica in Taipei. She has published *Shiho—Xiongshi Meishu fazhanshi koshu fangtan*《獅吼─〈雄獅美術〉發展史口述訪談》(*Roar of the Lion: An Oral History of the Development of Hsiung-shih Art Monthly*), which won the Excellence Award of the National Publication Award.

CHUANG Kun-liang 莊坤良 earned his Ph.D. in English Literature from University of Southern California, USA. He is a professor at the Department of Foreign Languages and Literature of Feng Chia University. He once served as the chair of the English Department and dean of the International Office at National Taiwan Normal University. He was also the first president of the Irish Studies Association Taiwan. His research interests include James Joyce, Irish literature, postcolonial theories, aesthetic studies, and translation.

Brent HEINRICH 韓伯龍 is an American translator of Mandarin Chinese. He has specialized in art translation for more than 20 years.

HSIAO Chong-ray 蕭瓊瑞 was the Director of the Bureau of Cultural Affairs of Tainan City Government and now a Professor of Arts at National Cheng Kung University. He has authored many collections of art criticism, including *May and the Orient*《五月與東方》and *History of Taiwanese Fine Arts*《台灣美術史綱》.

Yauling HSIEH 謝瑤玲 is currently Professor of English at Soochow University in Taipei. She is also a professional translator, having translated more than 250 published books. In recent years, she has translated the librettos of the National Guoguang Opera Company and other theater troupes in Taiwan with Joel J. Janicki.

Joel J. JANICKI 葉卓爾 is currently Professor of English at Soochow University in Taipei. His fields of interest include American Literature, Russian literatures, Eastern European Languages and Cultures.

LEE Chun-yi 李君毅 was born in Taiwan and grew up in Hong Kong. He graduated from the Chinese University of Hong Kong and studied at the Graduate School of Fine Arts of Tunghai University, Taiwan. He received his Ph.D. in Chinese art history at the Arizona State University and was a post-doctoral fellow at the Phoenix Art Museum. He currently teaches at the National Taiwan Normal University.

LIU Jung Chun 劉榕峻 holds an M.A. in Art History from National Taiwan University. He participated in the National Palace Museum Digital Collection Project and is now a researcher at Jiansong Ge 翦淞閣 . He is also a contributing editor of *Art and Collection* 《典藏古美術》. His research interests include history, arts history, and the culture of book collection.

PAN Hsuan 潘煊 , born Pan Hsiu-yu, is an editor and a freelance writer. She is best known by her biographies of great Buddhist masters in modern Taiwan. Her book, *Ju Ming on Art* 《朱銘美學觀》, published 1999, records her interviews with Ju Ming, the well-known master sculptor.

SHEN Bo Chen 沈伯丞 , a native of Tainan, is an independent curator and art critic. He graduated from Tainan National University of the Arts and is currently a Ph.D. candidate of Art Theory at his alma mater. Having taught both at his alma mater and at the Taipei National University of the Arts, he is now Assistant Professor of Communications Design at Shih Chien University in Taipei. He has published *Yiqi zaoxiang* 《藝啟造像》 [Photographic portraits of artists in Taiwan, photos by Chen Ming-chung 陳明聰].

Darryl STERK 石岱崙 holds a Ph.D. from the University of Toronto. His dissertation focuses on the fictional representation of interracial marriage. Having taught at the University of Alberta in Canada and National Taiwan University in Taipei, he is currently Assistant Professor at the Department of Translation at Lingnan University in Hong Kong.

SUN Chao 孫超 was born in Xuzhou, China, in 1929. He graduated from the Fine Arts Department of National Taiwan Academy of the Arts in Taipei, and has worked at the National Palace Museum in Taipei. A master of ceramic arts and winner of the 1987 National Literary and Arts Awards, he has held many solo exhibitions around the world.

SUN Yiling 孫逸齡 grew up in the countryside of Taiwan surrounded by farmlands. She studies in the U.S. and has a bachelor's degree in Economics from University of California, Irvine and a master's degree in Actuarial Science from University of Connecticut. She worked in actuarial in insurance industry afterwards. She currently lives in Connecticut with her husband and their two children.

Sterling SWALLOW 師德霖 is a lecturer of English at the Hsin Sheng College of Medical Care and Management in Longtan, Taiwan. He teaches courses in introductory linguistics, Chinese-to-English translation, cinema studies, and English conversation.

Carlos G. TEE 鄭永康 holds a Ph.D. in Comparative Literature, and an M.A. in Translation and Interpretation Studies from Fu Jen Catholic University in Taipei. He received the Liang Shih-chiu Literary Award (English Translation Category) in 1997, 1998, and 1999. A freelance translator, copywriter, and editor, he now teaches at the Graduate Institute of Translation and Interpretation at National Taiwan Normal University.

Chao-yi TSAI 蔡昭儀 is currently Chief Curator of Exhibition at the National Taiwan Museum of Fine Arts. She graduated from the Taipei National University of the Arts, and holds a M.A. in Art History and Museum Studies from the City College of New York. She specializes in the curating of Asian Contemporary Art and modern/contemporary art history in Taiwan, and was the Executive Director and a board member of the Taiwan Fine Arts Foundation from 2010 to 2017. From 2002 to 2005 she was also a board member of the International Committee for Exhibition Exchange (ICEE) of ICOM.

TSAI Ming-tsan 蔡明讚 was born in Taoyuan County. An M.A. in Chinese from National Taiwan Normal University in Taipei, he has taught Chinese in high schools and colleges. He studied Chinese calligraphy and abstract ink painting and was President of the Republic of Chinese Society for Calligraphy Education.

Shih-ping TSAI 蔡詩萍 was born in Taoyuan in 1958. He holds an M.A. in Political Science from National Taiwan University, and was the chief editorial writer of *Lien-ho wan-pao*《聯合晚報》 (United Evening News). He is a noted writer, culture commentator, broadcast/TV program host.

David VAN DER PEET 范德培 was born to Dutch and German parents in Trier, Germany. He studied Chinese and Japanese at the University of Trier and received a B.A. in Chinese from National Cheng Kung University and an M.A. in Translation from Fu Jen Catholic University. He has been in Taiwan since 1989 and now resides in Tainan as a freelancer.

Cora WANG 王力行 received her B.A. degree in Journalism at National Cheng-Chi University, Taipei, Taiwan. After serving as Editor-in-Chief of *Woman* Magazine (1973-1978), and Chief Correspondent for *China Times* in Hong Kong, she co-founded *Common Wealth* Magazine in 1980. In 1986, she founded *Global Views* Monthly with Dr. Charles Kao, and became the Publisher and Editor-in-Chief of Global View-Commonwealth Publishing Group. She is a multiple award-winner, and was elected the President of the Chinese Chapter, World Association of Women Journalists and Writers (2001- 2003).

Joseph WANG 王哲雄 received his Ph.D. degree in Archaeology and Art History from Paris Sorbonne University and former head of the Department of Fine Arts of National Taiwan Normal University, is currently Professor of Industrial Design at Shih Chien University in Taipei.

Linda WONG 黃瑩達 was born in Hong Kong, educated in the U.K. and studied Art History at UCLA and Harvard University, U.S.A. She worked in various museums and as a Lecturer at the Museum of Fine Arts in Boston. She is a freelance translator and editor specializing in art historical subject matter.

WU Chitao 吳繼濤 was born in Tainan, Taiwan. He graduated from the National Institute of the Arts, and holds a Master of Fine Arts from Tunghai University. An artist of Chinese calligraphy and paintings, he has earned numerous awards and held solo exhibitions. Many of his works are collected by museums, galleries and private foundations. He is also an art critic, curator, and author. He now teaches in the School of Fine Arts at Taipei National University of the Arts and the Department of Fine Arts at Tunghai University.

Michelle Min-chia WU 吳敏嘉 was born in Taiwan and raised in New Zealand, Thailand and Korea. She holds a B.A. in Foreign Languages and Literatures from National Taiwan University and an M.A. in Translation and Interpretation Studies from Fu Jen Catholic University.

She is currently Assistant Professor of the Department of Foreign Languages and Literatures at National Taiwan University and a professional conference interpreter who enjoys dabbling in literary translation.

Yuyu YANG 楊英風 , also known as Yang Ying-Feng, was born in Yilan County, Taiwan, in 1926 and passed away in 1997. An acclaimed sculptor adept at playing with stainless steel, he started his career as a painter in 1942. Since then, he had studied art in Beijing, Tokyo, and Taipei and tried to create with various media and forms. Winner of many important honors and awards, including the Executive Yuan Culture Award, he founded the Yuyu Yang Foundation in 1993 to help promote artistic education in Taiwan.

YEN Chuan-ying 顏娟英 received both a B. A. in History and an M. A. in Chinese Art History from National Taiwan University, and a second M. A. and a Ph.D. in Art History from University of Kansas and Harvard University respectively. She is currently a Research Fellow at the Institute of History and Philology, Academia Sinica, Taiwan, and Professor at the Graduate School of Art History, National Taiwan University.

Contemporary Taiwanese Literature and Art Series *II* – Art
當代台灣文學藝術系列 *2*—美術卷

Publisher	Taipei Chinese Center, PEN International 中華民國筆會
President	Pi-twan Huang 黃碧端

4th Floor, 4, Lane 68, Wenzhou Street, Taipei, Taiwan 10660, Republic of China
中華民國台灣台北市溫州街 68 巷 4 號 4 樓
Tel: (886-2)2369-3609 Fax: (886-2)2369-9948
E-mail: taipen@seed.net.tw
http://www.taipen.org

Editor-in-Chief	Pi-twan Huang 黃碧端
English Editor	Yanwing Leung 梁欣榮
Assistant Editors	Feimei Su　蘇斐玫
	Sarah Hsiang　項人慧
Cover Design	Winder Chen 陳文德
Distributor	Linking Publishing Company 聯經出版事業公司

Published in Taipei, October 2018
With a grant from the Ministry of Culture, Republic of China (Taiwan)

2018 年 10 月出版（文化部贊助）
ISBN 978-986-8667440 （Hard cover 精裝）

豪傑，遙想公瑾當年，小喬初嫁了，雄姿英發。羽扇綸巾，談笑間，強虜